Praise for *Picasso's War*

'[Martin] has produced a skilful blend of art, politics and history to account for the creation and fate of one of the indisputable masterpieces of the 20th century'

Sunday Times

'Martin closely follows the political career and travels of the painting from the initial show and lack of interest taken in it by the press in Paris to its present international status as one of the most significant pictures of the 20th century – and of the 21st, too'

The Times

'It's an impressively diligent book . . . everyone interested in Picasso will be grateful to know how the painting came into being and how its afterlife has made it a focus for national feeling, let alone protests against war'

Andrew Motion, *Guardian*

'Certain great paintings accumulate incredible histories . . . In this well-conceived and intelligently felt book, Russell Martin skilfully summarises the historical context'

Frances Spalding, *Independent*

'Martin has constructed a highly readable narrative from the turbulent life of a great painting. He has a good, clear prose style. He interweaves art history, Spanish history, art criticism and global politics with some skill'

Sunday Herald

Russell Martin is the author of six previous books, including *Beethoven's Hair*, a bestseller and winner of the Colorado Book Award. *Out of Silence* and *A Story that Stands Like a Dam* were also met with international acclaim. He lives in Denver, USA.

Also by Russell Martin

Beethoven's Hair
Out of Silence
A Story that Stands Like a Dam
Beautiful Islands
The Color Orange
Matters Gray and White
Cowboy

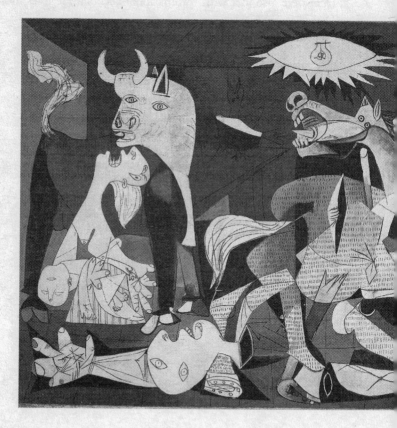

Picasso's War

The Extraordinary Story of an Artist, an Atrocity — and a Painting that Shook the World

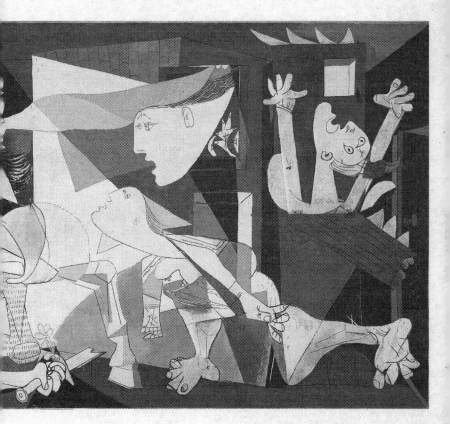

RUSSELL MARTIN

POCKET
BOOKS

First published in Great Britain by Scribner, 2003
This edition first published by Pocket Books, 2004
An imprint of Simon & Schuster UK Ltd
A Viacom company

1 3 5 7 9 10 8 6 4 2

Simon & Schuster UK Ltd
Africa House
64–78 Kingsway
London WC2B 6AH

www.simonsays.co.uk

Simon & Schuster Australia
Sydney

A CIP catalogue record for this book is available from the British Library

ISBN 0-7434-7863-0

Printed and bound in Great Britain by
Cox & Wyman Ltd, Reading, Berkshire

For additional information about *Picasso's War*, audio excerpts of inter-
views, historical and contemporary photographs that illustrate the *Guernica*
story, as well as a discussion guide, visit the companion Web site at
www.PicassosWar.com

a Angel Vilalta,
mestre, pare, amic

Contents

On a black and white canvas that depicts ancient tragedy, Picasso also writes our letter of doom: all that we love is going to be lost, and that is why it is necessary that we gather up all that we love, like the emotion of great farewells, in something of unforgettable beauty.

Michel Leiris

What do you think an artist is? An imbecile who has only eyes if he is a painter, or ears if he is a musician, or a lyre in every chamber of his heart if he is a poet, or even, if he is a boxer, just his muscles? Far, far from it: at the same time, he is also a political being, constantly aware of the heartbreaking, passionate, or delightful things that happen in the world, shaping himself completely in their image. How could it be possible to feel no interest in other people, and with a cool indifference to detach yourself from the very life which they bring to you so abundantly? No, painting is not done to decorate apartments. It is an instrument of war.

Pablo Picasso

It was an enormous canvas, so large that Picasso needed a ladder and brushes strapped to sticks in order to paint its heights, a canvas so grand that he had little doubt of its ability to captivate the citizens of the world who would see it exhibited beside the Seine in only a few weeks' time. Working from the ladder when he needed to, and sometimes on his knees, the artist began to paint on May 11, 1937, and he did so with a hot and focused intensity that was unusually keen even for him. He was determined to transform the vacant canvas into a monumental mural that would disturb and shock its viewers, alerting them to the horror that had occurred in a town in Spain a fortnight before, and reminding them as well that people similarly suffered unimaginable terror in every place and time.

Four months before, in the gray trough of the Parisian winter, Pablo Ruiz Picasso, at age fifty-six already widely considered the world's foremost living painter, had been visited at his home and studio in the rue la Boétie by a delegation that included Max Aub, cultural delegate of the Spanish embassy in Paris, and Catalan architect Josep Lluis Sert,

who recently had completed his design for the Spanish pavilion that would be part of the much-heralded world's fair scheduled to open in Paris in May. The men hoped to convince the artist—whose acquiescence they knew they by no means could count on—to paint something bold and arresting specifically for the pavilion, an important canvas that would lend the modest building a cachet it otherwise would not have. As part of their effort to persuade him, the visitors suggested that the painting would remind the world that Picasso was a son of Spain, and that he, like every true patriot, abhorred the rebellion by members of the Spanish military that had thrown the country into civil war six months before and that by now very seriously threatened the survival of the nation's nascent democracy.

Picasso listened, but was filled with misgivings: he had never created a painting as large as the one Sert hoped would fill a focal wall in the pavilion's courtyard; he disliked the notion of being commissioned to create an artwork; and despite his strong support for the embattled Spanish Republic, the mural necessarily would be something of an overt piece of propaganda—and the great Picasso was not a poster artist, after all. By the time his fellow Spaniards departed, the artist had gone as far as to assure them of his ongoing devotion to the cause of the republic, and that he would certainly like to be of assistance, but he had not specifically agreed to take up the mural project. He did promise his visitors he would give great thought to possible subjects for the mural, and he had continued to think but do nothing more until news reports reached Paris on April 27 that a town in northern Spain had been destroyed the day before by bombers of the Nazi Condor Legion acting under the orders of Spain's insurgent generals. According to rapidly mount-

ing radio and newspaper reports, the town of Gernika—as its name is spelled in Basque, pronounced *Gair-KNEE-kuh*—had been attacked during the busiest hours of a regional market day, and the slaughter of civilians and the destruction of homes, schools, businesses, and churches had been its only brutal goal. Picasso, like people throughout Europe and the rest of the world, responded to the news with immediate outrage, and at last he knew he had no choice but to go to war himself—to create the mural in both bold support for the Spanish Republic and in fierce opposition to the fascist tide that was engulfing his beloved homeland.

On May Day, more than a million Parisians marched along the historic route between the Place de la République and the Bastille in the largest workers' parade in the city's history, shouting their abhorrence of the bombing and pleas for aid to both its victims and Spain's republican government. And on that day as well, Pablo Picasso executed the first six of what ultimately would be five dozen sketches and drawings in preparation for the mural, a painting his huge anger now compelled him to commence. During the months since he had been asked to consider taking on the Spanish pavilion project, he imagined that a fitting subject for the mural might well be a painter at work in his studio, but now that decidedly self-absorbed theme demanded to be replaced by another. As he explained in a public statement issued a few days later, one that defined his position on the war more explicitly than ever before, "in the picture I am now working on and that I will call *Guernica*, and in all my recent work, I clearly express my loathing for the military caste that has plunged Spain into a sea of suffering and death."

Before he put his wet brushes into turpentine in the early evening of May 11, the celebrated painter already had worked

so long and with such dispatch that he had filled the whole of the 3.5- by 7.75-meter canvas (11'6" high by 25'8" long) with line drawings of the many images he had been working out on paper during the preceding days. The painting he would call *Guernica* (as the name is spelled in both Spanish and French) already had begun to take tentative shape, and the often-uncomfortably intersecting realms of politics and art—and of human misery and aspiration—never would be the same again.

Although I stood in front of the painting for the first time only in middle age, I came to know something about *Guernica*—and it began to matter immensely to me—when I was still a boy, one who had traveled a third of the way around the world to live in Spain for a year. The time was 1968. The painting by then had long been resident in New York City, and the people of Spain continued to live under the cruel and despotic control of Generalissimo Francisco Franco, the diminutive but boldly defiant leader of the military revolt that had thrust Spain into civil war more than three decades before. The whole of the planet appeared to have lost its ethical moorings in that year of assassinations, cancerous foreign wars, and bitter demonstrations. And as it had for millions of young people throughout the world, the painting might have seemed to me more immediately emblematic of the violence then being visited on the citizens of Vietnam than an event that took place in a town in the Basque region of Spain half a lifetime before. But because I discovered *Guernica* in totalitarian Spain, and because an extraordinary teacher in Barcelona had introduced the painting to his American students solely in the context of the ter-

rible war he had observed as a boy, *Guernica* initially for me was more fundamentally an historical accounting, a terrifyingly vivid depiction of a singular and awful event, than a universalized symbol of the horrors of war.

Angel Vilalta, a young, vibrant Spanish art and culture professor, wanted his American students to get to know "el Guernica" only after he first brought the tragedies of the Spanish Civil War to troubling life for us and ensured that the bombing of the town of Gernika was something we would viscerally apprehend. Picasso's *Guernica* was a report from the front lines of that war, first of all, and it spoke insistent truths to Señor Vilalta and subsequently to us. He made us understand the stark reality that fascism remained alive and well—in Spain at least—in the late 1960s, yet also that Picasso's by-then long–acknowledged masterpiece was proof that art sometimes can transfigure catastrophe, and he eloquently voiced his conviction as well that his country's art and literature mattered far more than its politics in the end.

I had not seen Angel Vilalta, now seventy-five, in the three decades since I watched him recede from view on a platform at Barcelona's Estación de Francia on a bright June day in 1969, all of us American schoolboys bound for Le Havre and a ship that would return us home to the United States nine days later. When I returned to Spain at long last in September 2001 to view the remarkable painting and investigate its history, I also wanted to pay a kind of homage to him and his vital mentoring of so many young Americans. Angel's eyes often danced during our three-day reunion as he repeatedly spoke of the miracle that had occurred in Spain since I had waved good-bye to him—Spain becoming open and democratic and its citizens blessedly *free* without first

having to suffer the bloodshed that had seemed inevitable back when an elderly Franco still ruled with the fiercest of iron hands. I listened carefully as he explained that throughout the decades that had followed Franco's death, the painting had been both a reminder of his country's tragic past as well as a potent symbol of the fact that Spaniards now were shaping a society that in many ways was utterly new. And as Angel described how the jubilant public response to the painting's arrival in Spain in 1981 at last had expiated a wide sea of political sins, it was clear to me that he had been right long ago when he assured us that art matters enormously.

I became reacquainted on that trip with the soft light and many scents of Barcelona, the Mediterranean city in which Picasso had been a boy and young man, and to which he always longed to return; I saw once again the rugged, green, and forested Basque country that Angel first introduced me to, the small region on the Bay of Biscay whose proud and self-protective people long have harbored democracy. I spent days in small but vital Gernika, rebuilt entirely since the afternoon in 1937 when German bombers screamed out of the sky and reduced the town to ash. There were days as well in nearby Bilbao, where the Museo Guggenheim Bilbao, one of the world's most extraordinary buildings, sits beside the Rio Nervión like a dry-docked and shining ship, waiting, so far in vain, for the time when it will take *Guernica* on board, the painting at last drawing very near the place whose unfortunate fate gave it birth.

And on September 11, 2001, at the Museo Nacional Centro de Arte Reina Sofía in Madrid, at last I was standing in front of the much-traveled canvas, three decades after Angel first had described it to me, when—across the Atlantic— the city of New York fell under an utterly new kind of attack,

yet one that also eerily echoed the April attack on Gernika sixty-four years before. In both instances, the targets were symbolic; the aim of both attacks was to incite terror from out of the otherwise sheltering sky, and to destroy thousands of people who had no inkling of their supposed crimes. In New York as in Gernika, barbarity and utter senselessness had taken hold. And similarly, it would fall to time—and to art—it seemed, to fashion meaning out of unimaginable evil, once more to offer hope.

I looked at *Guernica* for a long time on that warm September afternoon, joined by thousands of people who had come to Madrid from every part of the world to spend a bit of time in the presence of what is widely regarded as the most important artwork of the twentieth century. None of us was aware as we stood across from the brutal, horrific, yet somehow mesmerizing images of Picasso's war, that in those same moments the twenty-first century had been forced forever onto a new tack, that once more—as had happened in little Gernika—humans had transformed themselves into demons, and other humans suddenly searched for reasons why.

Chapter 1

The Spanish Dead

By the time the bombs rained out of the spring sky in Gernika, the Basque countryside that cradled the town—and the rest of Spain as well—had been at brutal war for nearly a year. The democratic national government, to which so much of the world had looked with hope for six years, already appeared to be in great peril. Spain, like countries throughout Europe at the time, was caught in a bitter intellectual struggle between those who believed the firm arm of fascism could best steer the course out of the economic miasma of the 1930s, those who were equally convinced that Marxism lit the way to a better world, and the anarchists and democrats of dozens more political perspectives who were horrified by the two impassioned extremes.

In Spain, the seven-year dictatorship of Miguel Primo de Rivera, which had been patterned after the clenched-fisted rule that Benito Mussolini had by then successfully brought to bear on the citizens of Italy, had come to an end in 1930. A precarious coalition of leftist democrats had forced his ouster, as well as the abdication and exile of King Alfonso XIII, who, like the Castilian kings who had preceded him for centuries, believed his countrymen were too simple, too untutored to govern themselves. The people who forged the

new government imagined a many-splendored Spain where regional autonomies and myriad political parties would flourish, as would personal and social liberties of every sort. Spain, like France and Great Britain, would become an open and progressive society, declared its democratic visionaries. The country might have taken great strides in that direction had not the growing international influences of Mussolini and Adolf Hitler—who came to power in Germany in 1933—emboldened Spanish conservatives in the military, the Roman Catholic Church, industry, and the aristocracy to oppose the fragile government at every turn. In parliamentary elections held in February 1936, the conservatives came within a few votes of wresting power from the loosely allied Popular Front, a coalition of democratic socialists, Communists, and anarchists who remained committed to the notion that Spain would not thrive until it truly was free of control by the wealthy and privileged classes, the military, and the church.

The bitterness of the defeat the conservatives suffered was exacerbated when church clerics, industrialists, and right-wing politicians increasingly became the targets of leftist vandalism and even assassination. By the summer of that year, four ultraconservative army generals, led by the unlikely forty-four-year-old Francisco Franco, were determined to respond with violence of a more organized kind. As was the case with the German leader he so admired, Franco's small physical presence and prickly personality initially made him appear incapable of engendering loyalty and deep devotion among his subordinates. Yet there was something in his bold and unshakable belief that God had marked him personally for glory, that he alone could return to Spain the honor it had lost in "el Desastre"—the country's defeat in

the Spanish-American War and the abrupt and decisive end of its empire—that he was able to communicate with extraordinary effectiveness. Franco combined a precisely focused and anachronistic eloquence with a passion for inciting fear, and he took unabashed pleasure in terrorizing his foes. It was that combination of unflinching vision and utter ruthlessness that allowed the pot-bellied and essentially insecure man to succeed, at least in part, when—with only the three other generals and the troops they commanded as his allies—he set in violent motion a series of regional coups d'état on July 18, 1936.

The four generals had hoped that the military muscle-flexing of a single day—carried out in key garrison towns and cities around the country—would incite panic among the leaders of the fractious regional parties in Barcelona and Bilbao, as well as the internally battered national government in Madrid, and that they could seize power following no more than a bloody skirmish or two. But seventeen more major generals and their troops remained steadfastly loyal to the republic on that hot and pivotal July day and for hundreds more days to come. Labor unionists and locally organized militias promptly joined in its defense as well, and all of Spain boiled quickly into chaos. Thousands of soldiers and civilians soon lay dead in fields and streets; the nation's key cities were bombed, burned, and looted, and the coups d'état gave way to brutal civil war in only weeks.

The war came quickly and horribly to the Basque country, hard by the French border on Spain's rainy northern coast, in part because the Basques themselves—like Spaniards everywhere—were maddeningly split in their political per-

spectives and allegiances, but also because Euskadi—the Basque name for the contiguous provinces that comprise their homeland—became a prize the rebels were desperate to seize. Franco and his confederates made military control of the region their highest priority, and soon thereafter it suffered massive blows.

The citizens of Euskadi had struggled to achieve the political autonomy they long had dreamed of during the first years of the republic. Never devoted to Madrid or the long succession of Castilian kings, they lived uneasily as part of Spain, constantly aware of ethnic and cultural distinctions that were epitomized by the reality that Euskera, the Basque language, and Castilian Spanish do not share a common root. Euskera, in fact, is related to no other language on earth, and its uniqueness is explained by the likelihood that the Basques were the first Europeans—aboriginal peoples who perhaps are the direct descendants of Cro-Magnon man. By the time Romans, Visigoths, and Moors encountered and conquered them, the Basques had lived in the mountains that meet the Bay of Biscay for millennia, and despite the fact that they virtually never were independent, they continually demanded self-rule, and succeeded to widely varying degrees in obtaining it over the centuries. Early in the sixteenth century, when Spain's Reyes Católicos, the Catholic monarchs Ferdinand of Aragón and Isabella of Castile, forcibly fused the Basques into the huge new country that comprised all of the Iberian Peninsula except Portugal, the Basques nonetheless were able to secure a promise from the king and queen that their ancient laws and customs, their *fueros*, would be respected.

Formally codified and transcribed in the twelfth century, the fueros were as much a part of the Basques' self-identity

as was their unique language. The fueros addressed civil, commercial, and criminal law—sometimes so exhaustively as to prescribe the acceptable purity of cider—and they affirmed as well the essential freedoms of the individual and the Basque people as a whole. For centuries, a Basque legislative assembly, the Juntas Generales, regularly met under a symbolic oak tree in the town of Gernika to create and rule on foral law. In 1826, a formal assembly building, the Juntetxea (or *Casa de Juntas* in Spanish) was constructed beside the sacred oak tree, and, as they had since the reign of Ferdinand and Isabella, representatives of the Castilian monarchy continued to be present inside the assembly at the opening of each legislative session to affirm that the authority of the Basque fueros would continue to be respected.

It was to the same assembly building in the heights of the town of Gernika that a group of Basque politicians secretly had stolen on October 7, 1936. Only a week before—and on the same day the rebels hurriedly and optimistically had declared Francisco Franco head of a new Spanish state—the Cortes, the national legislature in Madrid, had approved after lengthy and contentious debate legislation that made way for the creation of the Basque autonomous government, granting to the region the most substantive self-rule in its history. During the succeeding flurry of days, Basque president-elect José Antonio Aguirre, a charismatic thirty-two-year-old Bilbao chocolate-maker and soccer star, and his ministers had procured arms and ammunition to prepare the new government to join the fight against Franco and the insurgents. They already had begun to finalize proposals for a budget, taxation, education, and wide-ranging cultural programs. But because reports swirled throughout the Basque province of Bizkaia that Fascists bent on assassination were hidden in the

hills and mountains surrounding Gernika, the men who were about to take office had to hide their arrival rather than enter the town in long-awaited triumph. And they had been forced to post a lookout atop a tower near the Juntetxea to warn of an impending attack as Aguirre intoned his oath: "Humble before God, standing on Basque soil, in remembrance of Basque ancestors, under the tree of Gernika, I swear to faithfully fulfill my commission."

It was Euskadi's wealth, rather than its rich history of the protection of freedom, that made it a coveted target of the insurgents as the civil war flared and began to burn hot. If Franco and his confederates came to power, the region's mineral, manufacturing, and shipbuilding resources would matter as mightily to them as they did to the future of the republican government. But there was another reason why taking control of the Basque homeland had become such an insistent priority by the time José Antonio Aguirre swore in Gernika in October 1936 to uphold Euskadi's ancient laws.

For the first months of the fighting, the rebels had not fared well. Most of the nation's military remained loyal to the republic and fought diligently in its defense. Despite Franco's vision of the clear divinity of his cause, the tenuous and often unwieldy coalition of socialists, Communists, anarchists, and trade unionists still survived, lending the Loyalist soldiers essential popular support. The outlook appeared bleak enough for the rebels, in fact, that officials at the Vatican—where only a few months before, Franco had been seen as the certain winner in a crusade to return Spain to Roman Catholic piety—now urged the insurgent leader to seek a negotiated peace.

Surely the Basques, long understood to be Spain's most de-
vout Catholics, would agree to negotiation and the cessation
of fighting, he was told. But Franco abhorred the Basques,
and Basque nationalism in particular. It was their fierce inde-
pendence from the rest of Spain, together with the national-
ism of the people of Catalunya on the country's northern
Mediterranean coast, that had been the foremost cause of
Spain's humiliation in 1898, the little general believed. No,
he would not negotiate with the Basques, Franco informed
church leaders in Rome. Instead, he would annihilate Basque
nationalism wherever it raised its black-bereted head.

If the Roman Catholic Church was concerned about the
success of the military revolt in Spain, Adolf Hitler by now
had become truly alarmed, and therein lay one more reason
why Euskadi had to be brought to its knees. In the weeks be-
fore the war had begun, Admiral Wilhelm Canaris, chief of
the German secret service and a close friend of Franco's, had
been able to convince Hitler and his immediate subordi-
nates that Spain could be counted on to become a Fascist
stronghold if the generals planning an imminent revolt there
were offered military assistance. And within a week after fight-
ing commenced, the Nazis pledged twenty German trans-
port planes and six fighters to Franco's forces, with Mussolini
in turn promising to send twelve heavy bombers as well.
With German and Italian assistance, the rebels had been
able to take quick control of Spanish Morocco, the Canary
and Balearic islands, and much of northern Spain, as well as
the southern cities of Seville, Córdoba, and Granada. Yet
throughout the fall, the rebels had been stymied in their ef-
forts to gain more territory, and in November, even though
German pilots now were at the controls of the German air-

craft, a ground and aerial assault against Madrid had failed and the capital city remained in Republican control.

Nazi General Hugo von Sperrle, commander of the German forces then in Spain, reported back to Berlin that in his estimation, the siege of Madrid failed because Franco and the insurgents were unschooled in the means of deploying ground forces in concert with sustained aerial attacks. Franco was a nineteenth-century soldier, Sperrle explained; he did not understand how modern wars necessarily had to be fought from the skies and that victory in Spain would depend on the most contemporary military strategies and techniques extant. What had become clear, Sperrle argued, was that Franco's war in Spain could not be won without massive assistance from both Germany and Italy—support that soon was forthcoming, but not without the acceptance of four key conditions.

First, Franco, who the Germans believed was far too much of a plodder, had to agree to conduct what was termed a "more rational and more active campaign." He had to agree to allow Nazi forces in Spain to act entirely independently of the rebel Spanish army, the commander of the German forces subsequently answering to him but no other insurgent leader. Immediate shipments of large quantities of iron, copper, and other raw materials from regions under rebel control had to be made to help Germany fuel its rapid remilitarization. And the Basque region, home to more vital mining resources as well as the city of Bilbao—the most important seaport in the nation—had to be conquered as soon as possible, regardless of the cost in men and material.

What the agreement meant, of course, was that the military might of both Germany and Italy now would work to bring down the legitimate government of a neighboring nation—

the kind of warmongering the western democracies strangely would wait three more years to attempt to stop, only after the Fascists had invaded Albania and Poland and much of the world had returned to war. Because its foes were indifferent to the Nazi and Italian aggression in the Spanish war, Spain could be a dress rehearsal for the coming conflict, the perfect venue, explained German Luftwaffe commander Hermann Göring, in which to test his brilliantly trained but as yet untested pilots and their novel weapons. German air forces in Spain would be called the Condor Legion, and air and ground assaults henceforth would be meticulously coordinated. The war in Spain would be a "total war" as well, one in which the enemy was not solely an opposing army but also anyone who supported it. Civilians fleeing the fighting would be legitimate targets of strafing from the air, maintained the chief of the German general staff, General Wilhelm Keitel. In January 1937, Hitler himself warned the citizens of the Basque region to cease all resistance or face destruction. Then, at the end of March, bespectacled and deep-eyed General Emilio Mola, one of Franco's three fellow insurgents and now the commander of rebel forces in the north, declared in a radio broadcast heard throughout the Basque region, "I will raze Bizkaia to the ground, beginning with the industries of war. I have the means to do so." He did, in fact, have the wherewithal, now that the German Luftwaffe would be razing the region on his behalf. And just to insure that Mola's message frightened as many Basques as possible, the text of his speech was printed in leaflets dropped onto dozens of cities, fishing villages, and mountain towns by low-flying planes, making the none-too-subtle point that instead of paper, bombs soon would fall from the sky if the Basques did not back down.

* * *

Pablo Picasso had lived in Paris for more than thirty years by now, yet he never had sought French citizenship, and in the decades since his departure from Barcelona in 1904 he had become somehow *more* Spanish rather than less. Never impressed by officialdom, and always disinterested in political dogma and zealotry, he nonetheless liked to joke that he had been a Royalist when Spain was a monarchy and had become a Republican when the Spanish Republic was born. What he meant, more specifically, was that geography could not separate him from the nation of his birth, boyhood, and adolescent life. "Picasso"—the far larger-than-life figure who captivated and confounded so many people in Paris and beyond—did not exist absent Spain, its light and colors, it myths, symbols, and cultural traditions, its celebration of life and fascination with death. But the artist also knew that there was much to dislike in Spain, and surely at the top of that list was his homeland's long willingness to surrender to despots.

In part because all his Spanish friends who lived in Paris were supporters of the republic, and also because he clearly understood that the arts flourish only in open societies, Picasso, in his own self-focused way, cared deeply about democracy's survival in Spain. He did not publicly denounce the Fascist revolt in July 1936—in fact, he chose not to let it interfere with his August holiday in the Côte d'Azur—and neither did he work to raise funds for the republic's defense, as did many of his friends. Yet in September of that year, he quickly and enthusiastically agreed to the invitation from Manuel Azaña—the republic's intellectual, self-effacing, and in many ways reluctant president—for him to become the

titular director of Madrid's Museo del Prado. As a young art student, he had spent dozens of hours in the nation's great museum painting after the Spanish masters—Velázquez, El Greco, Goya—and now to be named the museum's head, if only honorifically, meant something enormous to him. It made him "feel so Spanish," he explained, and he began to take great delight in calling himself "el director."

But the early November bombing of Madrid by the German Condor Legion suddenly involved him directly and importantly in Spain and its terrible war. In the heavy attacks on the city by the Nazis' new Heinkel bombers, the Prado was damaged severely, and it suffered again when it was hit by artillery shells fired by rebel troops attempting to enter Madrid and claim it for Franco. Although Loyalist troops and soldiers of the International Brigades—young soldiers, most of them Communists, from fifty nations around the world who had come to Spain to support the Republican cause—succeeded at last in beating back Franco's own Spanish Moroccan colonial army, the fighting, much of it hand-to-hand, was horrific. Soldiers fought with bayonets and bolt-action rifles—sometimes only with pistols—for control of single city blocks, even single floors of classroom buildings at the university. Casualties numbered in the thousands; whole brigades on both sides suffered losses nearing 100 percent, and death and destruction lay over the city like a dark and sickening pall. Despite the fact that Madrid ultimately did not fall that November, the Republican government fled to Valencia on the Mediterranean coast—a move that incited the condemnation of many of its supporters—and director Picasso was among the group who hurriedly agreed that if Republican officials had to flee to ensure their safety, then, as a precaution, the Prado's great paintings should be

evacuated as well. A heavily guarded truck caravan ferrying the national treasures soon made its way through the narrow corridor still controlled by Republican forces linking Madrid to the Mediterranean. Picasso's close friend, the poet José Bergamín, waited to examine them and securely store them in Valencia's Museo Provincial de Pinturas and the fortified castle known as Las Torres de Serranos. Picasso was joyful when he heard from Bergamín that every painting had survived the journey undamaged, yet he was not convinced that the treasures were entirely secure anywhere in Spain at the moment. Acting somewhat administratively for the first time in his fifty-six years, he began to discuss and even plan a means for secretly shipping the priceless artworks to a safe haven in Geneva. And, the Spanish painter began to wonder, might it even be possible to exhibit the masters' works at the Paris World's Fair that would follow in the spring?

Picasso had been disgusted that the reviled Franco himself—as commander of the colonial army—had a hand in making the cherished El Prado a serious casualty of the civil war, yet the general's apparent disdain for what was truly important to the Spanish people seemed to fit what the expatriate painter already knew about Franco's temperament and tendency toward brutality. His ruthlessness first had become renowned in 1921 when, following his succession to the command of the Spanish foreign legion, he and his soldiers had returned from liberating a besieged fort with the heads of twelve Moroccan tribesmen on sticks. And the fact that cold-blooded killing was Franco's particular hallmark became even more widely understood in 1934 when he and the troops at his command quelled a miners' rebellion in the northern province of Asturias, then summarily executed as

many as two thousand of the rebel trade unionists and Communists. The general's loathsome disregard for Spain's artistic heritage—as Picasso interpreted it from Paris—coupled with being named the head of the illegitimate rebel government, already was plenty to engender the painter's venom. By the time Franco's army—together with nine battalions of soldiers supplied by Mussolini—stormed Málaga, the painter's birthplace on the southern coast, in January 1937, Picasso had responded bitterly to Franco and with artistic outrage.

The city of Málaga had remained a Republican stronghold in the months since the war began, and in the eyes of the rebels, it appeared, that meant it now had to pay a terrible price. Italian tanks and armored cars and rebel shelling had reduced the city to ruin before Franco's troops marched in unimpeded. The victors celebrated by destroying what property remained unharmed and by executing thousands of Loyalists. Italian and German fighter planes dove low to the ground to strafe—and kill—countless refugees attempting to flee the horror.

On January 8, as the monthlong siege of Málaga had begun, Picasso furiously penned in Spanish a poem he titled *Dream and Lie of Franco*, one he subsequently illustrated with a series of etchings done in the style of a multi-frame cartoon—much like the comic-book *aleluyas* and *dibujos* he had enjoyed as a boy in Málaga. Poetry was not new to the painter—he, his poet friends Paul Eluard, André Breton, Max Jacob, and others often enjoyed reading their surrealistic, stream-of-consciousness verse to each other—but never before had Picasso written with such rancor. As he imagined it at that moment, the march of Franco and his minions was a . . .

fandango of shivering owls souse of swords of evil-
omened polyps scouring brush of hairs from priests'
tonsures standing naked in the middle of the frying
pan—placed on the ice cream cone of codfish fried
in the scabs of his lead-ox heart—his mouth full
of the chinch-bug jelly of his words—sleigh bells
of the plate of snails braiding guts—little finger in
erection neither grape nor fig—commedia dell'arte
of poor weaving and dyeing of clouds—beauty
creams from the garbage wagon—rape of maids in
tears . . .

And the poem ended hauntingly, as if somehow the artist al-
ready understood that Franco and his allies would attack
barbarically again before long. But the next time, the poem
seemed to foretell, the slaughter of innocents might engen-
der not a cartoon but a great painting instead, its subject
matter not the hated general but rather his handiwork, a scene
of utter destruction accompanied by the desperate

. . . cries of children cries of women cries of birds
cries of flowers cries of timbers and of stones cries of
bricks cries of furniture of beds of chairs of curtains
of pots of cats and of papers cries of odors which
claw at one another cries of smoke pricking the
shoulder of the cries that stew in the cauldron and
of the rain of birds that inundates the sea which
gnaws the bone and breaks its teeth biting the cot-
ton wool that the sun mops up from the plate
which the purse and the pocket hide in the print
that the foot leaves in the rock.

For the moment however, the cartoon form was the one Picasso wanted to explore, and in the series of eighteen frames that ultimately were printed onto two broadleaf sheets, Franco himself is indeed the focal subject, depicted as a repulsive little monster, a kind of two-tentacled maggot sporting a bristly moustache. In one image, the vile Franco-worm smashes the classical bust of a beautiful woman; in another he walks a tightrope, his huge phallus brandishing a Catholic banner. Surrounded by barbed wire, he prays on his knees to the god of money in a subsequent frame. In another he is transformed into a hideous Andalusian matron who wears a mantilla and carries both a fan and a fighter's sword. He is gored by a bull in still another frame, and out of his bowels spill insects, rebel banners, and distorted symbols of the church. The eighteen frames do not tell a linear story, and neither do they reference specific events, but collectively they render the rebel general as a dreamer of ludicrous and often odious dreams. Certainly their creation was a perfect way for Picasso to vent his increasing abhorrence of the man who would as willingly destroy all of Spain as the Museo del Prado, he had to believe.

Sheets of *Dream and Lie of Franco*—the poem as well as the etchings—eventually were offered for sale, with all of the proceeds going to support the defense of the Spanish Republic, a government that Director Picasso now nominally had become part of, one that had grown increasingly embattled and sorely in need of assistance of every kind. At the beginning of the war, the French Popular Front government had been eager to offer financial aid to the Loyalist cause in Spain. But internal opposition, coupled with a fear of Ger-

many that would lead to the nation's virtual paralysis when it was invaded four years later, had forced an end to official French support within a few weeks.

In August 1936, France had joined Great Britain, Germany, Italy, and the Soviet Union in signing a nonintervention agreement whose ratification was nothing short of bizarre, given the fact that the two Fascist powers already were pouring both men and weapons into Spain to bolster Franco. And the Soviet Union was acting similarly in support of the Republic, ultimately contributing about five hundred troops to the Loyalist cause as well as selling them arms and material, albeit at exorbitant prices. Mexico had offered unequivocal moral support but little in the way of arms or money with which to buy them, and the only additional aid in defense of Spain's democracy had come from the International Brigades, zealous young men—and a few women—from around the world who were recruited, trained, and supplied by the Comintern, the Communist International headquartered in Paris and controlled by the Soviet Union. The first group of five hundred *internacionales* had arrived in Spain in October, and by early in the new year, seven battalions of soldiers—principally from France, nine other European countries, and the United States and Canada—had actively and often effectively joined the protracted fight against Fascism.

Unlike many Spaniards who fought solely to defend homes and villages—or because they had been conscripted when rifle barrels were stuck into their chests—the *internacionales* were committed ideologues. They were romantic and often impassioned young men who shared a common hatred of fascism and the fear that soon it would engulf all of Europe, yet whose personal political philosophies ranged

from Bolshevism on one extreme to world anarchism on the other. They had arrived in Spain hoping to fight a war of political principles and just causes, but by January 1937 virtually all of them had become terribly aware that in Spain, mud, blood, death, and despair were now the only concepts that claimed much currency.

"I used to think of the recruiting poster in Barcelona which demanded accusingly of passers-by: 'what have *you* done for democracy,' and feel that I could only answer: 'I have drawn my rations,'" George Orwell wrote in *Homage to Catalonia*, his compelling if often disheartening memoir of his year of service for the Republic.

> When I joined the militia I had promised myself to kill one Fascist—after all, if each of us killed one they would soon be extinct—and I had killed nobody yet, had hardly had the chance to do so. . . . All of us were lousy by this time; though still cold it was warm enough for that. I have had a big experience of body vermin of various kinds, and for sheer beastliness the louse beats everything I have encountered. Other insects, mosquitoes for instance, make you suffer more, but at least they aren't *resident* vermin. . . . I think the pacifists might find it helpful to illustrate their pamphlets with enlarged photographs of lice. Glory of war, indeed!

If the war the soldiers fought often was characterized by lice and the sickening stink of bodies unwashed for weeks, by hunger, exhaustion, and ennui as well as the close-at-hand constancy of death, the war the civilians knew was all those things coupled with the additional certainty that there were

scoundrels and brutes and madmen on both sides—better put, on *every* side. Anarchists, Royalists, Communists, Carlists, Syndicalists, Falangists, Loyalists and Nationalists, Republicans and Fascists—at times it seemed there were as many potential allegiances in Spain as there were voices with which to pledge one, and an increasingly dismaying truth at the outset of 1937 was that people from every perspective hailed destruction and death as essential tools for bringing about better days and something akin to justice. Spain could not return to national health, virtually every partisan averred, unless many more jackals died.

George Orwell had gone to Spain believing that fascism might be thwarted there before it took hold in all of Europe, and that conviction had not altered as he increasingly came to see that the Soviet model offered nothing better and that ideologies of every kind could be devilishly indifferent to the sufferings of humankind. Pablo Picasso, certainly someone who bore little allegiance to the Roman Catholic Church, nonetheless had been deeply disturbed to hear firsthand in letters from his mother in embattled Barcelona that the streets where he had grown up now were urban battlegrounds, and that the convent a few yards away from her apartment block had been burned to the ground specifically and only because it had been property of the church. For weeks, his mother lamented, the rooms she shared with her widowed daughter and five grandchildren had reeked with the stench of the fire, and her piercing black eyes—the remarkable and engulfing eyes she had passed to him—still wept from the sting of the smoke.

My teacher, Angel Vilalta, had been ten years old at the outset of the war, and lived in Lleida, a small Catalan city

150 kilometers west of Barcelona. Like all natives of the region, Angel had grown up understanding that Catalunya was his truest homeland, and that—as was the case in the Basque country—its language, history, and culture separated his region dramatically from the rest of Castilian-speaking Spain. His father was a prominent businessman who repeatedly had declined overtures for him to enter politics; his mother, he remembered devotedly, was one of those beautiful, miracle-making Spanish women who—once the war had altered their lives dramatically—could prepare her family a beautiful meal even on the many occasions when there was virtually no food in the house. And it was hunger—constant and nagging hunger—that remained Angel's fundamental memory of the war.

His parents were Royalists, if a single political ideology could be ascribed to them, Royalists who believed strongly in the idea of democracy: a Spain in which there was "one God and one King" was one in which his devout parents readily would have been comfortable. They longed for their country to emulate Great Britain in that regard—a nation that was filled with fine people, he remembers his father telling him, despite the propaganda he heard at school about how the English were lazy and drunken fops. Rafael Vilalta's business was an early casualty of the war, and so too was Angel's health. He contracted tuberculosis—as did thousands in Spain in those years—and it may have been for that reason, or simply because four children were a great challenge to feed absent any income, that he was sent to live with an aunt and uncle for a time in the midst of the brutal fighting that transformed virtually all of Catalunya into a killing zone. Although no farther away than nearby Mollerussa, Angel missed his parents and brothers and sister enormously, and

only relatively recently had he come to know how much his parents lost during those tragic years when he was away. "We were so happy before the war," Montserrat Vilalta told her youngest son shortly before she died at ninety-one. "We laughed so much, and our lives seemed very good. But afterward, life didn't seem joyful anymore."

Angel remembered that his father—a proud and confident man who theretofore had thrived on his interactions with colleagues and friends—grew sullen and introspective when his business was appropriated by radical anarchists and he was forced into hiding. As he secretly watched the destruction mount and his fortune crumble, as he listened to the constant bombing, shelling, and gunfire that signaled death, Rafael Vilalta cursed the Anarchists, cursed the Fascists and Republicans alike, cursed the quagmire into which his country had fallen, and he held out the neighboring French as the only society on the continent that hadn't yet gone mad. From Angel's own perspective, the politics were rather simpler: the rebel soldiers seemed like "normal" Spanish men, the kind he had observed in shops, cafés, and on the streets of Lleida since he was very small. The Republican soldiers were similar, of course, yet they seemed "joyous" in a way he didn't understand; and the German soldiers were giants—huge, blond, and imposing men who decidedly were *not* joyous, men who never laughed, he suspected, who marched, snapped to, and saluted as if those were the most important actions any man could undertake. Despite his father's strong opinion to the contrary, the Germans seemed to believe *they* were the best Europe had to offer, and by the time the war's outcome was foretold and Catalunya increasingly had come under rebel control, his teachers now agreed with them. The new Germany—*Nazi* Germany—

was a splendid place, they instructed, and henceforth Spain would follow in its path. "Every book, every film had to come from Germany. Everything in Germany was so wonderful, they told us. Like all the other children, by the end of the war I was part of the Juventud Franquista. I wore my blue uniform, and stuck my arm out like this." Angel thrust his arm into the Fascist salute, then let it fall and continued. "I'm sorry, really, but you know, I'm afraid I was a little Fascist. And my poor father just shook his head."

What the new Germany brought to Spain most of all was its renewed military might and strategic acumen, which Adolf Hitler had made his highest priorities when he came to power four years before. Humiliated by their country's exclusion from the Treaty of Versailles and its mandate of German demilitarization along the country's Rhineland border with France, Hitler and the members of the National Socialist German Workers' Party had vowed to make Germany mighty again, to *win* the next war—whenever it came—and to rid it and ultimately all of Europe of Communists, the vast majority of whom were Jews, or so the Nazis believed. Together with a pledge to rearm the country as quickly as possible, Hitler also had employed his nation's brightest military minds in determining how the next great conflict could best be fought. By 1937, his generals had grown eager to test their outlines for what they called *blitzkrieg*, lightning war, a tactic calculated to create shock and sudden disorganization in opposition forces with the use of surprise, speed, and superior firepower. Enemies could be subdued and defeated, the strategists contended, before they understood precisely what had hit them.

By the spring of 1937, the fighters and bombers of the German Condor Legion had assisted Franco's rebel army in taking control of much of Spain. Loyalist forces still held all of the Mediterranean coast from the French border to the outskirts of Málaga far in the south, as well as adjoining regions that reached as far inland as Madrid. The three small Basque provinces on the northern coast also remained in Republican control, but the rest of northern, western, and southern Spain now belonged to Franco. The fact that the Basques were very vulnerably surrounded, and that their conquest was so eagerly sought in Berlin as well as Salamanca— where the rebel "government" had been seated—meant that the Fascist war effort had become focused intently there. General Emilio Mola announced on March 31 his determination to destroy the homeland of what he labeled the "perverted people who dare oppose the irresistible cause of our national ideal."

Of all Euskadi, the port and capital city of Bilbao was the rebels' goal and most highly coveted prize. But in order to reach it, Mola's troops had to fight their way north- and westward through narrow, serpentine mountain valleys that were readily defensible by Basque soldiers taking advantage of the covert assistance of sympathetic town and village dwellers, the cover of dense forests, and the soldiers' intimate knowledge of their home terrain. If it had to be won solely from the ground, Bilbao would have been an elusive goal, one gained only at a great price. But the fighters and bombers that the Germans brought to battle on Mola's behalf—together with the fact that the new Basque nationalist government had only a paltry air force with which to respond in kind—appeared to ensure that the Fascists would gain ground quickly. Blitzkrieg brought from the skies would

soon prove maliciously effective, and the advance on Bilbao would move inexorably, or so it initially seemed.

The town of Durango, thirty kilometers southeast of Bilbao, felt the first bolts of the lighting war on the day Mola issued his clarion call by radio. No one had anticipated the sudden and intense bombing of roads, bridges, and factories by the Condor Legion that quickly was followed by a rebel-army ground assault, one made significantly simpler by the fact that Basque army regulars already had fled the city in retreat. German bombers, under the command of Lieutenant Colonel Wolfram von Richthofen—cousin of Manfred von Richthofen, the storied Red Baron of World War I—returned to Durango from their bases in the nearby cities of Burgos and Vitoria on three successive days, each time pounding it again from the air. More than 120 civilians died in the first day's attack and an equal number perished over the course of the subsequent days. The city now belonged to the rebels and it appeared that the rich reward of Bilbao was only days away as well.

But then the offensive bogged down, and it did so less than a week after it had begun: Mola suddenly was forced to contend with a threatened insurrection by fiercely monarchist Carlist troops (most of them native Basques) who balked at accepting his leadership. Basque nationalist militiamen, known as *gudaris*, were being driven toward Bilbao, but they were inflicting heavy casualties on the advancing rebels as they slowly retreated; and in village after village, the Basque citizens themselves also showed little stomach for surrender. Three weeks passed before the strategic towns of Ochandiano and Eibar fell, and although the noose around the region was indeed tightening, the pace of the conquest was frustratingly sluggish. General Mola argued to von Richthofen that

the Germans ought to forego frontline support and simply fly forward and utterly level Bilbao, but he was reminded by the lieutenant colonel's better strategic mind that the city's port, its foundries, and factories were the goal they sought, after all, and that it made little sense to destroy them. Yet both the German and rebel commands did agree that a show of overpowering strength—an attack of sufficient force and scale, a bombardment as symbolic as it was destructive—might well succeed in breaking the spirits of the Basque people and their defenders and hasten the capture of all the region, with Bilbao at its industrial heart.

No records survive that explain precisely who participated in the decision to bring blitzkrieg to bear on the last remaining strategic town between the Fascists' frontline and Bilbao, a town whose destruction would be far more devastating symbolically than the razing of the capital city would be, yet one whose intact survival certainly wasn't essential to the invading forces. Mola surely would have brought his virulent hatred of the Basque people to the early planning and von Richthofen no doubt added his impatience with the creeping pace of the current assault. General Sperrle, commander of all German forces in Spain—the man Hitler liked to call his "most brutal-looking general"—would have been eager to unleash the three full squadrons of fighters and bombers that at the moment stood idle at airfields in Burgos and Vitoria. And General Francisco Franco—who increasingly wanted to be called *El Caudillo*, the Spanish equivalent of *Il Duce* or *Der Führer*—surely would have enthusiastically acquiesced to the likely loss of life. Nine months before, Franco had assured American reporter Jay Allen that he would "save Spain from Marxism no matter what the price." Allen had responded incredulously: "That means you will

have to shoot half of Spain"; and Franco, in turn, had simply smiled before he added, "I repeat, at whatever cost."

What does appear incontestable is that once a joint decision was made to make a terrible example of the town that all Basques held sacred—a place that was the capital of their collective soul—it fell to von Richthofen to chart the operation and to choose the moment when it would begin. Like his better-known cousin, stocky and pugnacious Wolfram von Richthofen also could count numerous air victories from World War I; he too thrilled at what fighting planes and their weapons could accomplish, and the new mission was one he delighted in orchestrating, despite the fact that his role as chief of staff meant he would be forced to coordinate operations from the ground.

It was clear to the lieutenant colonel that a stone bridge over the small Mundaka River on the northern outskirts of Gernika ought to be a prime target of a massive attack; if the bridge were destroyed, it would block a route already being used by retreating Basque gudaris. The town itself, he believed, was harboring hundreds of soldiers as well, and he was determined to roust them out wherever they might be found. At his disposal were the Luftwaffe's four impressive warplanes—the Dornier 17, Junker 52, Heinkel 51, and HE-111, each aircraft carrying two powerful machine guns and payloads of up to 1,500 kilograms of bombs—as well as the spanking-new Messerschmitt 109B, a fighter the Nazis believed soon would revolutionize air warfare with its top speed of 350 miles an hour, its 36,000-foot ceiling, and its twin 20-millimeter cannons. Additionally, Italian pilots under the German colonel's command stood ready to aim Fiat CR-32s and Saboya 79s—planes roughly equivalent to

those in the German fleet—at the targeted town. At von Richthofen's combined disposal were fifty aircraft, 120 airmen, many thousands of pounds of percussion, projectile, and incendiary bombs, and countless rounds of ammunition. And when Monday, April 26 dawned fair and his squadron meteorologist assured him that skies would remain clear along the northern Spanish coast throughout the day, he ordered an afternoon operation into motion—eager, confident, nearly giddy pilots and bombardiers making last-minute checks of their planes and equipment, von Richthofen himself rushing in his Mercedes-Benz roadster from Vitoria to a high point near the summit of Monte Oiz, twelve kilometers southeast of Gernika, where he would be able to watch unfold what he was sure would be a spectacular scene.

In command in the air was Lieutenant Rudolf von Moreau, the most experienced German pilot in Spain. Already, von Moreau had played key roles in ferrying Franco's troops from Morocco at the outset of the war, in destroying the Republican battleship *Jaime I* in the siege of Málaga, and he and his bombardier, the dashing Lieutenant Count Max Hoyos, had demonstrated remarkable precision when they had dropped provisions for starving rebel fighters directly into the plaza of the embattled Alcázar in Toledo eight months before. Von Richthofen knew that von Moreau and Hoyos clearly were the best team to lead this newest Condor Legion mission, and he watched the two depart from Vitoria in their Dornier bomber precisely at 4:00 on the fateful afternoon.

Lieutenant von Moreau guided his plane over rendezvous points at Villareal and Garai as the two men made the short flight north. He flew within three kilometers east of Gernika as he continued north to the rocky Bizkaia coast,

where he banked the Dornier over the fishing village of Elantxobe and turned nearly 180 degrees to the south. The plane now followed the broad and beautiful estuary of the Ria de Mundaka eight kilometers south to Gernika.

The town of about seven thousand inhabitants stretched north to south in a broad and breathtakingly green mountain valley, tucked between the river and the shoulder of a high forested hill with the hamlet of Lumo at its summit. The town's uniform red-tiled roofs were bright in the afternoon sun, and the plane passed low above them, the two airmen who were confined in its narrow cockpit and bombardier's bay swiftly scouting for evidence of antiaircraft defenses and visually orienting themselves to their several targets below. Flying at 200 kilometers an hour, it took only moments for the Dornier to pass over the southern boundary of the town, then it banked into a wide and sustained turn, circling back over the estuary and once more crossing the dense cluster of rooftops from the north. This time, however, Hoyos released twelve 50-kilogram percussion bombs as the plane neared the railroad station and the plaza that fronted it on the west, the bombs falling in a tight cluster and exploding almost in unison as they found the busy depot, the sunny plaza, and the unsuspecting ground.

"There were a lot of people in Gernika that day," remembered seventy-three-year-old José Ramon Arriandiaga six decades after the bombing. "It was a market day. Suddenly we saw a plane coming toward us from the Mundaka area, flying very low. People were afraid and started to run. My father grabbed us and took us to the train station and hid us under a carriage. But then he realized that the station had to

be a military target, so we got out. He was right. No sooner than we ran away it all blew up." Nine years old at the time of the attack, Arriandiaga and his family had traveled by train from Bilbao and were waiting for a bus that would take them to their home in nearby Elantxobe, but the bombing trapped them instead in the heart of targeted Gernika, where dozens more bombs soon reduced whole rows of buildings to rubble. "The first planes were followed by many more; soon they all were dropping bombs, huge bombs, and Gernika was being destroyed. We were running aimlessly because we didn't know where to go. Houses were collapsing everywhere. It was incredible bombing."

At last Arriandiaga and his family joined dozens of others in a makeshift shelter in the basement of a large private home five blocks west of the train station. "Men had to hold the doors to the cellar closed because the shock waves of the nearby bombs would blast them open. Everyone inside was crying and screaming and said we were all going to die. The noise was terrible. A priest came and gave us all absolution and told us to prepare to die."

Stories like José Ramon Arriandiaga's are told only infrequently in Gernika anymore. The survivors of the bombing who remain alive were children or adolescents then, and whole lifetimes have quieted their once-incessant need to replay the horrific day, to see the explosions and fires and hear the terrible cries time and time again. Yet when pressed, when someone occasionally pleads for a firsthand report, their memories remain vivid and shocking, and their words still bear witness to the terror:

> I was on the mountain, up toward Lumo. My mother had sent me to pick up pieces of a kind of wood

that is good for baking bread. Suddenly I saw a plane in the sky and I thought it must be a Communist plane. I watched it pass over Gernika, then it made a big turn and came over again and dropped several bombs. Then more planes came and suddenly there were fifteen or twenty planes and they appeared to be coming at me. I started to run home into town and had to go about a kilometer to reach it. All those planes started dropping bombs. It was a disaster. A disaster. Houses trembled, then fell down. Then I began to meet many women as I ran toward my house. They were coming out of town toward me and they were running very fast. I thought, how can these women run so fast?

His name was Bernardo, and he had been eight years old when Gernika was destroyed. Nowadays, he lived in the nearby village of Muxika and was broad-faced and ruddy beneath his navy-blue beret. He and his friend Emilio—both *solteros*, widowers—came to Gernika's market each Monday in hopes of meeting friendly widows, he explained with a wide smile. But he wouldn't disclose his *apellido*, his surname, because—more than sixty years since the day he had just described in a flurry of passionate words, and a quarter-century after Spain at last had become democratic again—he couldn't be sure it was safe to speak. "I might go to prison if I'm heard talking," he said. "But I will tell you this. I knew by the time I got home that, without a doubt, it was the Germans who were bombing us. And I knew how terrible it was because I could see and hear the disaster all around me, and because those women ran so fast."

After von Moreau and Hoyos had passed over the town the second time, and after they had emptied the bomb bays of the Dornier, they rendezvoused with the trailing planes from their squadron in the air above the village of Garai—and within easy sight of von Richthofen, who watched from his sports car high on Monte Oiz. Then the lead plane circled again, guiding twelve more bombers, six of which were Italian, north to the coast, then south above the broad estuary of the Mundaka to Gernika, where they too released their bombs and let them fall to the red rooftops below. It was a process that continued over the course of the next three hours: empty warplanes returning to their bases for rearming and refueling, then returning to Gernika—now readily marked by the thick column of black smoke that rose high into the sky from the center of town—to drop still more bombs before beginning the cycle again. It was a sight that thrilled the lieutenant colonel, who observed from the safety of his nearby mountain redoubt. "Confirm report that Gernika is leveled to the ground," he hurriedly radioed from his car, but now there was more bombing to be done: "Dispatch at once: [fighter squadrons] A/88 and J/88 to chase up and down the roads in the Marquina-Gernika area. . . . They've got to be closed off if there's to be success against the enemy's personnel and material."

Already the news had reached Bilbao, 20 kilometers from Gernika, that the Germans had unleashed a ghastly and ongoing attack on the town: the Gernika stationmaster had successfully telephoned the report before subsequent explosions had severed the lines. But virtually nothing could be done by way of mustering a military response; the German and Italian planes could continue to bomb with impunity, and so they apparently planned to do.

City firemen from Bilbao did quickly prepare to travel to the town to offer what assistance they could, and medical personnel also soon were dispatched. And by chance, a thirty-four-year-old Basque priest named Alberto de Onaindía arrived by car moments after the bombing began. He and a friend had been en route to rescue his mother and sisters in the nearby town of Marquina, which was about to fall to the rebels. Continuing their journey was made impossible by the intensity of the bombing, and the two men also soon believed that they too were about to die. Yet Father Onaindía did survive to record the first eyewitness account of the disaster, a report he made public in Paris soon thereafter:

> We reached the outskirts of Gernika just before five o'clock. The streets were busy with the traffic of market day. Suddenly we heard the siren, and trembled. People were running about in all directions, abandoning everything they possessed, some hurrying into the shelters, others running into the hills. Soon an enemy airplane appeared . . . and when he was directly over the center he dropped three bombs. Immediately afterwards we saw a squadron of seven planes, followed a little later by six more, and this in turn by a third squadron of five more. And Gernika was seized by a terrible panic.
>
> I left the car by the side of the road and we took refuge in a storm drain. The water came up to our ankles. From our hiding place we could see everything that happened without being seen. The airplanes came low, flying at two hundred meters. As soon as we could leave our shelter, we ran into the

woods, hoping to put a safe distance between us and the enemy. But the airmen saw us and went after us. The leaves hid us. As they did not know exactly where we were, they aimed their machine-guns in the direction they thought we were traveling. We heard the bullets ripping through branches and the sinister sound of splintering wood. The *milicianos* and I followed the flight patterns of the airplanes, and we made a crazy journey through the trees, trying to avoid them. Meanwhile, women, children, and old men were falling in heaps, like flies, and everywhere we saw lakes of blood.

I saw an old peasant standing alone in a field: a machine-gun bullet killed him. For more than an hour these planes, never more than a few hundred meters in altitude, dropped bomb after bomb on Gernika. The sound of the explosions and of the crumbling houses cannot be imagined. Always they traced on the air the same tragic flight pattern, as they flew all over the streets of Gernika. Bombs fell by the thousands. Later we saw bomb craters. Some were sixteen meters in diameter and eight meters deep.

The airplanes left around seven o'clock, and then there came another wave of them, this time flying at an immense altitude. They were dropping incendiary bombs on our martyred city. The new bombardment lasted thirty-five minutes, sufficient to transform the town into an enormous furnace. Even then I realized the terrible purpose of this new act

of vandalism. They were dropping incendiary bombs to convince the world that the Basques had torched their own city. The destruction went on altogether for two hours and forty-five minutes. When the bombing was over the people left their shelters. I saw no one crying. Stupor was written on all their faces. Eyes fixed on Gernika, we were completely incapable of believing what we saw.

It all had gone according to von Richthofen's carefully crafted three-part plan: the first wave of blast bombs destroyed virtually every building in the core of the city. Next, hundreds of townspeople who attempted to flee the conflagration were strafed with machine-gun fire from low-diving planes. And then finally, hundreds of incendiary bombs set fire to the rubble, obliterating all of Gernika save the western heights of the town where the Juntetxea, the Basque assembly building, still stood—neither it nor the fabled oak that grew beside it touched by the blasts or the fires. Throughout the rest of the town, the destruction was cataclysmic, and it was precisely what von Richthofen had hoped for, as he reported with pride to his superior officers on Friday, four days later:

> Gernika literally leveled to the ground. Attack carried out with 250-kilogram and incendiary bombs—about one-third of the latter. When the first Junker squadron arrived, there was smoke everywhere already [from von Moreau's first assault]; nobody could identify the targets of roads, bridge, and suburbs, and so they just dropped everything right into the center. The 250s toppled houses and de-

stroyed the water mains. The incendiaries now could spread and become effective. The material of the houses: tile roofs, wooden porches, and half-timbering resulted in complete annihilation. . . . Bomb craters can still be seen in the streets, simply terrific. Town completely blocked off for at least 24 hours, perfect conditions for a great victory, if only the troops had followed through.

But the ground troops hadn't been the German colonel's responsibility; they had been General Mola's, and the rebel army, only fifteen kilometers away, had failed to advance on the town, for reasons von Richthofen could not comprehend. Yet even so, he was delighted with what his heroic airmen had accomplished. The three-hour campaign had been efficient, accurate, highly effective, and it was precisely what was proscribed in German military strategist M.K.L. Dertzen's *Grundsätze der Wehrpolitik*, which had been published two years before and which von Richthofen had taken very much to heart: "If cities are destroyed by flames, if women and children are victims of suffocating gases, if the population in open cities far from the front perish due to bombs dropped from planes, it will be impossible for the enemy to continue the war. Its citizens will plead for an immediate end to hostilities."

For their part at that moment however, the citizens of Gernika were crying out solely in horror, and in the desperate hope that missing children, mothers, brothers might be found. "While we were in church with the Basque soldiers' choir singing," remembered Miren Gomeza, nineteen years old and about to become a bride on the day of the attack, "the priest stopped everything and said, this constant

air-raid siren, it can't be good. He told us to go home, and we did, but for many, our homes already were gone and we didn't know where our family members were. Were they lying under the rubble? Some of us made it to a shelter, but the shelter was terrible too. We were packed inside and were suffocating. We couldn't breathe and there was no water—nothing but darkness and crying. I remember licking the moisture off the damp walls of the shelter to try to slake my terrible thirst."

Outside of town as well, the bombs and bullets rained down in a sickening storm. At her family's farm to the west of the town center, thirteen-year-old Itziar Arzanegi was forced to crawl the length of a plowed field in order to reach the presumed safety of a small pine forest. "We had to go on our bellies because there were more and more planes coming. From the ground I saw a woman I knew, a neighbor, stand up and shout into the sky, 'You bastards, there are innocent people down here.' A plane dove toward her, and I could see the pilot, his face. And I'll never forget his horrible goggles. *Tat, tat, tat, tat.* He killed her with his machine gun. I made it to the woods, where we waited three and a half hours. It was getting dark when I was brave enough to walk home, but I found our farm destroyed. They had bombed our farm, our *farm*, and we were left with nothing."

By nightfall, the red glow of the burning town could be seen from hill- and mountaintops thirty kilometers away. Cobbled streets and sidewalks, moon-cratered by bombs, felt bizarrely hot underfoot. It had grown eerily quiet except for distant cries and the crackles of flames; thick black smoke, the acrid odor of the explosives, and the still-pale stench of death hung in the air like visceral scents of hell. Surviving townspeople had left the makeshift shelters by now, and

many of them wandered aimlessly through the streets, often-times trying to gauge what street, in fact, they were on, some praying at the places where they knew churches once had stood, some shifting with sticks through smoldering heaps that had been their homes. Carcasses of horses, cattle, and sheep were strewn throughout the market plaza, and many of them too had burned by now. Human bodies, or pieces of them, were scattered everywhere as well. "It was unbeliev-able," recalled José Bilbao, who had been a brick mason in April 1937. "Bodies were trapped between roof beams by the force of explosions. Even people who had been wearing heavy leather jackets were literally plastered against walls. It was sickening. You had to see it to believe it, but then you still could not."

"When it grew dark," wrote Father Onaindía, his damn-ing report widely distributed to reporters in Paris and ulti-mately reaching the incredulous Vatican as well, "the flames of Gernika were reaching to the sky, and the clouds took on the color of blood, and our faces too shone with the color of blood." For each survivor, there was something particular—a sight, a smell, a heartrending cry—that foremost symbol-ized the horror of that April afternoon. For the young priest, surely it was the ubiquity of blood—blood that had painted his own face red when at last he saw a mirror—that he never could clean from his troubled memory. And for everyone else who lived to bear witness to the day, something else seemed to capture the awful essence of the madness: the de-monic goggles that one of the killers wore, a cluster of dead sheep and the stench of their burning wool, the taste on a tongue of a concrete wall that surrendered no water, the sight of so many women running so swiftly away from doom.

Remembering
the Bullring

Although his radio would have crackled with static, Pablo Picasso could have heard in his native Spanish the first report to reach Paris of the bombing of Gernika late in the afternoon of April 27, 1937, twenty-four hours after the destruction of the town commenced. The Radio Bilbao broadcast was, in fact, picked up as far away as the French capital that day, and had he been listening, the Spanish artist would have heard Basque President José Antonio Aguirre announce:

> German airmen in the service of the Spanish rebels have bombarded Gernika, burning the historic town that is held in such veneration by all Basques. They have sought to wound us in the most sensitive of our patriotic sentiments, once more making it entirely clear what Euskadi may expect of those who do not hesitate to destroy us down to the very sanctuary that records the centuries of our liberty and our democracy.

Aguirre spoke in Spanish rather than Euskera in order to reach the widest sympathetic audience possible, and also to

warn the "invading enemy" that the Basque people would respond to terrible violence in kind and with "unheard of tenacity and heroism."

The first Paris newspaper account of the bombing contained little more detailed information about what had occurred than did Aguirre's radio speech, yet it is probable that Picasso—or perhaps one of his friends, who quickly would have relayed the news to him—did read on the evening of April 27 the brief item in Paris's *Ce Soir*, a month-old paper funded in part by the Spanish Republican government and edited by the painter's friend Louis Aragon. Its report simply relayed what the paper's correspondent had telegraphed that morning from Bilbao—the news that German bombers had entirely destroyed the town of Gernika in three hours of bombing Monday afternoon. But it wasn't until Wednesday morning that Picasso and virtually every Parisian who ventured onto the city's boulevards saw the first newsstand headlines drawing outraged attention to what had occurred less than a hundred kilometers from France's border with Spain. MOST HORRIBLE BOMBING OF SPANISH WAR. THOUSAND INCENDIARY BOMBS DROPPED BY HITLER'S AND MUSSOLINI'S PLANES REDUCE THE CITY OF GERNIKA TO CINDERS, shouted *L'Humanité*, a newspaper widely regarded as an organ of the French Communist Party.

The city's dozen other papers, virtually none of which pretended impartiality on any subject, paid the bombing only modest, if any, attention—at least for the time being. But across the English Channel, in contrast, the *Times* of London led its Wednesday edition with a long eyewitness account by correspondent George L. Steer, one that was published by the *New York Times* as well and which soon became the account of record of the tragedy throughout the democratic

world. "Gernika, the most ancient town of the Basques and the center of their cultural tradition, was completely destroyed yesterday afternoon by insurgent air raiders," Steer's article announced.

> The bombardment of this open town far behind the lines occupied precisely three hours and a quarter, during which a powerful fleet of airplanes consisting of three German types, Junkers and Heinkel bombers and Heinkel fighters, did not cease unloading on the town bombs weighing from 1,000 lb. downwards and, it is calculated, more than 3,000 two-pounder aluminum incendiary projectiles. The fighters, meanwhile, plunged low from above the center of the town to machine-gun those of the civilian population who had taken refuge in the fields.

When Steer reached Gernika at 2:00 on Tuesday morning, traveling by car from nearby Bilbao, he observed a town still "flaming from end to end." Houses and buildings had continued to fall throughout the night. Even before daybreak, he had watched as survivors loaded farm carts pulled by oxen with the few possessions they managed to save, then abandoned the ruins of their former home, most of them heading for Bilbao, where thousands of people from other parts of the Basque region lost to the rebels already had sought refuge.

"In the form of its execution and the scale of the destruction it wrought, no less than in the selection of is objective" the reporter reflected,

the raid on Gernika is unparalleled in military history. Gernika was not a military objective. A factory producing war material lay outside the town and was untouched. So were two barracks some distance from the town. The town lay far behind the lines. The object of the bombardment was seemingly the demoralization of the civil population and the destruction of the cradle of the Basque race.

Concerned people in Paris received their first detailed information about the atrocity in Gernika on Thursday, April 29, when *L'Humanité* reprinted Steer's article in its entirety, and surely Picasso also read it carefully and with immediate outrage by the end of that day. No record survives detailing the artist's first anger-infused conversations about what had occurred in Gernika, with both French and Spanish friends, but it's clear that for virtually all of Paris's artistic and intellectual elite, the subject soon was inescapable. Nothing like this calculated and meticulously planned massacre of hundreds, perhaps thousands of civilians—the death toll as yet remained unknown—had occurred before in modern times. *This* was the bloody footprint of fascism, the city's poets, thinkers, and artists agreed in animated conversations in cafés and salons, their comments increasingly taut with the realization that the governments of France, Great Britain, and the United States simply didn't seem to care.

Although the rebel government in Spain immediately denied any responsibility for the attack—claiming too that no German planes had been in the air in Bizkaia on the most recent Monday—*L'Humanité* reported to its readers that also on that Monday, German Luftwaffe commander Hermann Göring had been in Rome meeting with Benito

Mussolini to discuss ways in which to win the war in Spain as quickly as possible. The Fascist powers would act with barbarity—and with apparent impunity—the newspaper warned, then willingly lie about their wicked acts.

It was Friday before *L'Humanité*, joined by *Ce Soir* and the widely read and politically conservative *Le Figaro*, published the first photographs of the few standing walls in the stricken town—their window holes appearing like vacant eyes or perhaps open wounds. They were images that struck at the hearts of those, like the Spanish painter, who could comprehend the bombing of a heavily fortified city such as Madrid, who even could understand why the rebels would firebomb the Republican stronghold cities of Málaga and Barcelona, but who could make no mental or emotional sense whatsoever of a conscious decision to wipe a simple town from its mountain landscape and to kill as many of its citizens as could be cut down from the air.

It was the Friday edition of *L'Humanité* as well where Basque president Aguirre's first written statement in response to the annihilation of Gernika appeared, one in which he swore

> before God and history that will judge us that for three and one-half hours German planes bombed with inconceivable destruction the undefended civil population of Gernika, reducing the celebrated city to cinders. They pursued with machine-gun fire the women and children who were frantically fleeing. I ask today of the civilized world if it will permit the extermination of a people whose first concerns always have been the defense of its liberty and de-

mocracy, which the tree of Gernika has symbolized
for centuries?

Although Picasso never acknowledged that he had been
stirred to action by Aguirre's question, by his urgent inquiry
to people of conscience everywhere whether they would
permit the atrocity of Gernika to go unchallenged, Pablo Pi-
casso did respond in as bold a way as he knew how. On Sat-
urday, only a day later and less than a week after Gernika
had been reduced to ash—a May Day that saw a million
Paris workers take to the streets to denounce fascism and its
newest and most terrible manifestation, one people already
were simply calling "Guernica"—the painter retired to his
Left Bank studio rather than joining the throng marching
toward the Bastille, and drew the first preliminary sketches
for a painting that soon would shout *no!* in answer to
Aguirre's query and also would change the world.

On Tuesday evening, only a few hours after Aguirre had
announced by radio from Bilbao that the sacred town of
Gernika had been bombed by the German air force acting in
the service of the Spanish rebels, Radio Nacional in Sala-
manca responded with bitter affront on behalf of the "gov-
ernment" of General Franco. "Lies, lies, lies," the newscaster
virtually shouted into his microphone,

> Aguirre lies! He lies basely. In the first place, there
> is no German or foreign air force in national Spain.
> There is a Spanish air force, a noble, heroic Spanish
> air force, which constantly fights against Red planes,
> Russian and French, piloted by foreigners. In the

second place, we did not burn Gernika. Franco's Spain does not set fires. The incendiary torch is the monopoly of the arsonists of Irún, of those who set fire to Eibar, of those who tried to burn alive the defenders of the Alcázar of Toledo.

And then, as if a late bulletin bearing great truth had just arrived, the broadcaster added,

In these moments, news arrives from the Bizkaian front that shows the falseness of Aguirre's speech. Our planes, because of bad weather, have not been able to fly today and consequently could hardly have bombed Gernika.

According to that pronouncement, as well as a similar one issued the same night by rebel General Gonzalo Queipo de Llano on Radio Sevilla, the *siri miri* that characteristically moved onto the coast of northern Spain from the open Cantabrian Sea each spring, bringing with it soft rain and heavy cloud cover, had blown strong on that Tuesday, making aerial bombardment impossible. Yet while no one anywhere disputed that Tuesday's weather had turned foul, the rebel propagandists apparently were unaware that Gernika was attacked on *Monday*.

By the time Franco's headquarters issued an official communiqué on the subject on Wednesday, someone in Salamanca apparently had noted the mistake. The Nationalist air force had been unable to fly "during these last few days because of the fog and drizzle everywhere," stated the report, this time blurring the questions of when both the attack and the inclement weather had commenced. "Basque fugitives

who come to meet our columns tell in frightened tones of the tragedies of towns like Gernika, burned and almost completely destroyed in the fires deliberately set by the Reds when our troops were still more than fifteen kilometers away," the communiqué continued. It was "Basco-Soviets" who had annihilated the sacred town, the rebels hoped the world would believe, and wasn't it typical of both Basques and Russians that they would lie about who had set fire to Gernika, just as they had lied about German planes and German pilots dropping bombs on the town from out of a storm-swept sky?

From the vantage point of the present day, it is hard to comprehend entirely how Franco and his subordinates could have stated so boldly—as horror and disgust at what had happened in Gernika quickly mounted in Europe and North America—that "there is no German or foreign air force in national Spain." Yet that was precisely the same peculiar fiction the governments of France, Great Britain, and the United States already believed, or desperately wanted to. If the Fascist armies of Germany and Italy were, in fact, waging war in Spain at the moment, then the western democracies would have been forced—despite their extreme reluctance—to take strong action in opposition. Instead, it simply was far more expedient, and politically benign, to contend that the German and Italian aid being offered the rebels came from "volunteers," the Fascist equivalents of the soldiers of the international brigades.

Over the course of the next two days, Franco's headquarters continued to issue a flurry of statements, still vigorously denying any rebel involvement in the bombing, issuing "proofs" that often seemed to be rather more simply obfuscations, as well as laying the groundwork for shifting the blame

for the attack directly on the Nazis—if, perhaps, the crescendoing furor over what had occurred eventually demanded it—the statements repeatedly affirming that "the national air force did not fly yesterday [Tuesday] because of the fog, neither over Gernika, nor over any other point of the Basque front." If *German* planes had flown earlier in the week, well, that was another matter, the statements began to imply.

It was Friday of that infamous week before Francisco Franco at last spoke personally about the incident that by now commanded huge headlines around the world. But the rebel leader appeared at the moment to be rather more concerned about the psychological demeanor of his troops than anything or anyone else, insisting that "the indignation of my nationalist troops could not have been greater because of the lies of the enemy." His soldiers were dispirited because they were being unfairly blamed for the bombing of Gernika, the caudillo wanted the world to know. And neither did he miss the opportunity to note that on the day before, those same troops had entered the ruins of the sacred town of the Basques and claimed Gernika for the rebel cause.

No one as yet could provide an accurate accounting of the number of deaths by bombing, fire, and machine-gun bullets in Gernika five days before. How many of the town citizens had been torn to pieces by the blast from a percussion bomb? How many had been crushed by a falling roof beam, a collapsing wall? How many who were trapped by debris subsequently burned to death when the fires commenced. How many had become the targets of machine-gunners as they ran for their lives? Some newspaper accounts

spoke of thousands of dead and hundreds of wounded, but apart from that, for the moment the loss in human lives could be weighed only with more questions: how many residents of the town of seven thousand inhabitants were at their homes or businesses or schools when the bombing began? How many people from out of town had come to the weekly market? How many escaped once the conflagration commenced? How many died as they frantically fled?

What *was* increasingly all too clear in every town and province of embattled Spain was that the nine-month-old civil war had grown dreadfully bloody by now. Hundreds of combatants on both sides died at the several fronts each day, and for nearly every one of them, another soldier was murdered or executed behind the lines. Tens of thousands of civilians already had died of starvation and war-related diseases like gangrene and tuberculosis; and the people of Gernika were only the latest civilians in Spain to be killed in significant numbers by weapons that once had been brought to bear only on the battlefields. Just as an exact death count was impossible in Gernika for the time being, so too was an accurate accounting of the number of dead—both military and civilian—throughout the country since the rebellion had erupted the preceding July. Yet the number of Spanish dead surely had reached 200,000, perhaps 300,000 by now, and the toll would be doubled at least before the fighting at last was finished.

"Spain is the only nation where death is a natural spectacle," the by-then-world-renowned Andalusian poet and playwright Federico García Lorca had written before he was assassinated by rebels a month after the war began. "In Spain, the dead are more alive than the dead of any other

country in the world." Even before war turned the whole of the country into a killing field, Spain was, in fact, a nation of people for whom death possessed a mystical cultural power as well as its universal ubiquity. Death, Lorca observed, rose out of and forever slipped back into the dark and teeming soil that also held the roots of the Spanish race. It was the daily possibility of death that gave living its passionate intensity, and it was only in a direct and courageous confrontation with death that the human spirit truly could soar, and in which great art could be born. It made perfect sense to Lorca therefore that the corrida, the bullfight—a sport in which death is desired—long ago had become the nation's *fiesta nacional*. In the corrida, the foreordained death of the bull had become a ritual as profound as the sacrament of the mass, and the constant risk that death could come for the torero, the matador, as well had given the corrida its tension, its passion, and its truth. The spirit of *duende*, Lorca believed—that clear-eyed, calm, and essentially spiritual confrontation with death that empowered the great toreros— also infused and ennobled Spain's great artists, in particular its painters. Yet before his assassination in the summer of 1936, Lorca had wondered aloud whether the dean of Spain's living painters, Pablo Picasso, was filled with duende, in fact, or merely boundless creative energy. But instead of being meant to disparage the expatriate painter, the comment had been the poet's way of asking whether Picasso—whom he much admired—metaphorically risked his life as he painted, or if he only *saw*.

For his part, Picasso always had been notoriously reluctant to discuss the psychological motivations that shaped his paintings and sculpture. The people who viewed his work were wonderfully free to make of it what they chose,

he liked to state. Yet he loved the fact that both he and his images remained very Spanish thirty years after he had come to Paris, and perhaps nothing in fifty-six years of living except for his work had so captivated him as did the Spanish corrida.

The bullfight was born in ancient times in Málaga, the Andalusian city where Picasso had been born. He had grown up entranced by its spectacle, its violence, its artistry and symbolism. He loved the corrida's pageantry, its meticulously observed set of rituals, and, like Lorca, he was powerfully drawn to its embodiment of duende. As early as age seven, the young artist began to produce drawings whose subjects were the unfolding of the sunlit struggle between man and horse and bull. By the turn of the century, he often drew scenes from the point of view of a spectator of the multifaceted action inside the ring, and in 1917 he began to depict in isolation the intense and deadly confrontation between bull and horse that was the part of the great drama that he most preferred.

In every corrida Picasso had ever observed, a black bull had entered the ring alone, alarmed, angry, and already wounded by tiny lances driven into his neck. Many dozens of times by now, he had watched the bull make a series of vain charges at the broad and beautiful capes wielded by lone toreros, before a horse and picador, its mounted rider, quietly had entered the ring and held still. Frustrated by its inability to gore the swirling cape, the bull had been free to charge the blindfolded horse and gore it, while the picador attempted to drive his long lance deep into the bull's powerful neck muscles, weakening him dramatically and making him vulnerable to the lethal penetration by the torero's sword that soon would follow.

The goring and likely death of the horse in order to bring down the bull had compelled and fascinated the artist throughout his life. It was a ritual sacrifice that resonated an inexpressible truth for him, one that some critics began to claim reflected his essential belief in a compulsory battle between the sexes. Whether Picasso himself conjured that symbolic connection while he drew and painted seems doubtful, yet without question, he did often return to the visually intense and entangled subject of a bull impaling a stricken horse on its horns at those times when his relationships with the women in his life were at their most volatile and painful.

By the 1930s, the always-prolific artist had lost interest entirely in the larger canvas of the bullring, and even toreros and picadors seldom were included among his bullfighting images. It was solely the focused figures of the horse and bull that continued to spark his artistic interest until, in 1933, both bull and horse began to take on human qualities and to leave the bullring in favor of other symbolic settings. They also began to be joined, surrealistically, by naked nymphs and female toreras whose full breasts spilled out of their classically embroidered jackets. At the same time too, a minotaur—half-man and half-bull—began to inhabit both etchings and drawings, a creature that seemed to fuse for the artist the base with the divine, the spiritual with the erotic, and perhaps even love with hate. In a series of images he continued to create into the spring of 1937, Picasso variously depicted the minotaur reveling with nymphs at a bacchanalian fete, having sexual intercourse with a human female, suffering a death by goring in the bullring, death by a picador's lance, and death by the minotaur's own hand while a female picadora watched from the back of her horse. Sometimes the minotaur was blind and needed the assistance of a virginal girl,

and always he was portrayed sympathetically, even when his passions resulted in his public defeat. The minotaur never was half-horse and half-man; it was the bull—the beast of power, ardor, and ultimately heroic death in the corrida— that seemed to Picasso to blend most symbiotically with the human, with the humane. It wasn't entirely surprising therefore when, on May Day, he began to respond graphically to the calculated obliteration of the town of Gernika not by sketching the ruins of buildings, or the stricken bodies in streets and fields, or the fires that had been funeral pyres, but instead by executing six pencil drawings of a fallen and anguished horse and a bold but momentarily passive bull.

Chapter 3

Images Spilling
from Fingers

The sole son of a tall, fair-skinned, and bearded art professor, ten-year-old Pablo Ruiz began to show a particular aptitude for drawing in 1891, by which time his parents, José Ruiz Blasco and Maria Picasso y López, had moved their son and daughters away from the dry days and clear light of their home on the Costa del Sol to La Coruña in faraway and rainy Galicia. At age fourteen, following the family's subsequent move to Barcelona in 1895, Pablo was admitted to La Llotja, a Catalan art academy that allowed him to skip its introductory courses because his talent was so clearly prodigious—remarkable enough, in fact, that his father simply stopped painting and drawing around the same time as he recognized that his son's skill already surpassed his own. Two years later, the promising artist enrolled in Madrid's prestigious Royal Academy of San Fernando, but the adolescent was bored by the quality of instruction he received, and instead spent most of his time copying the great paintings he visited daily in El Prado, as well as recording in drawings what he observed in the city's streets, cafés, and brothels.

Seventeen-year-old Pablo Ruiz contracted scarlet fever in the spring of 1898 and spent much of the following year convalescing and emotionally emancipating himself from

his family in the Catalan village of Horta de Sant Joan in the company of Manuel Pallarés, a friend from La Llotja. By the time he returned to Barcelona early in 1899, he had learned to speak Catalan with impressive fluency, had decided that he would not study to become an art instructor, as his father had hoped, and he had begun to sign his work "P.R. Picasso," assuming his mother's maiden name because it had the air of Italy and the exotic about it, but perhaps also because he was like her in so many ways. People were drawn to him like they were to her: both were quite mercurial and could charm anyone they chose; he was short and dark-complected like his mother, and she had given him her round peasant's face and her dark, piercing, and altogether stunning eyes.

Back in Barcelona, Pablo Ruiz transformed himself into the companionable Catalan artist "Pau Picasso" over the course of the next five years, a time he spent reveling in the city's progressive "modernista" culture and establishing himself as a painter worth watching. It was also a period in which he began to travel regularly to Paris, then to spend significant time there, and in 1904 he made a decision to move to the French capital, which from all then-current perspectives was the world's epicenter of contemporary art. In Paris, the stocky and intense young man who now liked to be called simply "Picasso" came unshackled from the constraining influences of the Spanish masters. His art grew increasingly less realistic and he began to experiment with new forms of construction, composition, and perspective. Occasionally, his work was dramatically influenced by other artists— as it was early on by the Postimpressionist paintings of the Provençal painter Paul Cézanne—and at other times, his influences seemed to be solely his own boundless desire to

express himself visually and his determination to do so in ever-evolving ways.

Working closely with his friend and fellow Paris painter Georges Braque beginning in 1909, Picasso developed a new form that critics later labeled Cubism. Previously forbidden inconsistencies such as differing points of view, axes, and light sources, as well as the inclusion of both abstract and representational elements in the same picture radically recast the notion of what was possible in a single painting, and both painters abandoned a centuries-old commitment to illusion as the sole means with which objects in a painting could be seen as accurate representations of their literal selves. It was with Braque as well that Picasso subsequently began to experiment with attaching paper, cardboard, wallpaper, wood, and sand to painted surfaces as a means of focusing attention on the "reality" of the work itself and not the objects to which it referred. The technique that became known as collage was perfectly suited to still life, a rather new form for Picasso, and it was curious that in addition to everyday objects, the guitar—the particularly Spanish guitar—became a favorite subject.

As the painter's reputation grew in Paris, and as his circle of influential friends greatly broadened by the onset of World War I, Picasso's legacy as an innovator already had become secured, and his work—represented by dealer Daniel-Henry Kahnweiler—now was highly sought after by collectors who wanted to buy art that they believed lay on the cutting edge. During the war, Picasso collaborated with poet Jean Cocteau, dance choreographer Léonide Massine, and composer Erik Satie to create *Parade*, an avant-garde opera-cum-ballet to which he contributed both sets and costumes. And after the war, it was a separate circle of friends—principal among them

poets André Breton and Paul Eluard, and painters Max Ernst, André Masson, and fellow Spaniards Salvador Dalí and Joan Miró—who collectively captured Picasso's interest in their artistic attempts to blend both the conscious and unconscious realms of experience into, as Breton put it, "an absolute reality, a surreality." Drawing on the exciting new theories of Sigmund Freud, Breton—the novel movement's most passionate proponent—believed the unconscious was the wellspring of all imagination and that artists in every medium were compelled to tap it if they were to create their best possible work.

Although he never became identified as a true surrealist painter, something about the surrealists' interest in myth, dream, and the unlikely juxtaposition of the real with the imagined began to captivate Picasso in the mid-1920s, a fascination that continued throughout the rest of his life. It was in the probing of his own unconscious that a frank eroticism emerged in both his painting and the new sculptural work with which he now experimented in collaboration with his fellow Spanish expatriate, the sculptor Julio González. And also, it was the influence of the surrealists that was directly responsible for the emergence and continuing allure of the minotaur, for his deepening symbolic attraction to the bull and horse of the corrida, and even for the unfettered imaginative fancy of works like *Dream and Lie of Franco*.

A series of twelve pencil-and-ink sketches, each executed during two days in mid-April 1937, make it clear that Pablo Picasso—by this time not only the most renowned artist in Paris but also the world—had, in fact, finally committed himself to creating the requested mural for the Spanish pavilion at the world's fair. Yet instead of once more probing the unconscious of the little general who was bent

on killing so many of his fellow Spaniards, or perhaps find-
ing a way to depict graphically the great cause of the repub-
lic, Picasso planned, as late as April 19, to contribute to
the Spanish government's overtly propagandistic anti-Franco
and antifascist presence at the fair with a huge mural popu-
lated not with images supportive of the Spanish govern-
ment's message, but rather with surrealistic images that
would resonate solely with him. In each of the little-known
drawings—discovered by researchers in the archives of Paris's
Musée Picasso only in 1985—he experimented with the fig-
ures of an artist and his model, as well as the idea of a paint-
ing within a painting, a painting *about* a painting. In the first
of the twelve sketches, blank canvases were mounted on an
easel and a wall, and a sofa—over which Picasso scribbled "*le
canapé*"—was shaped unmistakably like a penis. Two volup-
tuous models, arms circled around their heads, reclined in
the fifth pencil drawing and floated disassociatedly from a
standing artist who was turned away from them, and whose
maleness was suggested by an arm and torso that could
readily be interpreted as an erect penis as well. The heads of
all three figures, however, were the strong-nosed female
heads in profile that had fascinated Picasso since Marie-
Thérèse Walter had become his model and lover six years
before. The sixth drawing focused entirely on the enfolded
model, capturing her head, breasts, and vulva in careful de-
tail, as well as dissecting parts of her body—an eye, a hand, a
nipple, her nose, her mouth and tongue—and scattering
them in space.

In each of the remaining six sketches, Picasso drew the
outline of a long, rectangular painting whose proportions
were remarkably similar to the stretcher and canvas on

which he began to paint *Guernica* four weeks later. It is fascinating to note that in terms of both composition and subject, the sketches began to foreshadow key elements of the painting. The town of Gernika still stood on April 18 and 19, yet already Picasso imagined a massive mural designed around a central compositional triangle; he was interested in placing a light at the apex of the triangle, and he imagined a staircase or ladder far to the right, as well as a partially open door. In the final sketch for the mural he thought perhaps he would call *The Studio*, Picasso even sketched the mural's placement in the covered courtyard of the Spanish pavilion—whose construction site he had visited by now. As he imagined the setting, placed at either end of the very long mural would be the two plaster busts of women mounted on stands that the artist already had sculpted and planned to contribute to the pavilion—busts that ultimately were exhibited a floor above the courtyard where *Guernica* was hung— themselves the curious precursors of the heads of anguished women that would anchor the final painting's left and right margins.

Although no record exists to prove it, it seems very likely that by April 19 Picasso had ordered a stretcher for the pavilion mural, and the stretched canvas may already have been waiting for him in his attic studio three blocks from the left bank of the Seine. Spain's renowned expatriate painter at last had truly committed himself to creating a major work for the Republican government's pavilion; by now he carefully had blocked out its composition and even imagined the company in which it would hang. And given Picasso's vaunted ability to marshal both energy and passion for his projects, it seems equally certain that *The Studio* would have been ready to greet eager visitors to the pavilion six

weeks later had not the German Luftwaffe been so eager to
see in the interim what blitzkrieg could bring to bear on an
unsuspecting Spanish town.

The war in Spain at last had ended and Angel Vilalta
was in his final year of high school in Franco's rigidly repres-
sive Spain before he heard for the first time—in 1944—of a
painter, exiled in Paris, who had joined the elite company of
his country's master painters. A young, bright, and inspiring
teacher had come to Lleida from Barcelona, and after class
one day she had wanted to speak to the dark and intense
young man who had seemed troubled by the state-mandated
chauvinism he heard in a class called "Great Ideas of the
Spanish Empire." Privately, secretly, she had wanted him to
know that *el imperio español es una vergüenza.* "The Spanish
empire is shameful. It is not, was not, something great. But
we do have good things in Spain, you know. Spain has pro-
duced much that truly is great." Carmina Pleyan, in her
mid-eighties and by now a lifelong friend of Angel's, had as-
sured him on that long-ago afternoon that Lope de Vega,
the prolific dramatist of Spain's sixteenth-century golden
age, had been a national treasure and was the Spanish
world's William Shakespeare. *La Celestina*, the fifteenth-
century play by Fernando de Rojas, remained one of the first
masterpieces of world literature, she explained, and was the
most influential work of the early Renaissance. Miguel de
Cervantes's great novel *Don Quixote* would be read round
the world for all time, to be sure; and there were the great
painters—Goya, El Greco, Velázquez—in which all Spaniards
should take great pride. Even today, she wanted her pupil to
know, Spain continued to produce great painters. A man

who had been born in Málaga before the turn of the century, and who had grown up in nearby Barcelona, was the greatest painter alive, she believed. He lived in France, and could not return to Spain following Franco's victory in the war, but he was *Spanish* in every way, and yes, of a man like Pablo Picasso her students comfortably and rightly should be very proud.

The work of Spain's painters and sculptors comprise the country's greatest artistic legacy simply because Spaniards are such visual people, Angel Vilalta suggested to me. "Our eyes are the most important sense to us, you know. We like to look at things. When I go to England, I see that everyone keeps their eyes down; people feel they mustn't look. But here, we look very much, very much. Sometimes foreign women complain because they are looked at so openly, but you know, we look not just at them. We look at everything."

Sitting in the library of his Barcelona apartment beneath a portrait of himself as a young man, one painted by his close friend, the renowned Maria Girona, Angel speculated that the Mediterranean climate, with its sunny skies, vivid light, and distant vistas, was foremost responsible for creating a culture of *viewers*. "It's through the eyes that we live in Spain, so of course, paintings are richly enjoyed, and it's very honorable here to be a painter, probably more than any other kind of artist.

"We have very few great composers, I think, because music is abstract and we don't care about abstraction. Even Picasso, you know, he never was an abstractionist. He always wanted to paint what he could see, to take it apart and then see it in a new way. And Velázquez, oh, he could see so many things. He saw so much. When Andy Warhol came to Spain and saw the paintings of Velázquez in El Prado, he said, 'this

man had special eyes. He could see things other people can-not see.'

"We are not thinkers, *los españoles*, we don't stay at home and think like the Germans; that's why we have practically no philosophers. We like to be out where it's sunny and in-teresting, where we can see what's going on. When we go to other countries, the streets look empty to us. We think, where is everybody? Well, they're at home, thinking! But we don't think very much. Perhaps we should think a little more."

Although he was reluctant to do so, at last Angel named the men who he believed were Spain's foremost artists of all time: Velázquez, Zurbarán—and Picasso, but his exuberant mood shifted the moment he mentioned the third name. "You know, it is our shame that Picasso had to die abroad. It is our shame. But, of course, if he had lived here, Franco would have killed him. Franco hated him so much. Oh, politics have always been terrible in Spain, a tragedy really. You remember how it was with Franco in the 1960s; it was impossible to think, impossible to truly see and to paint." Then he brightened a bit and his face flashed his consuming smile. "But that has changed at last, and permanently I think. I hope so, of course. At last, before I die, I live in a democratic Spain where people are free to look, even to think if they can."

On the evening of April 19, 1937, Franco was bent on destroying Spain's mid-century democracy, and the country's democratic neighbor, France, seemed unconcerned. On the evening of April 19, Pablo Picasso was distressed to read on the front page of *Paris-Soir*—the city's largest-circulation

newspaper and surely its most sensational—the account of a speech the day before in which French Foreign Minister Yvon Delbos strongly had urged the continuation of France's nonintervention policy in Spain. "France, in its realistic desire to ensure peace and safeguard security, looks for an understanding with all and neglects no possibility of rapprochement," Delbos had declared. It was the same desire to appease that would result, three years later, in the Nazis' remarkably effortless invasion and occupation of France, of course, and it was a comment that also immediately enraged the artist. Over the photograph of Delbos and the article outlining his comments, he furiously drew a small figure with an enormous left arm thrust skyward, in his clenched fist a single-handled tool with a hammer at one end and a sickle at the other—the same gesturing arm and implement that he had included in his final drawing for *The Studio* a few hours before.

The crossed-handled hammer and sickle long and ubiquitously had been a Communist symbol, of course—and Picasso himself officially would join France's Communist Party soon after the Allied forces liberated France from the Nazis eight years later. But at the moment, the artist's scribbling of the charged motif onto his newspaper had far more to do with disgust than with ideology. Spain's democracy now was gravely at peril; Europe's other democracies were threatened as well, if only they would awaken and observe that ominous truth, but the honorary member of Spain's Republican government believed he could do little in response to the crisis but issue a private howl. And his mounting frustration at his helplessness is forcefully implicit in the fact that for twelve more days that spring, Picasso did no further work in preparation for the planned mural, days during which he must

have puzzled at length over two interlocking questions: how could he square his artistic integrity and his fascination with his own interior myths and symbols with the need to create something truly meaningful—and valuable—on behalf of embattled Spain? How could *The Studio* save lives or even change minds?

Picasso had spent much of his life inside a succession of studios. He loved the visual chaos of painted canvases, collected objects, drawings pinned to walls; he loved the intoxicating smells of gesso, oil paints, and turpentine, loved the energy that hung in the air in those spaces, the creative possibility they inherently contained. It wasn't surprising, therefore, that the studio had captured his imagination as a subject for a grand mural, yet there was perhaps one more reason why it recently seemed so vital to him. In his three decades in Paris, Picasso had searched to find a perfect place in which to work and had never come as close to finding it as he had just a month before with the help of a young photographer named Dora Maar.

Since the end of World War I, Picasso had lived and painted on separate floors of a fine building on the rue La Boétie, a rather stylish street leading off from the Champs-Élysées. But beginning late in March, the painter began to commute to work across the Seine to a new block of rooms in an old seventeenth-century building in the rue des Grands-Augustins, an ancient, narrow, and cobbled street in the Latin Quarter reaching from the river toward the Boulevard Saint-Germain. The building, located just around the corner from Maar's own flat, had much to recommend it: the two upper floors the artist would occupy had vast open rooms with high, bare-raftered ceilings and red hexagonal-tiled floors. Huge windows looked out onto a gated courtyard, and the build-

ing's history seemed to offer excellent omens. Most recently, it had been a rehearsal hall for Maar's friend, the actor and director Jean-Louis Barrault, as well as the meeting space for a group of leftist intellectuals known as Contre-Attaque with whom she was acquainted and often allied. But better, and by a wonderful coincidence, it was No. 7 rue des Grands-Augustins that had been the setting for key scenes in Honoré de Balzac's *The Unknown Masterpiece*, published precisely a century before and one of Picasso's favorite novels, a 1931 edition of which he had illustrated with etchings and drawings. For the superstitious Picasso, that serendipity proved that the studio space was meant for him, and, as particular bonus, Maar, whose company he now regularly craved, lived only steps away and could be summoned to visit him at his whim.

Although women and the large subject of sexuality profoundly interested him throughout his life, passionate and libidinous Picasso had had only four enduring relationships by the time Dora Maar entered his life a year before. Soon after arriving in Paris in 1904, he met Fernande Olivier, an artist's model and fellow tenant in the bohemian lofts inhabited by painters and poets known as the Bateau Lavoir, and his relationship with her lasted seven years. As his relationship with big and often-brusque Fernande unraveled, Picasso shifted his amorous attention to Marcelle Humbert, the small and physically delicate lover of cubist painter Louis Marcoussis. Picasso called her "Eva" and treated her with unusual tenderness; she became the *"Ma Jolie"* who recurred in numerous paintings, but then had contracted tuberculosis, was hospitalized for long stretches, and died in December 1915, leaving Picasso heartsick and very much alone for a time.

In Rome in 1917—where he had gone to work on the sets and costumes for *Parade*—Picasso had met and immediately become entranced by Russian ballerina Olga Koklova, the daughter of a czarist military officer who danced with the touring Ballets Russes. From Rome he followed her to Madrid and Barcelona, then she had joined him in Paris, and in July of the following year they married in a three-hour-long Russian Orthodox ceremony. Olga loved the arts but adored the haut-monde circle of patrons and socialites that surrounded them even more. She introduced her new husband to a life of receptions, dinners, and elaborate fetes, one of invitations and obligations that was entirely new to him, and for the first years of their marriage, the middle-class Spanish artist truly reveled in the high life to which his wife was so drawn. Yet that fascination waned with time. Picasso craved solitude, and, perhaps more than anything else, he loved to work, and already he had begun to tire of social demands by the time Olga gave birth to Paulo, their first child. Although he could be fascinated by the infant—if only for moments at a time—and although his paternal care and depth of connection flashed intensely on occasion, Picasso was not a good father, and the clash of his mercurial temperament with Olga's always strong and often fiery demeanor had increasingly made him a less-than-successful husband as well. In early 1927, he met a seventeen-year-old Swiss girl in front of the Paris department store Galeries Lafayette. "Mademoiselle, you have an interesting face. I would like to make your portrait. I am Picasso," he said to her by way of introduction, but his name had meant nothing to her. Yet within six months, he and Marie-Thérèse Walter had become secret lovers, and her singular face and soft, round, and athletic body had begun to appear often in his work.

Simple and unassuming Marie-Thérèse was as different from Olga as she could be, and although his wife surely had some sense of the girl's importance in Picasso's life, Olga tolerated her role—at least what she knew of it—until, in the summer of 1935, she learned that Marie-Thérèse was pregnant.

The news quickly had precipitated Olga's move, with Paulo, from the flat in the rue la Boétie to the nearby Hôtel California; Picasso sued for divorce, then dropped the action, probably when he learned from his lawyers that Olga could claim and win fully half of everything he owned, including literally hundreds of unsold paintings. But regardless of the fact that they would never divorce—and that Olga would remain deeply embittered for the rest of her life—their marriage had ended in all but its legal contexts in September of that year when Marie-Thérèse gave birth to a daughter, Maria de la Concepción, whom Picasso had adored from the outset, whom he sketched, painted, and attended to with a devotion that he would never bring to his other children.

Picasso's separation from Olga had initiated a period of nearly two years in which his poetry—about which he was always secretive—had been virtually his only creative endeavor. The dissolution of his marriage shattered him in many ways, despite the fact that both Marie-Thérèse and the daughter he liked to call Maya remained close at hand. And he was not able to bring both interest and energy back to his art again until he met Dora Maar—as antithetical to Marie-Thérèse Walter as Marie-Thérèse had been to Olga—and it began to seem wonderfully possible to Picasso that he could, in fact, maintain simultaneous relationships with two lovers. At the close of April 1937, Picasso lived alone in the sprawling and increasingly squalid flat in the rue la Boétie.

Maya and Marie-Thérèse lived at art dealer Ambroise Vol-
lard's country house at Le Tremblay-sur-Mauldre near Ver-
sailles, where, beginning the previous autumn, Picasso went
for a few days each week to escape the attentions of friends
and sycophants and to paint a series of brilliantly colored
still lifes—of fish, fruit, flowers, plates, and cutlery—that
were curiously distinct from his current work in Paris. And
now, Dora Maar had found and made possible for him the
kind of studio space he always had hoped for, one so near
her own flat that he might simply have whistled whenever
he needed or wanted her had telephones not been a simpler
means of communication.

Picasso had met Dora at the café Les Deux Magots in the
Boulevard Saint-Germain early in 1936. Seated with his
friend Paul Eluard, he had watched her rapidly driving the
blade of a penknife between her fingers and into the surface
of a nearby table, noting that when she sometimes cut her-
self, drops of blood would spread between the embroidered
roses on her gloves. Yes, Eluard knew the striking and un-
usual young woman, he replied when the painter inquired
about her; and when Eluard introduced them, Dora had re-
sponded in Spanish to Picasso's greeting in French, thereby
completing his instant infatuation. They left the café to-
gether and in the street he had begged for her gloves as a
souvenir before they parted.

Although there had been an immediate and fiery at-
traction between them, the two didn't meet again for six
months. In August, at the summer home in Saint-Tropez of
surrealist writer Lise Deharme, they had been surprised to
encounter each other, and went for a miles-long walk along
the shore of the Riviera that forged the beginning of a rela-
tionship that would last a decade. The daughter of a Cro-

atian architect and a Frenchwoman, Henriette Theodora Markovitch was born in Paris but spent her childhood in Buenos Aires with her parents. In 1926, at age nineteen, she left Argentina and returned to Paris to study art and photography. Although she continued both to paint and take photographs ten years later, it had been her surrealist-influenced photographs that had earned her a swelling reputation by the mid-1920s. At age twenty-nine, Theodora Markovitch had become the dark, dramatic, proud, and enigmatically beautiful "Dora Maar," and Picasso had been overwhelmed by her. "She was anything you wanted," he explained to her good friend James Lord, "a dog, a mouse, a bird, an idea, a thunderstorm. That's a great advantage when falling in love." Never before had Picasso had a lover who was his intellectual equal—or superior perhaps—nor one who was an artist as well. He painted and drew her with eager fascination; she photographed him at work, at ease, and at play, and together the two celebrated the power of their creative desires, a decidedly erotic intensity that by now enveloped them and bound them tightly together whether in bed, on the beach, or in the studio.

Because she visited them often before she met Picasso, Dora had been certain that the cavernous rooms in the building where Balzac had imagined his obsessive painter Frenhofer at work would perfectly suit the obsessive painter with whom she now was very much in love, and she was willing to accept the unyielding rule that the space was solely his. She was welcome *only* when summoned by him, and within a month after moving in, Picasso already had unmistakably personalized the space, quickly stuffing it with a painter's myriad accoutrements and the thirty years of acquired objects with which he simply couldn't part. In his rooms in the

rue des Grands-Augustins, according to his friend the poet Jean Cocteau were

> piles of booty, consisting of his own work and pictures by Matisse, Braque, Gris, the Douanier Rousseau, Modigliani and hundreds of others. The tables and chairs were littered with an amazing variety of objects: Negro masks, twisted pieces of glass picked up in Martinique in the lava that engulfed Saint-Pierre, ancient bronzes, plaster casts, peculiar hats, deluxe books, reams of Holland paper and rice paper, piles of reviews, and unopened packets. Picasso kept everything he was given: bottles of eau de Cologne, bars of chocolate, loaves of bread, packets of cigarettes and boxes of matches, and even his old shoes, which were lined up under the table. . . . He had never thrown anything away, even hoarding useless household utensils, the old oil-lamp which lit the canvases of the Blue Period, a broken coffee-grinder . . . He considered that anything that had come into his hands formed part of himself, contained a portion of himself, and that parting from it was the equivalent to cutting off a pound of flesh.

In its totality, Cocteau observed, the studio possessed "a regal disorder, a regal emptiness—haunted by the monsters he invents, who compose his universe." The poet surely understood something profound and elemental about his often-difficult and multifaceted friend when he added, "Picasso is a man and a woman deeply entwined. Like in his paintings. He's a living ménage. The Picasso ménage. Dora

is a concubine with whom he is unfaithful to himself. From this ménage marvelous monsters are born." The painter's libidinous but caring minotaurs likely were the specific monsters to which Cocteau referred, and already Picasso had executed in colored pencil a lush and intricately detailed drawing in which a beatific and compliant Dora was sexually overwhelmed by the half-bull, half-man. And it would not be long before more minotaurs emerged in those cluttered attic rooms on the Left Bank of the Seine, before the bull and horse of the corrida again took shape beneath his brushes, before Picasso would find a way to depict the horrible handiwork of monsters then in Spain.

A week after Gernika was bombed, flames no longer rose from the ruins of the town, but piles of rubble still smoldered and the air remained thick with smoke and the stench of the fires. No longer did human bodies lie exposed to the elements, but the carcasses of dead animals still lay in the market plaza, and throughout the town, the air carried the stink of their rotting as well. Virtually everyone who had survived the attack by now had gone elsewhere—who knew when, or if, Gernika might be rebuilt?—and its sole inhabitants were the luckless rebel soldiers who were assigned to guard the massive destruction. It had been the vicious Reds who had dynamited and burned the town to the ground, the soldiers had been told, and it chilled them to think how truly horrible Communists could be—that they would destroy a place rather than allow it to become part of the glorious and godly Spain that Generalisimo Franco was re-creating. Rebel planes regularly flew over the town, as if to check to be certain that Gernika, in fact, was gone, and from the air reconnaissance

pilots now could see clearly that the central core of the town, about fifteen square blocks, was entirely destroyed. A few walls still stood, but not a single roof remained. Trees had been burned to stumps, and cars that had been catapulted by exploding bombs lay overturned on top of the rubble.

On the outskirts, however, roughly 25 percent of the town survived. The hallowed Basque assembly building was undamaged, as was the ancient oak, and on the nearby slopes that led toward the village of Lumo, churches, convents, and a few grand homes stood strangely undamaged. Across town, the Astra-Unceta factory—where pistols, machine guns, and bombs ironically had been manufactured until the week before—also remained unharmed, as was the stone bridge over the Mundaka that had been identified before the bombing as the Nazis' key target.

Cemetery custodian Pedro Calzada and the men who volunteered to assist him had dug graves for hundreds of victims of the attack by now—some of them necessarily mass graves—but they had to work quickly, and no one knew precisely how many people had been interred. No one knew how many bodies had been carried away by grieving survivors; and neither did anyone know how many bodies still lay undetected in forests and fields.

Father Alberto Onaindía, who had seen much of Monday's killing himself, made his way to Bilbao by Tuesday morning and reported what he had seen and experienced in Gernika to Basque President Aguirre. Stunned and profoundly outraged by what the Basque priest told him, Aguirre asked Onaindía to travel to Paris as quickly as possible and relate his story to journalists, politicians, and anyone who would listen. The priest arrived in Paris by train early on Thursday morning and had been met and surrounded at the Gare de

Lyon by newspapermen eager to hear who, in fact, destroyed the town. By Friday, newspapers throughout Europe that were sympathetic with the cause of the Spanish Republic as well as those that were openly anti-Fascist carried front-page stories of the horrors of the attack as seen through the cleric's eyes. In Paris, *Ce Soir*, *L'Humanité*, and the Christian-Democratic journal *L'Aube* all printed detailed accounts, accepting Onaindía's story with shock and without suspicion, and George Bidault, editor of *L'Aube*, editorialized as well that "faithful to ourselves and above all to our duty, we associate our voice with those raised around the world against the assassins of Gernika. For three hours, the German air fleet bombed the defenseless town. For three hours, the German airplanes fired their machine-guns on the women and children in the streets and in the fields. All of this in the name of civilization. And even, for the crusade, as they say."

Yet not everyone wanted to hear the priest, of course— or to believe him. And the rebel government in Spain remained diligently at work promoting the version of Monday's event that insisted that Basque and Asturian Communists— "Red hordes," they obliquely labeled them—had been the perpetrators of the crimes. Foreign journalists had been escorted to Gernika on Friday by rebel army officers on General Mola's staff and shown various "proofs" of the Communists' plunder. Most had been persuaded, and on Monday, May 3, only a week after Gernika had been annihilated, *Le Figaro*— a newspaper Pablo Picasso regularly read despite its editorial disposition toward the war in Spain—carried a lengthy article from the French news agency Havas under the headline GERNIKA COULD NOT HAVE BEEN DESTROYED BY BOMBS FROM THE AIR. IT IS THE REDS WHO BURNED IT "BY HAND." "Nationalist officers have drawn the attention of journalists," the

report explained, "to the fact that nowhere does one find signs of bomb splatter and that the absence of traces of projectiles, as well as the verifications made elsewhere, show that the town was deliberately set on fire. . . . In spite of meticulous searching, the journalists have found no bomb holes." The large craters that everywhere pockmarked the bleak streets of Gernika were caused by exploding mines, the article continued, and at least as far as *Le Figaro* was concerned, there likely had been few casualties in the Communist-fueled fires a week before because even Reds would have been unlikely to have torched themselves.

Picasso sketched the first five of his May Day studies in pencil on blue drawing paper, executing each one in only a minute or two. From the outset, images of the corrida flooded into his consciousness as he considered how to respond to the atrocity that occurred five days before. Even in the very first image that spilled from his fingers, a wounded horse and defiant bull were present, as were the head and arm of a woman leaning from a window and holding a lamp in her extended hand in order to light the scene. The horse and bull would be modified many times before the studies were translated onto canvas and the painting was complete in early June—their positions, depictions, and attitudes changing often as the work inexorably assumed creative weight. But the observing woman, her profile once more an unmistakable likeness of Marie-Thérèse, immediately assumed such vital symbolic and compositional importance for the artist that she only very subtly would change throughout dozens of subsequent sketches and in the several states the final painting would assume as well.

Although he, like most Parisians, by now had heard many conflicting details about the incident in Gernika, not once did Picasso experiment with images of airplanes, bombs, or exploding buildings on that first day or any other. It was his ongoing interest in the surrealistic linking of the conscious and unconscious that immediately turned him away from a documentary response to what had transpired. Also, he had not been truly interested in any sort of visual documentation since before the turn of the century, regardless of its subject. Perhaps more importantly, from those first days in May, Picasso found himself interested not so much in what the bombing and destruction of Gernika meant politically or even in humanitarian terms, but rather what they meant in metaphor. He wanted to address emotionally the destruction of his beloved homeland that was taking place both from within and without, and he already possessed a personal visual language with which to do so, one anchored in the violence, suffering, and passion of the corrida and its centuries-old tradition of making *viudas*, widows, out of the wives of the men who played out its pageantry. The civil war itself was a ghastly and gruesome pageant, it appeared to Picasso from France, one in which death appeared as terribly foreordained as it was inside the bullring.

In the second drawing of that Saturday, a small Pegasus appeared—similar to the fanciful winged horses Picasso remembered from the Spanish circus—mounted on the back of a confident bull. In the third, three fantastic monsters that echoed his horrific depictions of Franco some months before made a single appearance before they were discarded. The fourth sketch was a primitive drawing solely of a standing horse—a child's image, as it were, that seemed designed to test how best to represent the equine figure—followed on a

subsequent sheet of blue paper by a highly realistic sketch of a fallen horse, this one an illusion of a flesh-and-blood animal whose predicament was dynamically conveyed in its struggle to stand and whose pain was telegraphed by a terrified eye and gaping mouth.

At the end of the day of sketching, the artist abandoned blue paper for a gessoed board, but he continued to use a pencil to sketch the several elements of the unified work he now envisioned—the commanding bull executed in full profile; the stricken horse, out of whose gaping abdominal wound flew a tiny Pegasus, which appeared for the final time; the woman, given breasts now, reaching far out from the window with her lamp; and across the whole of the foreground, the addition of a supine soldier, depicted only this once as a helmeted classical warrior clutching his lance in death. It was impressive progress in only a few hours of sketching. Already the horse, its head reared skyward, and the horizontal warrior together formed the strong compositional triangle that would anchor the finished work. Already the key figure of the observing and illuminating woman was permanently linked to the scene, her lamp at the apex of the triangle, just as Picasso similarly had imagined a triangular, lamp-lit composition for his now-abandoned *The Studio*. And the haughty and enigmatic bull—did it represent Franco's rebels, the Nazis, the whole of Spain itself?—already demanded focal attention. An image of a proud bull would, without question, become central to his treatment of the destruction of Gernika, a town ironically as far removed from the sun-baked soil of the corrida as was Picasso's Paris.

The artist worked feverishly on Sunday, May 2, as well, and just as he had the day before, he ended a series of new sketches with a second drawing on a prepared board of the

evolving composition in its entirety. In the three studies that had preceded it that morning, Picasso had focused his attention solely on the head of the anguished horse, giving the animal a sharpened, spearlike tongue each time and experimenting with the placement of its teeth. But when he was ready again to combine the several visual elements at the end of the day, this time he sketched the horse with its head and gaping mouth bending toward the ground. Unlike the final drawing of the day before, in which the several subjects were presented rather statically, the scene was full of action now. This time, the bull leapt into the air as if to escape calamity; the observing woman's face had grown full of alarm; *two* soldiers now lay on the foreground, their faces more certainly evidencing death than sleep, and—with its head touching the chest of the central soldier—the horse appeared to be falling into its death posture as well.

The boards on which Picasso executed his two end-of-day sketches were almost square, whereas the canvas on which he would begin to paint in nine days would be a dramatically elongated rectangle. But much of the mural's final composition already had been determined: the bull would dominate the upper-left quadrant; the woman and the window out of which she reached would command the upper right, and a triangular scene of anguish and death would rise out of the lower half of the composition. None of the images bore a direct link to the bombing of Gernika; none echoed attributes of the town or even Basque culture; none represented the literal realities of the war that then raged in Spain. Yet the images already were very much alive in Picasso's oeuvre; they were metaphors to which he long since had become wedded emotionally as well as visually. To him

they—more than any others—spoke eloquently of Spain, of violence and death.

Given the great strides he at last had made on the mural during those first two days of May, it's curious that Picasso then abandoned the project entirely for a week. The reasons why he did remain a mystery: perhaps he traveled to Le Tremblay with Marie-Thérèse and Maya, where he continued his series of still lifes; perhaps the preparation of the mural's stretcher and canvas occupied much of his time during those subsequent days; or perhaps he and Dora, their relationship still new and deliciously consuming, may have focused that interim simply on themselves. Whatever the explanation for his hiatus, Picasso did turn his attention back to the mural on the following Saturday, May 8, and for the following three days, his sketching took a dramatically new turn.

During the preceding week, the reports arriving in Paris from embattled Spain had grown still more ominous. Basque resistance to the invading rebel army and its allied German and Italian forces had crumbled, in largest part due to the shock inflicted on all of the region by the horror of Gernika. Republican forces could not hold Bilbao much longer, it now was apparent, and British and French ships in the city's port had begun evacuating women and children in advance of the human carnage that seemed certain to follow its capture. Food was in terribly short supply, and for the old and infirm, death by starvation increasingly seemed as likely as death by aerial bombardment. In news reports sent round the world, reporters had begun to focus their stories less on the losing war effort and more on the plight of civilians and refugees, who were streaming onto roads throughout the

Basque country en route—often on foot—anywhere that seemed to offer safety.

L'Humanité, the Communist Party–aligned newspaper Picasso read almost daily, published on Wednesday detailed and very disturbing accounts by survivors of the annihilation of their town, as well as recent photographs of frightened, perplexed, and now homeless refugees. On Friday, it published a wrenching image of homeless Basque children; on Saturday, the day Picasso returned to work on the mural, both the weekly picture magazine *L'Illustration* and *Paris-Soir* offered their readers pages of photographs of the destroyed town and the now-desperate victims of the attack. While it is not certain that those stories and photos were directly responsible for the new images with which Picasso now began to experiment, it *is* sure that he saw and was moved by them, and for the first time on Saturday, a new composition study included—in addition to the images with which he now had become conversant—the drawing of a woman crawling on her knees with a dead infant in her arm, her head bent skyward in supplication. The pencil study that momentarily followed it focused solely on the stricken horse and the woman again, her child's chest and her own breast now drenched with blood. On Sunday, the tormented woman returned three more times, first in a detailed ink study that reflected Picasso's ongoing fascination with etching and engraving, and which poignantly depicted the woman's agony and her terrible plight. In a subsequent pencil sketch, Picasso moved the woman and child from the ground to a fragile ladder, as if in attempt to add to her torment, and in a pencil composition study also completed that day, the woman and child now crawled onto the belly of the fallen horse.

On his two most recent days of work, Picasso had begun

to draw on white paper that, when positioned horizontally, was twice as wide as it was high. The change simply may have been convenient, but it seems more likely that it was initiated by a visit to the Spanish pavilion, now nearing completion at the world's fair site. The painter was interested in the prefabricated building and had visited the construction site before; by now he would have been quite familiar with the long courtyard wall on which his mural would be hung. Although there is no record of the date when the stretcher and canvas were ready for painting, surely they at least were under construction by that weekend, and it seems obvious that Picasso now would want his composition sketches to begin to mirror the proportions of the final painting.

This was his fourth composition study so far, and it was much more detailed and highly developed than the previous three. Never before had all the subjects appeared interrelated spatially; there were a depth of field and density of images that were new, and for the first time too Picasso began to focus his attention on contrasting darkness and light. The setting was unmistakably nighttime now, the subjects lit both by the high central lamp in the observing woman's hand and by bright fires that flared in the background. The bull remained focal, its attitude still ambiguous, but its head was intriguingly humanlike now, and suddenly it faced the viewer directly. The fallen horse's head continued to bend to the earth; four human corpses—including the body of the child— occupied the chaotic foreground space, and, in addition to the observing woman, who had been present from the start, Picasso sketched two more female survivors, as well as four disembodied arms and fists raised in the Communist salute,

which had become a universal symbol in opposition to the Fascist war in Spain.

Picasso opted not to execute another composition sketch on Monday, May 10—a fortnight following the bombing and the first time he had worked on the mural on a weekday. Instead, he completed five more sketches of individual horses, suffering women, and a bull that by now had become very human. Unlike the minotaur—essentially a man whose bull's head implied his animalistic passions—this horned, spike-eared, and supremely powerful bull who possessed a classically beautiful human face seemed to be both primitive and comprehending, both base and somehow wise. With his addition of suffering people to the tableau that had included only the animals from the bullring in the beginning, the otherwise sharp distinctions between man and beast, between perceiving and feeling, between passion and compassion had begun to blur as the mural planning continued. And although it remained doubtful that he understood precisely what his bull-made-man "meant" in symbolic terms, it seems impossible to have escaped the artist's notice that the wide and insistent eyes of the bull now looked increasingly like his own.

The canvas on which Picasso began to paint on the morning of Tuesday, May 11, was more than twice his own height and nearly eight meters wide, so large that the stretcher on which it now was mounted had had to come up the building's rickety circular stairway in pieces, then had been reassembled before the cotton canvas was stretched onto it, tacked, and gessoed. The studio's high ceiling rafters were suspended a bit more than three meters above the tiled floor,

but the readied canvas measured three and a half meters, so it had to be tilted against the room's long wall, its top pressing hard against the rafters, the bottom held out from the wall with wooden shims.

For two successive weekends, the painter had foregone his habit of spending time in the country with Marie-Thérèse and their daughter Maya and worked diligently on the series of studies that readied him to paint. Work on the canvas— simply a vast white sea at the moment—now would begin to occupy his deep and transfixed attention every day for roughly a month. Dora would be with him constantly during that time, attending to his needs, discussing the painting's progress with him—something he otherwise always had loathed, his studio normally closed to visitors—as well as photographing the painting at numerous stages of its development. For decades, Picasso had been careful to date virtually every scrap of paper on which he drew as well as the back of every canvas—a means of anchoring his work in time and documenting its progressions and perambulations. Never before had he or anyone else photographed a painting of his while it was in progress, yet the idea greatly appealed to the artist. With Dora's photographs, he would possess a visual record of the mural's gestation, and historians might be interested as well—an issue to which he paid close attention. It seemed to make sense therefore that Dora would capture the canvas even at the close of Picasso's first day of painting, and he telephoned her at her nearby flat late on Tuesday afternoon to tell her to come at once to Grands-Augustins and to bring her beloved Rolleiflex with her—because the canvas no longer stood bare.

Using a narrow brush and black paint, Picasso had lightly sketched the outlines of all the characters with which he had

become conversant during the previous six days of drawing, but although the canvas clearly reflected the final composition study he had completed Sunday afternoon, there were key changes as well. The bull, who had turned toward the viewer on Sunday, once more was depicted solely in profile, his eyes cast away from the rest of the scene. The wailing woman whose dead child lay in her arms had been moved from the composition's right margin to its left, where, it now was suggested, the bull offered her a bit of protection. And the right half of the composition, defined by the outline of a tile-roofed house, now included the figures of three more women in addition to the observer holding aloft the lamp, whose position as always remained unchanged. Akin to a drawing made on Sunday, one of the new female figures descended a faintly suggested ladder to escape the fire that threatened the building; a second woman was caught in mid-stride as she fled toward the mural's center; and a third lay lifeless in the foreground, her expression strangely serene. The dead soldier still anchored the composition's base as he had before, his clenched fist still thrust upward in salute, and the twisted, writhing body of the horse still filled much of the painting's middle ground. Picasso had painted for only a few hours that Tuesday, but already he had populated more than 27 square meters of canvas with the characters he believed were his most compelling, the majority of whom would retain their current positions and collective importance as the canvas grew heavy with paint during the coming days.

In addition to the ten photographs Dora Maar made of the entire canvas as it evolved, she photographed her companion at work as well—squatting on his haunches to paint the bottom edge of the mural, working from high atop

a precarious ladder, using a low rung of the ladder for a make-shift seat, standing upright with brushes strapped to bamboo sticks in his hands—and almost always with a cigarette pressed between two fingers or dangling from pursed lips. In virtually every image, cigarette butts and spent paint tubes littered the floor, as did the small cardboard buckets and thin stacks of newspaper that served as his ready palettes. In some of the photographs, daylight streamed in from the building's commanding windows; in others, round studio lights mounted on stands illuminated the gigantic canvas at night. For four weeks, Picasso did little but smoke and paint and occasionally stand back briefly from the canvas to consider what he had wrought. He left the studio in the rue des Grands-Augustins only to eat and sleep, Dora herself his sole assistant during those days, the war in Spain and the destruction of an innocent town now his principal muse.

It was a measure of the many sides of the complex man that he presided one day during his obsessive work on the mural over an ugly quarrel between Dora and Marie-Thérèse, a fight he apparently was happy to fuel. Marie-Thérèse had come to Grands-Augustins from the country and had been disturbed to find Dora in the huge studio, clearly rather at home in the cluttered and cavernous space. "I have a child by this man. It's my place to be here with him. You can leave right now," Marie-Thérèse instructed the dark, severe, and unhappy "visitor," but Dora was undaunted by the demand. "I have as much reason as you have to be here. I haven't borne him a child, but I don't see what difference that makes," she responded.

The two women continued to argue, according to an account written by Françoise Gilot—who, in six years' time, would become the next woman to feature in the painter's life,

the story related rather gleefully to her by Picasso himself—until Marie-Thérèse turned to him and insisted, "Make up your mind. Which of us goes?" It had been a hard decision, he explained to Françoise. "I liked them both, for different reasons: Marie-Thérèse because she was sweet and gentle and did whatever I wanted her to do, and Dora because she was intelligent." So he simply suggested they settle the matter themselves. A bit of a catfight would amuse him while he painted, and, he swore to Françoise, the two women did indeed push each other about as they quarreled, and the painter took great pleasure in being the object of their struggle. He might be capable of exhibiting on canvas great compassion for women who suffered from war, but the agonies of these two women who loved him meant nothing to him, it appeared, and the incident remained "one my choicest memories," he later told Françoise.

But entertainment—whether dueling mistresses or something decidedly more conventional—was rare during those weeks, and Picasso was consumed with creative energy in a way Dora had not seen in the time she had known him. He had begun to work out the visual structure of the great painting back in mid-April, prior to the bombing and while he still planned a mural replete with images of a painter's studio. He had begun to grapple with symbolic, then literal images with which to address the subject of Gernika's annihilation virtually as soon it had occurred, and by now he had amassed more than three dozen studies—there would be forty-five by the time the mural was finished—drawings that focused, then refined his visual vocabulary. Now he was rapt in the heady process of bringing his vision to bear on a huge, two-dimensional surface, and was doing so with the wonderful fluidity and malleability of oil. He was *painting,*

and nothing, certainly not the two women who were devoted to him, could deter his artistic fascination or his focus on the truest of his life's many pleasures.

When Dora photographed the canvas again a week later, it had begun to assume a visual weight commensurate with its size. Large and irregular background areas now were black, and in contrast, the white and light-gray figures of both human victims and animals appeared to leap from the surface, the entire scene now lit by a bright disc of the sun that Picasso had placed at the focal upper center. The jumble of foreground bodies had been reduced to only the head of a female victim and the large corpse of the single soldier, his form turned entirely around so that his head now was near the left, positioned below the bull and the woman mourning her dead child. The warrior clutched a broken sword in one hand, and the other lay stretched beyond his head. His defiant salute also had disappeared, the painter concluding that the image that worked so well on propaganda posters appeared somehow hackneyed on canvas.

The next photograph in the series, likely taken about April 28, or perhaps a bit later—none of Maar's work was dated—showed the mural having reached a state in which, for the first time, its final visual and emotional forms were evident. It also recorded two dramatic changes: without altering the position of the bull's head, Picasso had reoriented his body, moving it to the far left edge of the canvas, so that the bull's head now was turned toward his uplifted tail. One eye, however, now was positioned below an ear, so that both of his piercing and intelligent eyes seemed to stare intently, and even with some supplication, out toward the viewer, the bull becoming the only character in the tableau who appeared to solicit direct communication. In the space where

the bull's body previously had been, the horse's head now rose in screaming pain, his nostrils flared, a spearlike tongue jutting from between his teeth, his body impaled by a lance. Instead of the bent and defeated animal of recent sketches, the horse now suggested defiance despite his deep wound—one caused, rather curiously, by the same weapon that is brought to bear in the corrida only on the bull.

When Dora captured the painting in progress again a few days later something brand new had occurred: Picasso had attached two separate pieces of *colored* wallpaper over the figure of the fleeing woman. A piece of red-checked paper covered the back of her head as if it were a scarf, and a bright strip with a floral pattern now hung from her shoulder, covering a previously exposed breast. The painter was uncertain, however, about whether he had achieved the effect he was hoping for. He soon removed the collages, then, on one of the first days of June, attached them again, as well as two more pieces: a rectangle of ornate purple-and-gold paper now covered much of the torso of the mother whose dead child lay in her lap, and a swath of checked paper reminiscent of a restaurant tablecloth, placed on a diagonal, now suggested a skirt worn by the woman falling from the building at the far right. The collages were attached only to female characters, and may have been meant to suggest the reality of walls, tables, and personal possessions torn to bits by the bombs, or the extent to which victims now were bereft of even their clothes. Yet the artist also simply may have continued to experiment with the totality of his design, testing to see whether those specific areas of the canvas needed more activity, more detail or perhaps less. Whatever their intended purpose, the collages also directed attention to the surface of the canvas itself: it was a flat, two-dimensional

plane—a conventional mural, of course—and it was obvious now that Picasso had simplified the many forms it contained over the course of the past weeks. He had created a massive picture, one replete in every part with action, drama, and even deep emotion, yet its shapes, forms, and depictions he purposefully had rendered quite simply.

Dora Maar's ninth and penultimate photograph, taken around June 5, recorded the painting very near its completion—and it was absent collages again. The dead soldier had a new, crudely drawn head now, his face turned upward, his two vacant eyes open and aimed at the viewer in a line directly below the expressive eyes of the bull. His head also had been severed from his body, but the break at the neck was a clean edge rather than a wound, one revealing that the inside of the soldier was hollow. He had become a plaster cast, a sculpture, only a fragile *replica* of a soldier in the last days, his meaning decidedly more ambiguous and less menacing now. The supine woman had disappeared entirely, her head painted over with a wash of gray, the only remnant of her the blossom she had held in her hand. The falling woman far on the right possessed only an upper torso now, but her skirt—darkened and striped by Picasso after he had pulled the paper away—remained on fire, her plight pronounced by the darkening of her uplifted arms in a way that suggested heat and smoke and the burning of flesh. A dim, dark, and simply-drawn table now stood between the heads of the horse and bull, and atop it a crudely sketched bird suddenly screamed at the sky. Nearby, the agonized horse had become, unmistakably, the tableau's central motif; his head presented in a kind of cubist detail that was unique among the many characters, his tortured face now lit by an incandescent bulb.

The round sun long since had been flattened into an oval, but for nearly two weeks, Picasso plainly had left it and the area around it unpainted—uncertain how best to complete it. His latest, and final, decision was to transform the oval sun into the shade of a suspended lamp, underneath which he sketched the lightbulb, sealing in the process the final ambiguity of whether the scene took place indoors or out. Walls, windows, and the tiled roof of the building suggested an outdoor scene, but tiled floors, the table, and now the electric light argued that the terror unfolded inside an enclosed place. It was an uncertainty that seemed to complement the overall chaos in the end, and a reference as well to the literal reality that in Gernika, the force of exploding bombs had thrown the inside of virtually every house into the open air.

There was little more Picasso was compelled to change, although he admitted in a call to pavilion architect Josep Lluis Sert that he really didn't know whether the mural was finished. By now he had devoted perhaps two hundred hours to the canvas, and likely a hundred more to the nearly fifty studies that had preceded it. Yet the mural finally would be done, he supposed, only when Sert came to collect it. He adjusted the tone of the background color in two locations; he added gray washes in others, and with Dora's assistance—the first time she, or likely anyone, ever had applied paint to one of Picasso's canvases—they worked together to stipple the horse's body with hundreds of short, vertical brush strokes that suggested hair, or perhaps the newsprint on which word of the atrocity had spread, or perhaps the tallying of the dead.

One of his final touches to the painting was the addition of an obscure and partially open door to the extreme right edge of the canvas, almost as if the painter had needed a way

to extricate himself from the scene, a way to walk away from it and be done. And with that, it now made sense to him to see what some others opined, although Picasso understood, of course, that praise and congratulation were far more likely to flow from friends and colleagues than were suggestions on how the mural might be improved.

Although its date doesn't survive, and the accounts of the afternoon trip to the studio vary with each of the several visitors who described it, it is certain that more than a dozen people came to see the completed mural about June 6, even though Picasso continued to make minor changes to the canvas in the days thereafter. Close friends of the painter periodically had seen the mural's progress during the preceding weeks, but this was the first time a large group had been gathered together. Although the painting was far too big to be cloaked in a sheet prior to the guests' arrival, the occasion did have the dramatic air of an unveiling about it. Spanish friends such as the poet José Bergamín and scholar Juan Larrea—both employed at the time at the Paris embassy of the besieged Spanish Republic—and Italian sculptor Alberto Giacometti, German painter Max Ernst, French poets Paul Eluard and André Breton, as well as British painter and art historian Roland Penrose and the sculptor Henry Moore and his wife Irina followed a festive lunch with an excursion to Grands-Augustins. There they were greeted by the painter, whose mood was ebullient, his spirits high with the completion of the project, and it seems probable that Dora Maar was there to welcome the group as well.

Some, particularly those who were seeing the canvas for the first time, were quite stunned the moment they entered the enormous room. The large group immediately fell into a reverential silence, and all paid the work deep attention for

some time. In an attempt to add a bit of theatricality to the occasion, Picasso had returned the several strips of wallpaper to the canvas, as well a bit of toilet paper attached to the hand of the fleeing woman and bits of bright-red paper that formed tears of blood flowing from the eyes of two women and the bull, whose direct gaze at the visitors clearly demanded their concentration. As the group stood motionless, still very moved by the massive work, Picasso approached the canvas repeatedly, each time removing another of the attachments, until at last only a final drop of red blood was anchored to the body of the dead child. As the painter moved to the painting and peeled it away—the canvas now bereft of any colors but black, white, and gray, *Guernica* now complete in every essential way—the group burst into poignant applause.

A lively celebration began not long thereafter, one that lasted well into the afternoon. Picasso smoked and drank with gusto; he accepted individual congratulations from his friends, and he spoke casually about the challenges of the project and his hope that the mural would be an important addition to the pavilion. When fellow Spaniard José Bergamín wondered privately whether one or more of the red tears might well belong in the painting's final form, Picasso embraced him, then quickly had a suggestion for his dear friend: why didn't the two of them save a single tear in a little box, then go to the world's fair every Friday and briefly place it again beneath an eye of the Spanish bull?

Chapter 4

Save Spain!

Paris in 1937 was a city that had seen more halcyon times. The optimism, freedom, and heady abandon of the 1920s long since had been swept away by depression, political disarray, and the undeniable potential for France to return to war. In 1935, economic conditions throughout the country had grown desperate enough that five separate governments had collapsed in the span of fourteen months, and a powerful group of ultraconservative organizations had responded to the instability by taking to the streets in increasingly violent protest. Many in the political center and on the left feared that fascism might take root, even in long-democratic France, if strident voices on the right weren't quickly and powerfully countered. In response to that crescendoing concern, socialists, Communists, and the centrists who called themselves radicals had joined to form the leftist Popular Front in June 1935, and the coalition had begun to sponsor dramatic and often angry demonstrations of its own. By May of 1936, when the Popular Front won parliamentary elections and seized control of the national government, the citizens of Paris had witnessed—or had participated in—at least one major political demonstration each day for more than a thousand days. It had become a "time of hatred"; the

angry rhetoric of the streets heated long-smoldering antagonisms over class and wealth to their flash points, and increasingly Paris and all of *la Firme France* seemed caught in a kind of undeclared and bloodless civil war.

It was in this climate of social chaos, and amidst the apparent rudderless drift of the national government, that a grand international exposition had been proposed. For half a century by now, cities around the world had been increasingly eager to host elaborate world's fairs that nominally encouraged international understanding, but more importantly, were designed to showcase the hosts' cultures, boost their economies, foster tourism, and provide critically needed jobs. All of those aims had seemed worthy and urgently desirable as the exposition's planning had begun in earnest, and by the time the Popular Front was organized in mid-1935, it appeared that the whole of the world was eager to come to Paris's fair.

Forty-four nations accepted invitations to participate in the exposition; the fair's master plan already had been redrawn a dozen times, and its budget tripled by the time the Popular Front assumed power in the spring of 1936. Yet although the fair's success now seemed assured to its organizers, they had begun to fret that France might well be upstaged at its own international show. Germany and the Soviet Union each requested 3,000 square meters of space for pavilions they intended to be massive and captivating symbols of the radically divergent world orders they separately espoused. Renowned architects had begun to design eye-stopping buildings that would attest to each nation's might and the accuracy of its political vision, and the two competing powers appeared determined to do rhetorical battle beside the Seine.

The fair—officially the 1937 International Exposition of Art and Technology Applied to Modern Life—opened on

May 24, three weeks later than planned because a series of strikes had slowed construction dramatically. But at last the vast promenade that linked the Trocadéro Gardens on the right bank of the river with the Eiffel Tower on the left had become a visual feast of fountains, flags, dramatic murals—and architectural competition. As visitors looked down the broad promenade from the Trocadéro's heights toward the tall and elegant tower that had become the city's signature in the years since it was constructed for a similar exposition in 1889, they could not miss the pavilion of the Soviet Union rising high and dominating its surroundings on the right. The building, designed by Russian architect Boris Iofan, rose in a series of steps from an auditorium at its rear to a great three-part tower at its entrance, atop which stood Vera Mukhina's colossal stainless-steel sculpture, almost as high as the tower itself, of two young male and female workers—windblown, proud, and energetic figures who strode forward with hammer and sickle in hand.

Directly across from the Soviet structure, Germany like-wise commanded the left flank of the promenade with an enormous pavilion designed by Hitler's colleague and chief architect Albert Speer, who secretly had become privy to Iofan's plans for the Soviet pavilion before he began his own design. Because "a sculptured pair of triumphant figures [would be] striding toward the German pavilion," Speer ex-plained years later, "I therefore designed a cubic mass, also elevated on stout pillars, which seemed to be checking the onslaught, while from the cornice of my tower an eagle with a swastika in its claws looked down on the Russian sculp-tures." Speer's tower was outlandishly large and even more grossly out of scale with its setting than was the Soviet building across the pedestrian boulevard. Its three stacked-

stone pilasters rose far into the Paris sky, and its entrance was guarded by a sculpture of three nudes whose stance seemed little less than belligerent. The two buildings faced each other down with open and angry contempt—a confrontation the fair's designers intentionally had anticipated, they later admitted—and the militant pair cast an unambiguously political shadow over what otherwise had been designed as an international showcase for cutting-edge technology and the myriad ways in which it improved everyday life. Communists and Fascists were engaged in the bloodiest kind of warfare in Spain as the exhibition opened, but in Paris for the following six months, theirs would be a battle solely of images and symbols and words.

In addition to the forty-four pavilions of participating nations and the numerous French *musées* dedicated to topics ranging from the marvels of aluminum to the invisible magic of radio, a series of major art exhibitions were mounted at venues around the city as cultural adjuncts to the fair. The newly inaugurated Musée d'Art Moderne hosted a mammoth retrospective of French art since the Middle Ages; at the Petit Palais, recent art of a safe and unchallenging sort was highlighted, and the Jeu de Paume in turn sponsored a dramatic survey of recent "independent" and decidedly more controversial art from around the world. The Jeu de Paume show included paintings and sculptures by dozens of cutting-edge artists at work in Paris at the present moment, among them sculptor Julio González and painter Joan Miró— both of whom had been born in Barcelona and whose international renown had grown dramatically in the years since their expatriation to Paris—and, of course, Pablo Picasso, who by now had lived in Paris for more than thirty years and

whom many had begun to consider a French artist. Yet the reality that the three were proud and dedicated sons of Spain soon would become unmistakable to the people of the world who had gathered in Paris—but not until the Pabellón de la República Española at last was ready to open its doors.

Josep Lluis Sert was only thirty-five years old, but already he had become one of Barcelona's most successful architects and planners, and it wasn't surprising that the opportunity to design the Spanish pavilion had gone to him. Sert believed deeply in the ideals of the embattled republic, and as president of Barcelona's Amigos de las artes nuevas— Friends of the New Arts—he also was an energetic champion of the work of his nation's foremost contemporary artists. It was clear to him from the outset of the project that the pavilion would feature powerful and provocative Spanish art, and it was essential to him as well that the building be as modest and unpretentious as the German and Soviet pavilions were grandiose.

Although the pavilions of all other neighboring allies of France were located near the French national pavilion in the shadow of the Eiffel Tower, Spain had been assigned, for reasons that were not made clear, a site immediately adjacent to Albert Speer's massive tower on the right bank of the Seine, a location whose political irony certainly hadn't been lost on the Spaniards exiled in Paris in the aftermath of the Nazis' destruction of Gernika. The Spanish pavilion, which for want of funds had yet to be completed when the fair opened in June, had been largely prefabricated from basic materials in order to further reduce as much as possible

its cost to the republic, whose scarce resources necessarily were desperately needed for food and armaments at the moment. The steel skeleton of the flat-roofed, three-story structure was exposed on its exterior; its walls were covered with plywood, Celotex, and corrugated asbestos. The lower level, partially open to the air, was paved with cement squares, and the upper floors were carpeted with natural straw matting. Sert had selected a color scheme of light grays and tans, complemented occasionally by bloodred and white accents, intended both to further the visual understatement as well as avoid detracting from the artwork and informational displays, which the architect himself had positioned.

It was a measure of the force of Sert's convictions as well that when the pavilion finally was ready to receive visitors on July 12, the workers who had constructed it were invited to a reception where they officially were the first group to view the great pieces of art the architect had collected. As they toured the building, the construction tradesmen—who had been at work on the building only since the end of February—were escorted by Sert's friend Max Aub, the deputy director of the pavilion and an official at the Spanish embassy, a Spaniard who had been born in Paris and whose French remained quite fluent. Aub wanted the men—many of whom had discarded their dungarees in favor of trousers, ties, and coats for the occasion—to know that it seemed "almost impossible in the struggle that we are conducting now, that the Spanish Republic has been able to construct this building. There is in it, as in everything of ours, something of a miracle." And he also wanted the men standing before him to look carefully at the enormous painting by this man called Picasso, one which filled an entire wall of the lower-level portico that served as the building's entry point:

Look at this painting attentively, profoundly; let us not be intimidated by its difficult appearance and extreme colors.... To those who protest saying that things are not thus, one must answer asking if they do not have two eyes to see the terrible reality of Spain. If the picture by Picasso has any defect it is that it is too real, too terribly true, atrociously true. I wish I could make you understand, with this single example, the effort of those who collaborated on this undertaking: the sculptor Alberto, with his magnificent cry of hope that rises at the entrance of the pavilion; Joan Miró with his great, extraordinary, and splendid picture. When they say that these artists work only for the few, tell them that is not true; say that they are Spaniards who express the reality of Spain in their own way and manner.... The Spanish pavilion is honored to have as its first public those who built it, and hopes that your sacrifice and work will not have been in vain, and that the visitors to the exposition will understand our truth. I hope that when it closes its doors, we shall destroy this building with the same joy afforded by our decisive victory over fascism.

Pablo Picasso had personally delivered *Guernica* to the pavilion on a morning at the end of June when painters were putting the final touches on the modest structure. On the cement floor of the open portico, the artist had reassembled the wooden stretcher, then, with the help of several assistants, had unrolled the canvas, stretched it tightly around the wooden bars, secured it with tacks, and at last mounted

it on the wall where Sert believed it would be shown most forcefully and altogether unavoidably, since visitors would have to pass near as they entered and exited the building. The architect and the painter had studied *Guernica* for a long time once it hung on the wall; they had agreed the covered portico was the proper place for it, and speaking in Catalan, Picasso had expressed to Sert his pleasure with what he had done. "He was in love with his picture," Sert would attest ten years later at a symposium at New York City's Museum of Modern Art, "and he really considered it very important and a part of himself."

The next time Picasso returned to the pavilion, two days following the gathering held in honor of the men who had built it, he came to attend the official inauguration of the pavilion and a subsequent reception at which he now was an honoree, together with the other artists whose work lent the pavilion its only measure of true prestige. Beside the steps leading to the building's main entrance now stood Alberto Sánchez's tall and totemic abstract sculpture, which he had titled *The Spanish People Follow a Way That Leads to a Star*, a twisting concrete pillar that to many viewers appeared to be a slender cactus rising out of the Spanish earth. Nearby were Julio González's *Montserrat*—a life-size figure constructed from sheet iron of a proud Catalan peasant pressing a blanketed child to her left shoulder and carrying a sickle in her opposite hand—as well as a cement casting of Picasso's own *Head of Woman*, a bust he had sculpted six years before—a sensuous, even sexual image of a woman's neck and head that bore no direct relation to the pavilion's themes. In the stairwell that connected the portico to the galleries on the upper two floors, Joan Miró had painted a 5-meter-high

mural he called *El Segador, The Reaper*, directly onto the Celotex wall. Titled after "Els Segadors," the Catalan regional anthem, the bold and brightly colored mural reflected the largely abstract and surrealistic style in which Miró currently painted, yet bound within its many indefinable shapes also were vivid images of a sickle, a red star, a raised fist, and the red cap of liberty that had become a potent symbol of freedom as long ago as the French Revolution.

Just as Picasso recently had contributed *Dream and Lie of Franco* to the Republican cause—copies of which now were on sale in the pavilion shop—Miró too had contributed a small poster painted in red, yellow, and blue that depicted a Spanish worker with his fist held high in defiance. *Aidez l'Espagne* it shouted—Save Spain!—and for only one franc, visitors to the pavilion could purchase the Miró reproduction and thereby assist the cause. In his own hand beneath the image, the artist had expressed his view that "in the present battle, I see on the Fascist side ruinous forces; on the other the people, whose immense creative forces will give Spain an élan that will astonish the world."

American Alexander Calder, who had become Miró's close friend in recent years, was the sole non-Spanish artist whose work was shown in the pavilion. His sculpture found a place in the entry portico near *Guernica* only because Josep Lluis Sert abhorred the fountain Republican government officials earlier had hoped he would use, a prizewinner at the 1929 world's fair in Barcelona that recently had been shipped to Paris from Spain. It looked like nothing more than a common drinking fountain, Sert had responded with great dismay when it was removed from its crate, and neither could it accommodate the heavy liquid mercury—from

the renowned Spanish mercury mines at Almadén—that he had envisioned being an integral part of the "water" feature that would anchor the entry to the pavilion.

Miró had suggested that Sert contact Calder—who had lived in Paris since 1929 and whose sympathies with the Spanish Republican cause Miró knew would make him eager to help—to see whether he could envision a dramatic and modern fountain that could make use of liquid mercury. Calder had begun to experiment with sculptures whose component parts could be set in motion by motors, air currents, or moving water, but he had not yet exhibited one. On very short notice he had indeed soon engineered a way for the viscous and shiny metallic liquid to splash down moving chutes and shallow steel bowls into a deep basin. Calder called his creation—the first of the "mobiles" he then would pioneer—*Spanish Mercury from Almadén.*

All the artists who were represented at the pavilion—the four Spaniards plus the expatriate American—were able to attend the pavilion's inauguration, and their presence should have been enough to attract the attention of the city's press, who had become more than a little jaded by mid-July, when the myriad special events associated with the fair had lost their luster. If none of the other artists were household names in Paris as yet, Pablo Picasso certainly was, and surely the city's legion of newspapers would be eager to report on an event at which he would ascertain personally how the world responded to his latest complex and masterful painting. But in fact, hardly anyone was interested, it seemed. The fair was seven weeks old by now, and nothing associated with it was necessarily front-page news any longer. The Spanish pavilion wasn't even listed in most of the official guidebooks

and catalogues of the exposition. Only the Communist-oriented newspaper *L'Humanité* ultimately bothered to mention the opening reception, and then only to list the Soviet diplomats and French Communist Party officials who had attended the fete. It was deeply disheartening to Sert, Aub, and a number of others for the pavilion to open at last to such torpid indifference. They hoped the pavilion would, like Miró's poster, sound the successful cry that Spain needed help in immediate and myriad ways. But already it began to seem that real assistance—the kind that could mean the difference between winning and losing the terrible war—was as rare and hard to hold on to as the mercury that came out of the earth at Almadén.

As visitors did begin to trickle into the Spanish pavilion, and as their numbers inevitably swelled in the weeks that followed, they were greeted by images that both compelled and repelled them, that attempted to lift their hearts with hope for democracy's future as well as shock them into the recognition that the world would lose something critically important if fascism ultimately prevailed in Spain. Picasso's tall, primitive, and iconic sculpture *Woman with a Vase* guarded the southern wall of the pavilion, and as visitors approached the building from the promenade, they immediately were met not only by the Sánchez and González sculptures and the Picasso bust, but also by a bold exhortation in large letters on the building's wall beneath a huge photomural of ranks of Republican soldiers:

> We are fighting for the essential unity of Spain. We are fighting for the integrity of Spanish territory.

We are fighting for the independence of our country and for the right of the Spanish people to determine their own destiny.

Once inside the open courtyard, Calder's fountain and the sensuous movement of mercury commanded immediate attention. At either end of the long and otherwise empty space were *Guernica* on the right, and on the left an enormous photograph of a man of friendly countenance and engaging eyes, beneath which were posted the words FEDERICO GARCÍA LORCA, POET KILLED AT GRANADA. Beyond the portico lay a large open-air patio, over which canvas awnings could be pulled on rainy days, leading finally to a small stage and projection booth where visitors could see, if they chose to tarry a while, three films that ran in constant succession—*Spanish Earth* by Dutch filmmaker Joris Evens and American novelist Ernest Hemingway, *Madrid '36* by the Spanish director Luis Buñuel, and *The Heart of Spain* by American photographer Paul Strand—each one a documentary on the larger injustices and daily horrors of the Spanish war.

Near the stage, a long and curving ramp conveyed visitors to the top floor of the boxy main building, where three more busts by Picasso were on display, as was a photograph of the ruins of the town of Gernika accompanied by the French text of Paul Eluard's new poem, *"La victorie de Guernica,"* in which the poet assured the victims of the attack that "your deaths will serve as warning" to the world of what Hitler's war machine was capable. The exhibition space of the mid-level gallery was devoted to displays that chronicled the republic's strides toward educational and social reform, and visitors to those exhibits tended to be caught off guard by the intensity of color in Miró's mural—which filled the

stairwell connecting the three levels—and its sharp contrast with the somber presentations. Depending on the day of their visit, people from France and elsewhere in Europe—and even a few Americans who had come to the continent to experience the fair—were treated to flamenco, lace-tatting, and cooking demonstrations, as well as decidedly more somber lectures, all of which were conducted at varying locations around the portico, patio, stage, and galleries.

There certainly was no common response to the Spanish pavilion—so earnest, proletarian, and rather inadequately small-of-scale in comparison with the majority of buildings contributed by other nations. It was the kind of place of which French painter Amadée Ozenfant, a frequent Picasso critic, could nonetheless note, as if composing a letter, "Sunday. I am writing at a little table in the Catalan café of the Spanish pavilion. Sorrowful. The exhibition of Spanish sorrow. Beneath a poignant photograph of orphans one reads: *Their parents were all they had had in the world . . . and suffering has made their expressions as profound as those of grown men.*

> The huge *Guernica* by the great Spanish painter is before me. . . . *Guernica* makes one *feel* the frightful drama of a great people abandoned to medieval tyrants, and makes one *think* about that drama. The master has used only those means that properly belong to the visual arts, and yet he had made the whole world understand the immense Spanish tragedy—if people have the eyes to see.

> Here's proof: A chic young woman goes past my table; she's come down from the second floor where

there are exhibitions of Spanish war photographs: one sees children massacred by Christians and Franco's Moors. The woman says to her daughter: "That's all terrifying! It sends shivers down my spine as if I had a spider running down my neck." She looks at *Guernica* and says to her child, "I don't understand what is going on there, but it makes me feel awful. It's strange, it really makes me feel as if I were being chopped to pieces. Come on, let's go. War is a terrible thing! Poor Spain!" And dragging her kid by the hand, she goes off, uncertain, into the crowd.

In bloody Spain, the city of Bilbao had continued to resist Franco's rebels in the weeks after the Nazis' destruction of Gernika. For months, as many as 15,000 men had worked to surround the city with more than 120 miles of trenches, forest clear-cuts, and barbed-wire fences aimed at keeping the invading army at bay. Supplies had grown so scarce that imported Mexican garbanzo beans, which were stockpiled in the city, and unlucky domestic cats had become the sole dependable food. The city had grown clogged with refugees from Gernika, Durango, Eibar, and other inland towns that had been heavily bombed. Tens of thousands of Basques already had struggled to find ways to flee to France, Belgium, Denmark, Switzerland, Mexico, and the Soviet Union, where refugees had been welcomed in varying numbers, and the British Royal Navy had assisted in the evacuation of 4,000 Basque children to a refugee camp in England. But after three months of assault, the poorly supplied and outnumbered Basque army at last had retreated west into the province of Asturias, and Franco had seized Bilbao on June 19. The rebel

offensive that had begun on March 31 had required eighty days in which to claim a mere twenty-five miles of Bizkaia territory, but now the government of José Antonio Aguirre was forced to flee into exile to Biarritz across the French border.

Although Franco and his subordinates still claimed in press releases and radio pronouncements that there had been no bombing of Gernika at all, the power of public outrage around the world already had led the rebels to create the beginnings of a paper trail that would accurately lay the blame for the bombing squarely on the Nazis' shoulders. From Salamanca, where Franco's government was headquartered, came the private admission—in a secret telegram cabled to the Condor Legion's commander Sperrle—that in Gernika some weeks before "units from our front line [had] asked the [German] air force to bomb the crossroads. Because of bad visibility, the Germans and Italians responding to the request dropped the bombs on the village."

On June 19, a week after Picasso's *Guernica* began to be seen by the fair-going public in Paris, the town of Gernika had remained a twisted, heaped, and rain-soaked waste— one inhabited only by battle-weary rebel soldiers and a legion of homeless dogs—and in Munich, Hitler had issued a virulent manifesto in opposition to all nontraditional modern art, work the führer labeled "degenerate, Bolshevik, and Jewish art." The speech had marked the opening of Munich's Haus der deutschen Kunst, whose inaugural exhibition featured nineteenth-century German masters as well as the work of state-sanctioned Nazi-propagandist painters. In a cynical "Degenerate Art Exhibition" held in one of the new museum's adjacent minor galleries, the work of Germany's truly significant modern artists was haphazardly displayed alongside drawings and paintings made by inmates at

a nearby asylum for the insane, and the Nazi press took venomous delight in assuring readers that it was impossible to determine whose work was whose. And in Paris late in July, the updated official German guidebook to the world's fair incorporated Hitler's recent pronouncements on modern art with the suggestion that German-speaking visitors simply pass by the pavilion of "Red" Spain because it contained nothing of interest or importance, least of all a mammoth black-and-white painting that seemed to be the dream of a madman, a melee of broken bodies that might have been the work of a four-year-old child.

Strangely, the response to *Guernica* from some quarters in Paris was almost as dismissive as the reaction of the Nazis whose bombs had triggered the painting's creation. Yet because of Picasso's renown, criticism most often was expressed with silence and the specter of utter disinterest rather than with words. Although pavilion architect Sert was a passionate supporter of the painting, he would later explain that a number of Spanish embassy and pavilion officials privately and very vocally had argued with him that the mural did not visually address the crescendoing crisis in Spain, nor did it directly and accurately blame the Nazis for their deplorable crimes.

As it was nearing completion on May 28, Picasso reluctantly had accepted 150,000 francs from Max Aub on behalf of the Republic of Spain as payment for *Guernica*. He had wanted to make the mural simply a donation to the national cause, yet Aub had insisted that at least he should allow the republic to pay for his materials—the cost of which were not insubstantial but which were certainly less than the approximately 6,000 dollars the painter ultimately had accepted,

an amount that, at the time, represented the largest sum Picasso ever had been paid for a painting. But because *Guernica* now belonged to the people of Spain, a number of officials at the embassy privately argued, the painting could be shown—or not—in any manner they chose. The Spanish pavilion was in no way *required* to keep the painting on display, and several key people urged that *Guernica* be replaced by an artwork that made a stronger statement about the terrible truths of the Spanish war.

Even *L'Humanité*, the only Paris newspaper that had paid immediate and ongoing attention to the brutal Basque campaign of the Spanish rebels and the bombing of Gernika by the Germans, found nothing to say about the painting in its coverage of the opening of the Spanish pavilion, and it wasn't until July 31 that the paper finally included in its arts section a small photograph of the painting accompanied only by a brief, identifying caption. The continuing silence in the press and the apparent disinterest in the painting on the part of precisely those who might have been expected to applaud its exhibition began to grow loud with implied objection. But still, no one would state publicly that the mural ought to be removed from the building until finally, Picasso's friend, the journalist Luis Aragon—who had written in opposition to the bombing itself but who hated the painting—was at least bold enough to assert that, mindful of the theme of the exposition, the Spanish pavilion should include only work created by "engineers of the soul" who understood art's obligation to be politically instructive. Yet Aragon wasn't daring enough to suggest which paintings or sculptures on display at the pavilion represented, in fact, the kind of "palliative" for the wealthy to which he so strenuously objected.

It wasn't until December, following the close of the fair,

that Le Corbusier, the renowned French architect and one of the exposition's key planners, at last went on record in open disapproval of the painting, yet he objected to it not because it lacked propagandistic directness, not because it failed to engineer a particular point of view, but because it wasn't pretty. While many of the fair's muralists—painters such as Raoul Dufy, Robert Delaunay, and Fernand Léger—had created stirring scenes without forgetting the eternal importance of *la belle peinture*, the beautiful picture, Picasso's mural, on the other hand, was ugly and off-putting. "*Guernica* saw only the backs of our visitors," he wrote, "for they were repelled by it."

Picasso had left Paris soon after the opening of the pavilion, although rumors about objections to the painting on both political and esthetic grounds by now had reached him in the village of Mougins near Cannes on the Riviera, where he had gone with Dora Maar for his summer holiday. When he had been interviewed by journalist Georges Sadoul for *Regards* magazine prior to his departure from the city, Picasso had declined to discuss its composition, symbolism, or the process through which it had reached it final form. Instead he had spoken only of the fall of Bilbao to the rebels and the plight of the Basque refugees. He had expressed pride in his role in protecting the Prado masterpieces six months before, but had downplayed his honorary position as director of the great museum, insisting that "the true conservators of the Prado cannot be the artists but rather those in the day-by-day reality, the tank crews, the aviators, all the soldiers of the popular army who fight for Madrid." As he had hung *Guernica*, he had attempted to link the painting directly to the fight for freedom in Spain, but now, he increasingly

understood, many fellow partisans of the republic believed that Picasso himself had fought poorly on its behalf.

While it's certain that Picasso discussed the negative reactions to *Guernica* over long, sun-soaked lunches with his friends Paul Eluard, Roland Penrose, Christian Zervos, and their spouses—all of whom were ensconced in the Hôtel Vaste Horizon in Mougins at the time—it's unclear whether it was those conversations, in fact, that prompted Zervos, founder a decade before of the widely influential contemporary art journal *Les Cahiers d'Art*, to return to Paris and quickly counter the grumbling criticism in a late-summer double-issue of the magazine devoted almost entirely to *Guernica*.

Filled with high-quality reproductions of many of the studies that had preceded the painting, Dora Maar's ten documentary photographs of the painting in progress, her informal images of the painter at work—as well as a two-page reproduction of the monumental *Guernica* itself—the issue also included a series of essays by writers and intellectuals who were convinced that far from being disappointing, Picasso's mural was something profound. In his own introductory article, Zervos himself asserted unequivocally that *Guernica* "is undoubtedly the artist's most humane, most stirring work."

> In *Guernica*, expressed in the most striking manner, is a world of despair, where death is everywhere; everywhere is crime, chaos, and desolation; disaster more violent than lightning, flood, hurricane, for everything there is hostile, uncontrollable, beyond understanding, whence rise the heart-rending cries of beings dying because of men's cruelty. From Picasso's paintbrush explode phantoms of distress, an-

guish, terror, insurmountable pain, massacres, and finally the peace found in death. . . . This work will forever enter our hearts, will inspire, stir up feelings, and arouse our convictions that there are greater things than "reality," and that to participate in their grandeur is to rise again in dignity.

Art critic Jean Cassou, a Spaniard who was a regular contributor to Les Cahiers d'Art, saw in the painting something that made it perhaps the most Spanish artwork he ever had seen:

> Goya is brought back to life as Picasso; but at the same time, Picasso has been reborn as Picasso. It has been the immense ambition of this genius to keep himself forever apart, denying his own being, making himself live and carry on outside his own realm—like a ghost frenzied to see his vacant home, his lost body. The home has been found again, both body and soul; everything that calls itself Goya, that calls itself Spain, has been reintegrated. Picasso has been reunited with his homeland.

Similarly, Spanish poet José Bergamín expressed his fervent belief that Guernica at once reflected and embodied something quintessential in his nation's character: "Spanish fury. It contains, limits, determines, expresses it. . . . Picasso paints veraciously, he paints the truth. Real things, obvious things, the way they are. The truth about things. That's why this painting is not only true as painting, it is true as history, truer than history."

Yet it was the distinguished ethnographer and surrealistic

poet Michel Leiris who understood that something stunning, something ominous in the painting made it a document every bit as much of the future as of the past. "On a black and white canvas that depicts ancient tragedy," he wrote, "Picasso also writes our letter of doom: all that we love is going to be lost, and that is why it is necessary that we gather up all that we love, like the emotion of great farewells, in something of unforgettable beauty." It was a warning that was chillingly prescient, particularly given the fact that Leiris wrote at a time when more than two years remained before the Nazis invaded Poland, then the Low Countries and France, before the world went to war again and the ovens began to burn.

In the months since Bilbao had fallen to Franco, his rebel minions had arrested 16,000 Basque civilians, their activism in José Antonio Aguirre's Basque Nationalist Party their sole crimes. By now already a thousand of those prisoners had been executed. As the city fell, the Basque army retreated west into Asturias and continued to fight despite a dearth of supplies of every kind and the crushing apprehension that the war in the north was lost. From Rome, Benito Mussolini helped bring an end to the fighting on the northern front by winning Franco's public assurance that surrendering Basque soldiers would be handed over to Italian forces and would not risk reprisals from Franco's own troops. On August 26, two thousand Basque troops formally laid down their arms and were escorted aboard two British ships in the harbor of the town of Santoña that had agreed to ferry them to safe exile in France. But before the ships could sail the following day, the Italians reneged, because Franco's rage

had caused him to change his mind. The caudillo simply could not allow Basque soldiers—some of whom had killed *his* soldiers—to escape unpunished. The Basques were forced to disembark from the ships and were forcibly marched to the rebel-held prison at Dueso, where almost all were summarily tried and executed, the "detergent of blood" cleansing once-pure Spain in the process, Franco later declared.

Although the date wasn't recorded, it likely was on very nearly the same day that Aguirre and the members of his cabinet—the government currently operating in exile in the city of Biarritz, just beyond the French border—visited the Spanish pavilion at the Paris world's fair and were photographed in front of Picasso's *Guernica*. Aguirre and his colleagues had gone to the French capital to attempt, once more, to muster alarm that France soon might have *three* Fascist states on its borders, and to plea for continued assistance for the thousands of Basque refugees who each day were fleeing into the country for safety. The politicians' visit to the pavilion was brief; it wasn't heralded in any way by Spanish officials in Paris, and the photograph, taken by an embassy photographer, was simply made as a kind of memento. But there was something haunting in it nonetheless. The nine men, each one impeccably dressed in a double-breasted suit and dark tie, standing in a casual line in front of the massive mural, cigarettes held in the strong hands of Aguirre and two more men, other hands stuffed into pockets, the expressions on the men's faces etched with resignation rather than rage, with deep and enveloping sadness now rather than fury.

Pablo Picasso returned to Paris a month later, having spent the whole of his summer hiatus with Dora Maar and friends in Mougins, where he had indulged his passion for

the beach and the sun and lingering, bacchanalian midday meals, the women often dining bare-breasted to perfect the scenes of sybaritic paradise that gave the painter such pleasure. Although the sea often had been his artistic inspiration—as had the faces and fascinating bodies of Nusch Eluard, British photographer Lee Miller, and, of course, Dora—Picasso had been unable to shed from his mind images of *Guernica* as he painted and drew during the holiday. From the time he had completed the mural until well into the autumn, in fact, he had created two dozen drawings, etchings, and paintings in which grieving, horror-stricken women had reappeared, often bearing dead children in their arms. The image of the suffering Madonna, lamenting the death of her son, Jesus, was one with which every Spaniard was visually fluent, of course, but these weeping women—most of whom unmistakably claimed Dora's face—seemed to spring without question from the intensity of the artist's focus on the collective images that had composed *Guernica*, and perhaps rather specifically even on the suffering of the women in its namesake town, suffering that continued daily throughout war-divided Spain.

It was a war whose fortunes were growing increasingly poor for the Republican government and its fighting forces. With the Republican surrender of the Asturian port city of Gijón in October, the rebels now controlled every square kilometer of northern Spain. Their comparable successes in Castile meant that Madrid was increasingly isolated and vulnerable, and while German and Italian aid to the rebels continued to increase, the Soviet Union's military support for the republic lately had been scaled back dramatically. In October, morale dropped to its lowest ebb to date—inside Spain and among the republic's defenders around the world

as well—when Great Britain, Europe's most stable democracy, officially abandoned Spain's six-year-old experiment in popular rule and recognized Francisco Franco as the nation's legitimate leader and the city of Salamanca as its temporary capital and the place to which the British embassy now would move. It was a crushing blow to the hope that fascism might, in fact, be halted in Spain before it spread its talons throughout the continent, and Britain's decision strangely allied it now with both Germany and Italy in the fight against freedom in Spain.

A few weeks following Great Britain's recognition of the Franco government, the *New York Times* published a statement from Picasso in which he expanded on comments he had made earlier in the year to a group of painters and art historians known as the American Artists Congress in defense of claims from across the Atlantic that the Spanish Republican government had allowed his nation's art treasures to be destroyed. And it was a false claim, of course. The Prado's masterpieces were safe in Geneva at the moment, and Picasso bristled at mounting criticism leveled at him from both the right and the left, from Frenchmen, Spaniards, and now from Americans, it seemed. Spain's great artistic legacy was not in jeopardy, he explained, nor were Spain's contemporary painters ignorant of the explosive climate in which they chose to continue to apply paint to canvas. "It is my wish at this time to remind you," he concluded,

> that I have always believed, and still believe, that artists who live and work with spiritual values cannot and should not remain indifferent to a conflict in which the highest values of humanity and civilization are at stake. . . . No one can deny the

vitality and the youth that the current struggle will bring to Spanish art. Something new and strong, which consciousness of this epic will sow in the soul of Spanish artists, undoubtedly will appear in their works. The contribution of the purest values to art will be one of the greatest conquests of the Spanish people.

Paris's grand exposition—on whose stage Europe's political struggles had played out rhetorically over the preceding six months—officially closed on November 25. Thirty-three million people had toured the fair during that time, marveling at the technological wonders of the modern world, and noting, if they cared to, that that world was in danger of flaring once more into war. During the five months it had received visitors—their numbers only a fraction of the fair's total attendance—the Spanish pavilion had all-too-eloquently affirmed that contemporary Spain was a place that spawned both beauty and horror, but now it appeared that even this simple opportunity for the country's embattled democrats to reach out to the rest of the world was ended. Fair officials, delighted with its great success, briefly had considered reopening the exposition the following spring, but logistical, financial, and political considerations led them by Christmastime to announce that the closure was permanent.

As the Spanish pavilion was dismantled, posters, photographs, displays, and much of the art that had been exhibited was packed and shipped by sea to Valencia. But the Republican government by now had fled once more—this time to a safer haven in Barcelona—and in the chaotic effort to prepare both cities for defense against Franco's rebels, almost all of the material was lost, including Joan Miró's

marvelous mural that painstakingly had been removed from the wall to which it was anchored, and Alberto Sánchez's monolithic pillar that had spoken symbolically of the Spanish people's embattled determination to reach the stars. For reasons that remain unclear, however—and despite the fact that the Spanish Republic had purchased Picasso's *Guernica* for a sizable sum—*Guernica* was not included among the items shipped to Spain. Instead, the massive canvas had been removed from its wooden stretcher, then rolled, and returned to the room at No. 7 rue des Grands-Augustins where it had come to artistic life. For reasons that remain a mystery more than half a century after the close of the Paris world's fair, more than six decades following the bitter conclusion of Picasso's war, *Guernica* did not go to Spain that season, then disappear forever.

A Wearable Pair of Boots

The walls of the Spanish pavilion of the Paris world's fair had yet to be dismantled in January 1938—and the town of Gernika remained in rubble—when Pablo Picasso agreed that the great mural could join work by three other artists in a tour of four Scandinavian cities. It was a clear indication of how the artist had begun to be labeled worldwide that he was included in an exhibition of work by the four foremost "French" artists of the day—Georges Braque, Henri Laurens, Henri Matisse, and himself—and characteristically, Picasso, the fiercely proud Spanish patriot, also appreciated the acknowledgment of his secondary nationality implicit in his inclusion in the show. Opening at the Kunstnernes Hus in Oslo, the collection of 118 paintings traveled on to the Statens Museum for Kunst in Copenhagen, the Liljevalchs Konsthall in Stockholm, and the Konstallen in Göteborg before returning to Paris in April. Unlike its reception in France during the preceding summer and fall—during which time *Guernica* at once captivated and troubled viewers and critics alike—*Guernica* was singled out for neither praise nor scorn during its months in Scandinavia, perhaps because the war in Spain and the cancerous spread of fascism still remained relatively minor concerns in Europe's frozen and dis-

tant north, but also because, as it was displayed alongside many dozens of other fine and challenging paintings, *Guernica* left the muddy arena of contemporary politics and propaganda and rather comfortably entered the rarified realm of art.

Although Picasso had confessed to Spanish pavilion architect Josep Lluis Sert that he hoped his *Guernica* one day would be housed in Madrid, it made little sense to try to install the painting in the Spanish national capital in the present moment, and so a second time he simply took possession of the great canvas on its return from Göteborg, and it remained rolled and stored in his studio in the rue des Grands-Augustins for five more months. *Guernica* had escaped the fate of Joan Miró's pavilion mural, the same ignominious end as Alberto Sánchez's sculpture, but how its future *would* unfold remained very unclear that spring. Its imposing size made its shipment and installation a challenging enterprise, and although it had been received in Norway, Denmark, and Sweden as a legitimate and important work of art, in other settings it still would be considered little more than an extravagant poster—a piece of visual propaganda not unlike the photomural of Republican soldiers that had hung on the exterior wall of the Spanish pavilion. Yes, *Guernica* belonged to the people of Spain, but no one—certainly not the storied artist who painted it—understood at the moment precisely how the painting could serve them best in the future.

Francisco Franco's rebel army now controlled all of western and northern Spain, and although it still had yet to capture Madrid, the capital city was surrounded on three sides by the insurgents. The Republican government had fled once more—this time to the presumed haven of Barcelona—and it struggled desperately to find the means to successfully

sustain its defense. Spirits had soared early in February when the Republican army—with vital assistance from soldiers of the International Brigades—was able to regain control of the city of Teruel in Aragón, but the victory proved only temporary and the rebels recaptured the city on February 22. On March 16—four days following the Nazi invasion and annexation of Austria—German and Italian bombers began three days of relentless shelling of Barcelona, the invading air forces dropping their payloads throughout Catalunya's capital city, killing 1,300 people and wounding 2,000 more. When news of the bombing reached Paris, Picasso was devastated. "All the barrios in the city have been hit," he told his friends José Bergamín, the Spanish poet, and French novelist André Malraux. "My mother is perhaps dead. My loved ones are perhaps dead."

Although his family did survive the bombing of the city he considered his true home, its psychological effect on Picasso was profound. Long filled with a primal dread of disaster coming from out of the sky—as it had in Gernika, as it lately had in his beloved Barcelona, as it would one day in Paris, he believed—Picasso wrote a series of fear-racked poems in which he pleaded for others to "listen in the distance in the country to the cries of three little girls attacked by vipers," vipers who flew in the "mathematical square of the air [where] the sun hidden in a block of ice is crushed on the sky by the cries of pain," poems in which he implored the enemy sky to surrender its "violent violet" and assume instead the clarity of a compassionate blue. And he responded to the destruction and death in Barcelona with his financial largesse as well: he donated the sum of 150,000 French francs he had received in payment for *Guernica* to the Spanish Refugee Relief Campaign, the same organization to which

proceeds from the sales of *Dream and Lie of Franco* had gone; he supplied milk to needy children in Barcelona, helped fund a hospital for Spanish refugees in the French city of Toulouse, privately offered monetary assistance to friends and strangers alike, and he eagerly assented when plans were presented to him for a series of fund-raising exhibitions of *Guernica* in Great Britain.

In late September 1938, Picasso personally shipped the mural and many of its preparatory drawings—none of which had been exhibited until now—across the English Channel to the National Joint Committee for Spanish Relief in London, which had arranged a three-week show at a prestigious Regent Street gallery, all of whose proceeds would be sent directly to Spain. During its October 4–29 residency beneath the New Burlington Galleries' vaulted and skylighted ceiling, three thousand Londoners saw the celebrated painting that many of them had begun to hear about more than a year before, together with two dozen of the sketches and drawings that had preceded it. Exhibition patrons included numerous members of parliament from the Labour Party as well as writers E.M. Forster and Virginia Woolf, and it probably was inevitable that their financial support for bringing the painting to Britain, as well as for the Republican cause in Spain, would quickly elicit the ire of both the conservative right and the Marxist left.

Writing in the *Spectator*, critic Roger Hinks entirely ignored the painting's political implications, yet he could not be silent about his objections to Picasso's having "introduced all sorts of intellectual puzzles and period oddities into a work which ought to make a frontal attack on the emotions." Art historian Anthony Blunt, on the other hand—still four decades away from the day when his espionage for

the Soviet Union at last would be made public—ridiculed
Picasso for having lived his life in an ivory tower, a "Holy of
Holies of Art," that made it impossible for him to under-
stand the true complexities of the Spanish war. In an article
titled "Picasso Unfrocked," which appeared in the *Spectator*
as well, Blunt charged that the painting was nothing more
than a series of "abstruse circumlocutions" with no meaning
whatsoever for serious observers of art *or* politics. Neither
should the painter, Blunt instructed, produce work that was
too esoteric for ordinary people to decipher or enjoy. "In the
religious half light of the temple [of art] Picasso looked like a
giant. Now, in a harsher glare, and up against more exacting
standards, he appears a pygmy."

Herbert Read, a curator at the Victoria and Albert Mu-
seum and editor of *Burlington Magazine*—and a regular lunch
companion of Blunt's at London's Reform Club—was none-
theless quick to respond to his friend's attack, but he did so
in the pages of the *London Bulletin*, where he labeled Blunt
as one of those "middle-class doctrinaires who wish to use
art for the propagation of their dull ideas." The kind of socio-
political grandeur that Blunt believed *Guernica* lacked was
currently impossible to achieve, Read countered. "The monu-
mentality of Michelangelo and the High Renaissance cannot
exist in our age, for ours is one of disillusionment, despair,
and destruction. *Guernica* is a monument to destruction—a
cry of outrage and horror amplified by the spirit of genius.

> Not only Gernika, but Spain; not only Spain, but
> Europe, is symbolized in this allegory. It is the mod-
> ern Calvary, the agony in the bomb-shattered ruins
> of human tenderness and frailty. It is a religious pic-
> ture, painted, not with the same kind, but with the

same degree of fervor that inspired Grünewald and
the master of the Avignon Pietá, Van Eyck, and
Bellini. It is not sufficient to compare the Picasso of
this painting with the Goya of the "Desastres."
Goya, too, was a great artist, and a great humanist;
but his reactions were individualistic—his instru-
ments irony, satire, ridicule. Picasso is more univer-
sal. His symbols are banal, like the symbols of Homer,
Dante, Cervantes. For it is only when the widest
commonplace is infused with the intensest passion
that a great work of art, transcending all schools and
categories, is born; and being born, lives immortally.

Immediately following the New Burlington show, *Guer-
nica* and the drawings were moved to the Whitechapel Art
Gallery in London's East End, where twelve thousand peo-
ple attended an exhibition that had been hastily arranged at
the request of Labour Party leader Clement Attlee, who had
toured Republican Spain the previous December. His party's
head since 1935, Attlee had steered Labour toward resis-
tance to Fascist aggression on the continent, but the party
remained reluctant to support British rearmament. Although
he long had been uneasy with the Tory government's official
neutrality in the Spanish conflict, Attlee's visit to Spain had
transformed him into something of an antifascist zealot, one
eager to see Britain join the fray on the republic's behalf. At
a dinner in Barcelona with soldiers of the British Battalion
of the International Brigades, Attlee had promised to do his
utmost at home to end "the farce of non-intervention," and,
in turn, the battalion's first company had renamed itself the
Major Attlee Company. "I would assure the brigade of our
admiration for their courage and devotion to the cause of

freedom and social justice," he had proclaimed to the British volunteers. "I shall tell the comrades at home of what I have seen. Workers of the world unite!"

Although his rhetoric at the official opening of the Whitechapel exhibit lacked the collectivist flair he exhibited in Spain, Attlee did extol the accomplishments and visions of Spain's Republican government before a largely working-class audience, and he warned those to whom he spoke that the nightmare contained in the painting hanging behind him was an example of what the Fascists in Germany and Italy planned to unleash on all of Europe. Unlike the New Burlington exhibition, to which an entrance fee had been charged as a means of raising funds for Spain, visitors to the Whitechapel exhibit were admitted only if they brought with them a wearable pair of boots for donation to desperately needy Republican soldiers. Each pair of proffered boots was placed on the Whitechapel floor beneath the enormous canvas and the collection of boots grew into the thousands by the time *Guernica* came down and the boots were crated and shipped to Spain.

Poet Stephen Spender, who had been deeply influenced by the work of Federico García Lorca and who himself recently had returned from imperiled Madrid, defended *Guernica* before its London tour ended against continuing criticism that it was visually explosive—little more than a cacophony of disconnected images. "*Guernica* affects one as an explosion, partly no doubt because it is a picture of an explosion," Spender wrote in the *New Statesman and Nation*.

> So long as a work of art has this explosive quality of newness, it is impossible to relate it to the past.

People who say that it is eccentric, or that it falls
between two stools, or that it is too horrible, and so
on, are only making the gasping noises they might
make if they were blown off their feet by a high-
explosive bomb. . . . *Guernica* is in no sense report-
age; it is not a picture of horror which Picasso has
seen and been through himself. It is the picture of a
horror reported in the newspapers, of which he has
read accounts and perhaps seen photographs. This
kind of second-hand experience, from the news-
papers, the news-reel, the wireless, is one of the
dominating realties of our time. The many people
who are not in direct contact with the disasters
falling on civilization live in a waking nightmare of
second-hand experiences which in a way are more
terrible than real experiences because the person
overtaken by a disaster has at least a more limited
vision than the camera's wide, cold, recording eye,
and at least has no opportunity to imagine horrors
worse than what he is seeing and experiencing. . . .
The impression made on me by the picture is one
that I might equally get from a great masterpiece,
or some very vivid experience. That, of course,
does not mean that it is a masterpiece. I shall be
content to wait some years before knowing that.

Although many people by now had championed the
emotive power and social significance of the vast canvas,
Spender was the first to suggest that it might be a "master-
piece." But paintings that by consensus *are* masterpieces sel-
dom go into storage, and that was *Guernica*'s fate come the

close of the Whitechapel show, at a time when it seemed increasingly likely that the Spanish Republic was living its last desperate days.

The Munich accord—ratified at the end of September between the leaders of Germany, Italy, Great Britain, and France—had sanctioned the seizure of key territory in Czechoslovakia by the Nazis in return for Hitler's hollow assurance that he intended no more aggression elsewhere in Europe. At the same time, Spanish Prime Minister Juan Negrín had announced at the League of Nations in Geneva the unilateral withdrawal from Spain of the International Brigades that had fought successfully for the republic—the move made in the hope that Europe's powers at last would adopt true positions of nonintervention and that Germany and Italy would begin withdrawing their forces from Spain as well, just as the Soviet Union recently had begun to do. On November 1, the thousands of volunteer soldiers from around the world who remained alive and committed to the Republican cause were honored in Barcelona with a farewell parade at which Negrín offered the thanks of a grateful, if nearly defeated nation. But his words were overshadowed by those of a Basque member of the Republican parliament, a sloe-eyed, strong-nosed, and diminutive former sardine seller named Dolores Ibarruri, whose bold and stirring speeches throughout the war had won her the sobriquet *La Pasionaria*. "A feeling of sorrow, an infinite grief catches our throat— sorrow for those who are going away, for the soldiers of the highest ideal of human redemption, exiles from their countries, persecuted by the tyrants of all peoples—grief for those who will stay here forever mingled with the Spanish soil," she intoned before an enormous and deeply emotional crowd, her words spoken into a crackling microphone:

. . . From all peoples, from all races, you came to us like brothers, like sons of immortal Spain; and in the hardest days of the war, when the capital of the Spanish Republic was threatened, it was you, gallant comrades of the International Brigades, who helped save the city with your fighting enthusiasm, your heroism and your spirit of sacrifice. . . .

Mothers! Women! When the years pass by and the wounds of war are stanched; when the memory of the sad and bloody days dissipates in a present of liberty, peace, and well being; when the rancors have died out and pride in a free country is felt equally by all Spaniards, speak to your children. Tell them of these men of the International Brigades. . . . They gave up everything—their loves, their countries, home and fortune, fathers, mothers, wives, brothers, sisters, and children—and they came and said to us: "We are here. Your cause, Spain's cause, is ours. It is the cause of all advanced and progressive mankind. . . ."

Comrades: political reasons, reasons of state, the welfare of that very cause for which you offered your blood with boundless generosity, are sending you back, some to your own countries and others to forced exile. You can go proudly. You are history. You are legend. . . . We shall not forget you; and, when the olive tree of peace is in flower, entwined with the victory laurels of the Republic of Spain—return!

Later that afternoon, the first of 4,600 international soldiers boarded boats in Barcelona's harbor bound for France, and the following day the newly emboldened rebel army—its German and Italian air support buttressed by recently arrived planes and munitions—began to drive toward the Ebro River and its goal of the taking of Catalunya, the last true stronghold of the republic. By November 9—the date of the maniacal destruction throughout Germany of Jewish homes, businesses, and synagogues that became known as *Kristallnacht*—relentless bombing by the Nazi Condor Legion had sent the Republican army into retreat across the Ebro, and Catalunya now seemed certain to fall.

Battle-beaten Republican soldiers were rationed only a few grams of bread and meat each day, and army commander-in-chief Hernández Saravia warned President Manuel Azaña that he had only 17,000 rifles with which he could supply his troops in Catalunya's defense. The well-supplied rebel army, in contrast, was supported not only by German bombers in the smoky skies overhead, but also by Italian mobile divisions that advanced over the ground with blistering speed. By Christmastime, both sides agreed—one exultantly, the other with tragic resignation—that Catalunya and its capital city, Barcelona, would belong to the rebels well before winter gave way to spring.

War-weary, world-weary Maria Picasso y López died at age eighty-two in her apartment in Barcelona on January 13, 1939, as German bombers pounded the city's harbor, their targets not vessels attempting to resupply the desperate Republicans—there were no such ships—but rather a fleet of small boats crowding the port to receive residents of the city who were increasingly desperate to get away. "Enormous disaster. The army has disappeared," President Manuel Azaña

scribbled in his personal diary as rebel troops took command of the summits of Mount Tibidabo and Montjuich at the entrances to the city, and resistance to Barcelona's occupation was so scant that atop the first rebel tank to rumble into Plaça Catalunya in the heart of the city on January 25 sat a young German woman, recently freed from a Republican prison, who laughed mockingly at the few people brave enough to be in the streets, her arm held high in the Fascist salute.

People were desperate to flee as Barcelona fell, Angel Vilalta explained. For days, armed Falangists—Spanish Fascists who theretofore had suffered at the hands of the Communists, syndicalists, and anarchists who had loosely controlled the city—roamed Barcelona bent on retribution, killing as many as 10,000 people, some of their victims zealously pro-Republican and viciously violent themselves, others simply citizens unlucky enough to be crossing the wrong *plaça* at the wrong moment. Immediately, Republican posters and painted slogans were washed from walls, books were burned, and the clenched-fist salutation of Republican solidarity was forcibly replaced by the stiff-armed, open-palmed Fascist salute. Catalan autonomy was immediately rescinded; the simple and communal—and utterly harmless—regional dance called the *sardana* was expressly forbidden, and the Catalan language was summarily banned. Whether in schools, churches, shops, or in homes, only "*cristiano*"—Christian, meaning Spanish—could be spoken henceforth. Barcelona and all of Catalunya would be "purified," according to Álvarez Arenas, the new military governor of the city, and hundreds of thousands of Catalan patriots now struggled to find ways to abandon their homeland.

France was the nearest haven, and likely the safest as well,

and for weeks people streamed north toward the border—a
serpentine line following the ridgelines between summits
high in the Pyrenees. Angel first described that exodus on a
warm Saturday evening sometime in the spring of 1969 in
the old stone farmhouse in the hamlet of Dorria he and his
brother Carlos had renovated into a mountain retreat, the
house itself less than a kilometer from France. We had gone—
five of us high-schoolers—to Dorria as Angel's guests, and
we spent much of that Saturday night in eager conversation
about the madness of the war in Vietnam and the new reign
of Richard Nixon. We drank red wine from a Catalan *por-
rón*, deconstructed the Beatles' new *White Album*, and we
listened at length as well to Joan Baez's *Baptism*, brought
along by Angel, on which she performed Norman Rosten's
poem "In Guernica,"

In Guernica the dead children are laid out in order upon the
 sidewalk, in their white starched dresses, in their pitiful white
 dresses.
On their foreheads and breasts are the little holes where death
 came in as thunder, while they were playing their important
 summer games.
Do not weep for them, *madre*.
They are gone forever, the little ones, straight to heaven to the
 saints, and God will fill the bullet holes with candy.

We heard much about Gernika that night, about the
Nazi bombing and the brave and long-suffering Basques—
their language taken from them in the same way that An-
gel's native Catalan had been robbed from him—about the
insanity into which Spain had sunk during the war, madmen
and murderers on each side, the republic too fragile, the rest

of Europe too little concerned. But what I remember most from that firelit night now more than thirty years past was the story Angel told us about the village of Dorria itself, a tiny place to which the war had come very late but nonetheless brutally.

Situated on a mountain shoulder above the town of Toses, two train stops beyond the larger town of Ribes de Fresser, Dorria was nothing more than a small collection of farmhouses and their companion barns and stables, all built from the granite that littered the steep and treeless slope. Above the village, a high, windswept ridge encircled it protectively, and it was the shape of that ridge, Angel explained—the way in which it twisted away from the longer ridgeline that formed the border with France—that mistakenly convinced refugees fleeing from Spain and Francisco Franco on foot that the cluster of farms they viewed below them were French farms, in fact, that below them were houses where of course Catalan still was spoken, and from which houses they would be directed on toward a series of safer redoubts.

But what the refugees from Barcelona hadn't known— couldn't have known without maps, or guides, or miraculous intuition—was that Dorria remained on Spanish soil, that it therefore still was a war zone, and that rebel guards waited in the village to machine-gun the individuals and families who rushed toward them, expressions of joy at their presumed freedom suddenly and forever erased from their faces.

In the weeks following the fall of Catalunya, as many as half a million Spaniards did safely reach France, most of them quickly confined to a series of squalid refugee camps near Toulouse, but thousands traveled individually and in

small groups to cities throughout France and beyond. In Paris in the winter of 1939, the presence of personally shattered and utterly impoverished immigrants from Spain was apparent on every street corner, and among the hundreds who directly or indirectly sought help from Pablo Picasso were his nephews, Fin and Javier Vilato, sons of his sister Lola. The two young men had fought for the republic since the beginning of the war, but had gone underground and fled as Barcelona fell to Franco. Via a succession of way stations, they had made their way to Catalunya's border with France, then crossed into safety at a remote and unguarded mountain location. Within days, they had reached Paris and found their celebrated uncle at his studio in the rue des Grands-Augustins. Picasso was elated to see his nephews—both apparently unharmed in the escape—and to hear from them the poignant details of his mother's death and funeral, as well as the assurance that their parents and their house were unharmed and safe, at least for now. Unsure how soon—or if ever—they would be able to return to Barcelona, Picasso found work for his nephews at the printmaking atelier in Montmartre operated by his friend Roger Lacourière, where the artist himself had been laboring for months on new etchings that would accompany a book of his poetry—one that the outbreak of the war, now only months away, ultimately would bar from being published.

Although the ongoing war in Spain was not lost—not entirely, not yet—it was increasingly difficult to imagine it could be won, and the painter redoubled his several efforts to assist refugees, whether family, friends, or strangers. When he was approached by a New York organization that hoped to exhibit *Guernica* in the spring to raise funds for Spanish relief, Picasso eagerly acquiesced to their request, making

arrangements for the painting to travel from the city of Manchester in England—where it received its final British benefit exhibition in a rented automobile showroom from February 1–15—back to Paris for recrating, then across the Atlantic by ship, the expenses borne personally by him as a contribution to the deteriorating Spanish cause.

Hitler had captured Prague, and Mussolini was poised to annex Albania when Francisco Franco took beleaguered Madrid in a final and all-but-bloodless assault on March 28. Although thousands more executions were still to come, the three-year-old Spanish civil war ended entirely absent drama three days later when soldiers in the holdout Republican cities of Alicante, Valencia, Almería, Murcia, and Cartagena laid down their weapons and raised their arms in surrender. "Very good. Many thanks," the solitary leader of a newly totalitarian Spain said when he was informed at his headquarters in Burgos of the concert of final conquests, and with Franco's few words the war was over. Picasso, in turn, responded to the heartbreaking news he had known was imminent simply with an oil painting of a fat tabby cat with menacing, goggle-like eyes and frightful white claws tearing the guts from a black bird it had captured. This time, neither dying horses nor bulls nor grieving women were images with which the painter chose to reply to events in his homeland. Metaphors that were particularly and meaningfully Spanish were simply too painful for him to employ when the subject appeared to be nothing less than the terrible fatality of his beloved Spain itself.

At the welcoming restaurant a few doors down from No. 7 rue des Grand-Augustins—which Picasso had dubbed Le Catalan—at the café Les Deux Magots, the Café de Flore, and other nearby haunts where he often spent his evenings,

the conversations among friends and acquaintances increasingly centered on war, on the one just ended so tragically in Spain as well as the other war that seemed certain to commence the moment Hitler chose for it to begin. No longer did the citizens of Paris profess belief that the Nazi führer would be satisfied with the conquests of Austria and Czechoslovakia, and it was a commonplace for Picasso and his friends to place ghoulish bets on the date when German troops would march belligerently into Poland. France at last would be compelled to fight the Fascist states when that happened, and all of Europe—it seemed inevitable—once more would fall into war and ruin. Because the painter long had been terrified by the specter of bombs descending on him like rain, he increasingly spoke of finding a safe haven, one well removed from the latent dangers of the capital city, a place where he and Dora and Marie-Thérèse and his daughter Maya and the hundreds of paintings he hoarded as if they were banknotes—which in a way, of course, they *were*—all would be safe from the same Nazi bombs that had annihilated Gernika. And it comforted him as he oversaw the rolling and crating of the canvas of *Guernica* one day early in April to know that the painting he cared about perhaps more than any other at the moment was about to travel far away from trouble, that it was about to set sail across the Atlantic for New York City, where the actions of Adolf Hitler likely never would cause too much concern.

Early on Monday morning, May 1, 1939—two years to the day since Picasso had begun to sketch elements of the painting—*Guernica* arrived at New York's 48th Street pier aboard the French liner *Normandie*. In the hours after the

ship docked, a long crate—inside of which the painting had been rolled onto a specially fabricated wooden cylinder— was lowered to the dock together with three flat wooden cases that contained the seven preparatory paintings and many drawings that had preceded its completion. Escorting the increasingly renowned *Guernica* was Juan Negrín, the cosmopolitan physician from the Canary Islands, who, until only a month before, had been the prime minister of Spain. At the pier to meet Negrín and to insure that *Guernica* safely reached its destination was a small group of Columbia University graduate students, all of them volunteers for the Spanish Refugee Relief Campaign, which had been organized three years earlier by Herman Reissig, a Protestant minister and American Socialist Party activist.

The campaign boasted a distinguished group of sponsors from the worlds of American politics, academia, and the arts, including U.S. Secretary of the Interior Harold Ickes, who served as the campaign's honorary chairman, as well as Malcolm Cowley, Theodore Dreiser, Albert Einstein, Lillian Hellman, Ernest Hemingway, Archibald MacLeish, Thomas Mann, Edna St. Vincent Millay, and Lewis Mumford, among many others. Although its fund-raising efforts now solely supported refugees who had escaped from the newly established Fascist regime in Spain—and who were languishing in terribly overcrowded camps in the south of France at the moment—it successfully had supplied food, clothing, and medical supplies and personnel to Republican fighting forces back when the democratic cause in that country still had burned bright. Working in concert with the American Artists Congress, a group of left-leaning artists, critics, and historians, the campaign hoped to raise significant capital from showings of *Guernica* in New York, Los Angeles, San

Francisco, and Chicago before the painting returned to New York in November to be included in a massive forty-year retrospective of Picasso's work planned at the city's Museum of Modern Art.

It was a measure of the painter's ongoing dedication to aiding refugees from Spain that earlier in the year he had turned down a request from MOMA director Alfred Barr for *Guernica* to highlight the opening of the museum's fine new building on West 53rd Street. The dates of the inaugural MOMA exhibition would have conflicted with the fundraising exhibition scheduled to begin on May 4, and Picasso sharply insisted that, despite the importance of the new building's inauguration—and the museum's long and steadfast support for his work—*Guernica*'s premiere United States showing would indeed be at the Valentine Gallery four blocks away, where owner Valentine Dudensing would exhibit the painting in an otherwise empty space as his own contribution to the cause.

Like the patrons and supporters of the relief campaign, Americans from many walks of life long had been disturbed by their government's indifference to the fact that Fascist rebels were attempting to overthrow a democratically elected parliament in Spain. "I hope that if Franco wins, he will establish a liberal regime," President Franklin Roosevelt had told Spain's ambassador to the United States, Fernando de los Rios, in the summer of 1936, awkwardly exhibiting the fact that the U.S. chief of state knew next to nothing about Spanish politics, nor of the rebels' allegiances and intentions. Soon thereafter, the Roosevelt administration had enforced an arms embargo against Spain—prohibiting even private shipments in support of the republic—yet over time the president had grown increasingly sympathetic to the Republican

cause, in large part owing to the persuasive influences of Sec-
retary Ickes, Secretary of the Treasury Henry Morgenthau,
Secretary of Agriculture Henry Wallace, and his wife Eleanor,
all of whom maintained far greater interest in international
affairs than did the president himself. Officially, however, Roo-
sevelt's position had not wavered, and he even had chosen to
look the other way when the American petroleum giant Tex-
aco, headed by its devoutly profascist president Thorkild
Rieber, had supplied—on unsecured credit—1,866,000 tons
of oil, then worth 6 million dollars, to Franco and his war
machine. On the day that Barcelona fell to the rebels, Roo-
sevelt at last had informed his cabinet that the arms embargo
against the Spanish Republic had been "a grave mistake," but
by then it was deemed too late to try to correct it, and the
United States formally recognized the now-firmly-entrenched
Franco government on April 1.

Eleanor Roosevelt and Harold Ickes traveled from New
York to Washington a month later to attend the opening of
the *Guernica* exhibit, and they were joined at the gala fund-
raiser by luminaries who included Simon Guggenheim,
W. Averell Harriman, Georgia O'Keeffe, William S. Paley,
and Thornton Wilder, all of whom were decidedly more
interested in seeing the massive painting in person than
they were in meeting the genial former Spanish prime min-
ister Juan Negrín, now an exile himself, or in hearing dis-
tressing details about the plight of Republicans in camps in
France. Only a hundred people paid five dollars each to at-
tend the May 4 preview, but nearly two thousand people did
contribute fifty cents each to the refugee cause when they
attended the exhibit during its three-week run.

"It is a half-dollar well spent," argued critic Elizabeth
McCausland in the *Springfield Republican*, "for it symbolizes

the passage from isolation to social identification of the most gifted painter of our era."

> [Picasso] wants to cry out in horror and anguish against the invasion and destruction of the Spain of his love. He wants to protest with his art against the betrayal accomplished by Franco and his fascist allies. He wants to wake in the breasts of all who see *Guernica* an inner and emotional understanding of the fate of Spain. He wants simple and well-meaning citizens everywhere to live through the tragedy of bombardment, physical mutilation, and death, so that they in turn will raise their voices in a passionate cry for justice and peace.

In the opinion of Henry McBride of the *New York Sun*, *Guernica* was "the most stunning attack that has yet been made upon the eyes and nerves of the art-loving portion of the public."

> You don't have to be especially susceptible to cubism to understand it. It is only too plain. Death and destruction are furiously indicated and the gestures of the victims have a largeness and ferocity unequalled in art since medieval times. This sounds like propaganda and in fact the picture was intended to be such, but it ended in being something vastly more important—a work of art.

But *New York Times* critic Edwin Alden Jewell wasn't impressed, work of art or not. As far as he was concerned, the painting epitomized the "foreign values" that were creeping

into contemporary art, values that attempted to shape something aesthetic out of "grotesque shapes, human and animal, [that had been] flung into a sort of flat maelstrom."

As McBride perceptibly noted, the great canvas was no longer referred to as a mural and its propagandistic days were receding rapidly when it reached California in August, where reaction to it similarly was spilt. *Guernica* was labeled either a brilliant transformation of social consciousness into the power and emotive meaning of art, or it was a ghastly collection of fearsome images, tossed together in a way that was little less than disgusting.

At an elaborate benefit preview of the painting and its preliminary works at the Stendahl Galleries in Los Angeles on August 10, sponsors who included George Balanchine, Bette Davis, Dolores Del Rio, Janet Gaynor, Dashiell Hammett, Fritz Lang, Dorothy Parker, and Edward G. Robinson were uniform in their agreement that the painting was a stunning artistic achievement, but the *Los Angeles Herald Express* told its readers that the general public, in contrast, responded quite negatively to *Guernica* and other "cuckoo" art of its ilk. In the *San Francisco News* two weeks later, San Francisco Museum of Art director Grace McCann Morley lauded Picasso's remarkable ability to transform his personal response to a singular event into a work of art that possessed universal meaning, while a reactionary group calling itself Sanity in Art, in turn, mounted a protest exhibition of realistic landscape and portrait painting at the city's de Young Museum. That exhibit bore a disquieting similarity to the state-sanctioned work Hitler had displayed in Munich two years before, and the angry rhetoric they posed against Picasso employed precisely the same adjectives—"revolting," "dangerous," "grotesque"—as did the Nazi response to Ger-

man "degenerate" art, an irony that appeared entirely lost on the affronted protestors, who clearly longed for a time when art and politics did not intersect and when painting's only goal was illusion.

For all the otherwise positive attention *Guernica* received in the Golden State, its showings did disappointingly little by way of encouraging Californians to assist Spanish refugees monetarily—the war, its aftermath, and its meaning already apparently of only little concern. The Motion Picture Artists' Committee for Spanish Orphans exhibit in Los Angeles netted merely 240 dollars; the San Francisco exhibit 535 dollars, and when all expenses were tallied and deducted, the collective U.S. *Guernica* showings ultimately generated a total of only a little more than 700 dollars to forward to those who had fought for democracy in Spain and whose lives were now terribly interrupted. Picasso's painting reminded many people of something they wanted to forget—if, in fact, they had paid the Spanish war any attention while it was under way—and that discomfort was something San Francisco Museum of Art curator Alfred Frankenstein attempted to address in an information sheet that was posted on the wall beside *Guernica* as the museum's exhibition opened on August 29: "It is no part of wisdom to slay the bearers of ill tidings"; he wrote, "the horrid facts remain, and it is they, not the report of them, which deserve abhorrence. . . . This [painting] is the *Last Judgment* of our age, with a damnation of human manufacture, and nowhere the promise of a paradise."

A world of paradise seemed at a particularly far remove to those who witnessed *Guernica* in the coming days. On the evening of August 31, Hitler ordered his forces to begin their long-anticipated invasion of Poland early the following morning, and on September 3, both Great Britain and

France in turn declared war on the German state. Across the Atlantic, people in the United States remained calm, despite the newspapers' huge headlines, because the new war was half a world away. Yet in San Francisco, the ill tidings that Picasso's painting bore—the grim truths that wars both begin and end but that hostilities endure forever—seemed to pierce the skin of the city's many museum-goers a bit more forcefully on that fateful Sunday than they ever had before.

Chapter 6

Exiles

Europe's two great Fascist powers were flush with confidence as World War II flared and began to burn hot, in large part because their victory in Spain had convinced them of their military prowess in addition to the primacy of their cause. Early in June 1939, 20,000 Italian troops had embarked from Cádiz and 14,000 members of Germany's Condor Legion had boarded planes in León, bound for their homelands and the celebrations that awaited them, Hitler and Mussolini hosting festive victory parades in Berlin and Rome at which they assured their fighting men that the world was a purer place for their having gone to Spain to assist in the crushing of godless communism. "Your heroic struggle in Spain has been a lesson to our enemies," Hitler wanted his airmen to know.

Inside Spain, the departure of the troops who had assured Franco's victory paralleled the exodus from the country of politicians, labor leaders, soldiers, and citizens whose cause had been the Republican cause, and who now greatly feared for their lives. As many as 500,000 people had fled newly dictatorial Spain during 1939—finding passage to

Mexico, Cuba, Argentina, Chile, and Great Britain in significant numbers, but most—perhaps 400,000 of them—fleeing only a few dozen kilometers north of the border to squalid refugee camps in France. For them, the end of the war meant hunger, disease, and hopelessness, and roughly 10,000 Spaniards died in the camps before they at last were disbanded during the height of World War II. Ten thousand more Spaniards—most of them former Republican soldiers—evaded the defeat and despair of the camps, but only by enlisting in the French army, their days of fighting Europe's Fascists not yet finished. The exiled members of the Spanish Republican government, who had escaped without harm, established themselves in Paris, where Juan Negrín remained the defeated republic's titular prime minister, and José Antonio Aguirre and members of the exiled Basque nationalist government similarly kept close watch from the small city of Biarritz near the Spanish border.

The war's victors and their supporters celebrated in towns and cities across Spain throughout 1939. Fears that their homeland would become a Soviet satellite now were quelled, and the thousands who longed for the return of the primacy of the monarchy and the church believed that Generalisimo Franco surely planned to rule only temporarily. Many people, such as Angel Vilalta's parents, gratefully welcomed the end of the war and applauded its outcome as well. In the midst of the worst of the fighting, the parish priest who had married Rafael and Montserrat Vilalta had been shot by pro-Republican and anti-clerical zealots, his only crime the collar he wore; the family business had been seized and now was destroyed, yet Spain—a devoutly Catholic Spain—would confess its collective sins and thrive under Franco, they hoped.

In Lérida—the Catalan name *Lleida* now forbidden—and in Barcelona and Madrid, priests could openly wear their birettas again without fear they would become the targets of snipers. The deeply conservative Catholic nationalists in the Basque country, called Carlists, donned their signature red berets and wore them proudly once more. And throughout the country, the unique three-cornered, patent-leather hats of the guardia civil reappeared in daunting numbers; what had been an uneasy symbol of the authoritarian strength of the state during previous dictatorships became a chilling icon again, proof that popular rule had been supplanted by a repressive state. "*Atención, españoles,*" repeatedly shouted Radio Nacional. "Peace is not a comfortable and cowardly siesta in the face of history. . . . Spain remains ready for war"—war against external forces surely still bent on communism's dominion, war against those within who had fought for the Republican cause and who therefore could never be trusted. Books with liberal, so-called "Marxist," themes—the works of writers as wide-ranging as Thomas Mann and Mark Twain—were burned in great bonfires in a number of cities, and anyone who was accused of "revolutionary excess" was hunted down, given a summary military trial, then either shot or transported to prisons, whose populations grew enormous. As many as a million people languished in prisons or did hard labor in camps in the first years after the war, and a reported 100,000 were dealt the sentence of the firing squads, fully a fifth of those being Basque nationalists who were marked by Franco for particularly intense postwar repression— their egregious offenses their fierce defense of their homeland and their stalwart determination to defer surrender as long as they possibly could.

During the course of the war, Francisco Franco had proven

his strategic skills as supreme commander of the rebel forces. The recklessness he often displayed as a field commander early in his military career had been replaced with a certain caution and patience during the war—the quiet belief in the invincibility of his cause that often had exasperated the German and Italian commanders who had come to his aid. Unlike Hitler and Mussolini, the thin-voiced caudillo was in no way an orator, and as he began to rule war-ravaged Spain, it soon became clear that neither did he share his allies' grand designs for a perfect Fascist world. Franco foremost was a Spanish puritan—albeit often a ruthless one— and he wanted nothing more, it soon became obvious, than for Spain to retreat as far into the past as possible, back to a time when piety, obedience, and acceptance of the rule of force were collectively held as the highest ideals. Franco's new Spain would be a nostalgic reinvention of a country he believed had flourished in the past; no longer would it be home to intellectualism, experimentation, the kinds of hedonism he despised, nor the undisciplined chaos of democratic rule. He romantically longed for the return of a heavy-handed Catholic monarchism that would endure for centuries. He would become the de facto king until he deemed it safe to return a true king to the Spanish throne, and he had only passing interest in creating vital strategic allegiances with Adolf Hitler and Benito Mussolini, the two soon learned to their great dismay.

Hitler and Franco at last met face-to-face in October 1940—four months following the Nazis' rather effortless occupation of France—in the small French coastal city of Hendaye just meters from the Spanish border. The two had traveled by separate trains, and Franco was both embarrassed and outraged to arrive some minutes late. The two men

deferentially addressed each other as "führer" and "caudillo" when they met on the station platform, and they remained at the station while they discussed whether Spain would enter the war as an Axis ally. Hitler was eager to forge that alliance and use Spain's soldiers, natural resources, and factories to buttress his war machine, but Franco was of very mixed mind. He believed without doubt that the Fascist powers would win the war and soon control all of Europe, but he was far from eager to become newly subordinate to the strange and singular man whose blistering temperament he now greatly mistrusted.

The führer made his case to the caudillo, outlining his military challenges and needs, and making it clear that Spain could not count on a glorious future if it chose not to enter the war. He reminded the Spanish leader of the Nazis' critical role in bringing him to power, as well as the fact that Franco's new government currently owed the German state 400 million reichsmarks, an amount that *might* be forgiven if some sort of pact ensued. For his part, Franco admitted his willingness to join the Axis powers, but not without numerous guarantees: Spain would go to war on Hitler's behalf if Germany would supply all the fuel and equipment the Spanish army required, as well as the additional troops and specialized equipment that would be required if Spain were charged with wresting strategically important Gibraltar at the mouth of the Mediterranean from the British. Furthermore, Germany would supply half a million tons of grain, whose shipment would begin immediately, and also would hand over to Spain all of French Morocco. Hitler was both stunned and affronted by Franco's terms—he believed he had *made* the little man, after all—and the two continued to speak for only a few more minutes before Hitler stood and announced that more conversa-

tion would simply waste breath. "You can't do anything with this character," the führer steamed as he reboarded his train, and when he later reported the unsuccessful meeting to Mussolini, he swore that he "would rather have three or four teeth pulled than to go through that again." Franco's train, in turn, chugged back across the border into Spain—a country that increasingly would become an international outcast as World War II wore on, one that the embattled western democracies now were deeply suspicious of, one that Hitler had no means to make obey.

Although Francisco Franco was eleven years Pablo Picasso's junior, the two belonged to the same Spanish generation that had been heavily burdened by their country's defeat and loss of empire in the Spanish-American War. Both men were combative and very capable of being cruel, and each was deeply patriotic in his own way—each believed his homeland had profoundly shaped the man he had become. But there the similarities between them ended, except for the shared hatred for each other that in no way had diminished with the end of the civil war. Almost certainly, Franco had been informed of the visual content of both *Dream and Lie of Franco* and *Guernica* by now and perhaps even had seen reproductions of them, and it may have been specifically in response to those perceived artistic outrages that Spanish embassy officials posted notices on Picasso's flats in the rue la Boétie and the rue des Grand-Augustins announcing their plan to seize them as payment for Spanish taxes while he was away from Paris in the summer of 1940.

In the first days after the German invasion of Poland and the commencement of the new war, Picasso had traveled

with Dora Maar, his friend and personal assistant Jaime Sabartés and his wife, his chauffeur Marcel and his Afghan hound Kazbek to the Atlantic coastal town of Royan—to which locale he had sent Marie-Thérèse Walter and his daughter Maya some months before. The somnolent town of Royan had been selected because it was a relatively short drive from Paris, because its seaside location might afford at least a few of the pleasures of the Riviera, and also because it would allow an exodus from France by boat if one were suddenly demanded. Picasso previously had declined offers to immigrate, from both Mexico and the United States, but somehow, journeying as far as France's periphery was the thing that made most sense to him in the face of the troubling times. Yet after having returned to Paris for several short visits during the year spent on the Atlantic coast, he decided in August 1940—two months following the Nazi occupation of France—that the city remained relatively sheltered from the calamities of the war, and that it was a far better place to live and work than was provincial Royan.

Picasso was able to reclaim his studio and living spaces from the authorities at the Spanish embassy—although it remains unclear whether he was required to pay some sort of fee to close the matter—and he attempted to return to a facsimile of the life he long had loved in the city, despite the fact that the Nazis' control of Paris appalled him. With operation of the city's underground train and bus system suspended, and with gasoline severely rationed, he opted to close the flat in the rue la Boétie and move to his studio in the Quartier Latin, despite the fact that the cavernous rooms in the building at No.7 rue des Grands-Augustins were chronically cold and difficult to heat in wintertime. He returned to the bistros and cafés that for decades had been

the center of his social life, returned to the long days of painting he loved, and even was able to procure bronze for the casting of a number of sculptures at a time when it and all metals were difficult to find and were commonly confiscated by the Germans.

Yet Picasso also lived with substantial inconvenience, uncertainty, and occasional fear during the years of the war. Soon after his return from Royan, he was summoned to register for the Service de travail obligatoire, the national compulsory service agency, despite the fact that at fifty-nine he was only a year away from the age at which citizens became exempt from participation. His studio and personal quarters became the targets of searches by the German Gestapo, often under the pretense that they were attempting to find one or another of Picasso's Jewish friends who had gone into hiding. By 1942, Picasso himself was commonly accused of a being a Jew—although it was his celebrity that likely kept him from being deported—and in November 1943, he and others were both reprimanded and stiffly fined when they were caught dining on chateaubriand at Le Catalan, an offense against the strict rationing of beef that cost the restaurant its license to operate for the following month.

Although the artist was notoriously timid when it came to concern for his personal safety, and although the larger war never captured his anger nor his determination to find ways to fight for the cause of freedom in the profound way the Spanish war had done, Picasso nonetheless developed something of a reputation as a brave resister by the end of the war—at least in the United States. In the New York *Museum of Modern Art Bulletin* for January 1945—published four months after Paris's liberation by the Allies—Alfred Barr, the museum's reedy and erudite forty-three-year-old

director, heralded the man he had come to consider a friend as someone "whose very existence in Paris encouraged the Resistance artists, poets, and intellectuals who gathered in his studio or about his café table," and Barr offered as proof of Picasso's stature the comments of Gladys Delmas, a young American woman living in Paris who affirmed that the artist's "work has become a sort of banner of the Resistance movement." Picasso himself probably had contributed to Barr's and others' perception of him having behaved rather boldly throughout the war when, immediately following the liberation, he told an American correspondent for *Newsweek* magazine that on the day when a German army officer had recognized a sketch of *Guernica* pinned to the wall of his studio and had asked him, "Did you do that?" Picasso coldly had replied, "No, you did."

At times it seemed that, from an American perspective, the liberation of Pablo Picasso was perhaps the Allied invasion's single most important achievement. PICASSO IS SAFE, shouted a *San Francisco Chronicle* headline above a story that carefully detailed how the artist had survived the years of the occupation. Virtually every American journalist arriving in Paris in September 1944 requested—and most received—permission to interview the storied painter, and so many furloughed American soldiers were eager to make his acquaintance and view his wartime work that Picasso set aside every Thursday morning that autumn for group visits from the young men and women whose role in setting him and his adopted city free he was deeply grateful for, despite the personal inconvenience the pilgrimages meant for him. "Yes, it's an invasion," Picasso joked with his friend the photographer Brassaï. "Paris is liberated, but me, I was and I remain besieged."

One of the soldiers who made his way to the artist's studio was an American amateur painter with Marxist political convictions named Jerome Seckler, who arrived at the building on the rue des Grand-Augustins alone one Saturday morning, and who succeeded in winning Picasso's agreement to speak with him at length. Seckler wasn't a journalist, he admitted to the great man he quickly found himself remarkably comfortable with, yet he hoped to write an article about Picasso, his current work and current politics for the *New Masses*, published in New York. No doubt the painter's own escalating interest in Marxist ideals, as well as the young soldier's unabashed charm, played a role in his acquiescence, and the two men talked at length. "I told Picasso that many people were saying . . . he had become a leader in culture and politics for the people, that his influence for progress could be tremendous," Seckler wrote in an article that was indeed published in the *New Masses* in March of the following year.

> Picasso nodded seriously and said, "I know it." I mentioned how we had often discussed him back in New York, especially the *Guernica* mural. I talked about the significance of the bull, the horse, the hands with the lifelines, etc., and the origin of the symbols in Spanish mythology. Picasso kept nodding his head as I spoke. "Yes," he said, "the bull represents brutality, the horse the people. Yes, there I used symbolism, but not in the others. . . . Only the *Guernica* mural is symbolic. But in the case of the mural [the symbolism] is allegorical. That's the reason I've used the horse, the bull, and so on. The mural is for the definite expression and

solution of a problem and that is why I used sym-
bolism. Some people," he continued, "call my work
for a period 'surrealism.' I am not a surrealist. I have
never been out of reality. I have always been in the
essence of reality. If someone wished to express war
it might be more elegant and literary to make a bow
and arrow because that is more aesthetic, but for
me, if I want to express war, I'll use a machine gun!"

If *Guernica* was a machine gun, it also was "the supreme
glory of [Picasso's] life," according to Jerome Mellquiest,
writing in *The Nation* in December 1939, soon after *Guer-
nica* had been included among 364 works by the artist in an
exhibition titled "Picasso: Forty Years of His Art," a compre-
hensive and hugely influential show mounted by Alfred Barr
at New York's Museum of Modern Art beginning in Novem-
ber. The museum recently had acquired two highly renowned
paintings by Picasso for its permanent collection, *Les Demoi-
selles d'Avignon* and *Girl Before a Mirror*; the artist had con-
tributed ninety-five pieces from his own collection to the
show, including *Guernica* and its preparatory works, which
had arrived in the United States in May, and the overall im-
pact of the exhibition was to crown Picasso "the greatest
painting virtuosity in the world," or so he was declared by
the editors of *Time* magazine.

Even those critics who found the painter's work disturb-
ing and largely unlikable could not ignore the scope and size
of the MOMA show, and for a number of weeks at the close
of 1939—at a time when many in the U.S. and millions
more in Europe were focused entirely on whether the new
war would be as long and brutal as the first world war had
been—the cognoscenti of the American art world were

rather more intrigued by Pablo Picasso and his enormous new black-and-white painting, which often appeared to be loved and hated in equal measure. Influential critics and painters writing in *Art Digest* and the *New York Times* in early December labeled *Guernica* a grotesque social tract, the unfortunate evidence that its creator was merely "groping in the void," and "the quintessence of ugliness"—a critique offered by the much-loved American realist Thomas Hart Benton. Yet others countered that the painting powerfully captured the brutality and frenzy of the modern world, and that it clearly was "the most forceful achievement of art in our century"—that according to James Thrall Soby writing in *Parnassus*. Whether drawn to the canvas and deeply moved by it, or repelled by the chaos it both described and incorporated, critics and the public alike made *Guernica* the centerpiece of the MOMA retrospective in a way that both surprised and delighted Barr, who personally had championed the painting in the two years since its creation, but whose efforts to purchase it for the museum so far had failed.

Picasso long since had made it clear that there was little to discuss with regard to the painting's ownership: it had been commissioned and paid for by the government of the Spanish Republic, and he believed he merely served as *Guernica*'s guardian until the day the republic was restored and the painting could find a permanent home in Spain. He had served as honorary director of El Prado, but his work never had been exhibited in his country's most important museum. But the possibility that it might be one day—at a time when free elections and civil liberties again were spread across the Spanish landscape—and that *Guernica* might be among his work that would reside perpetually in his homeland was a

dream that appeared quite distant as Hitler and his confederates spread their menace across the continent.

Yet it was the outbreak of World War II, two months prior to the opening of the Picasso retrospective at the Museum of Modern Art, that quite inadvertently solved for the artist the problem of how and where *Guernica* could be exhibited and successfully cared for until the day when it could immigrate to a free and receptive Spain. In the late autumn of 1939—during the time Picasso himself had fled Paris and anticipated the possibility that he would have to leave France as well—the notion of returning *Guernica* or any of the works in the MOMA show to Paris made little sense. New York, on the other hand, was at a very distant remove from the fighting; MOMA had become one of the world's finest repositories of contemporary art, and *Guernica* and ninety-four more pieces already were on the premises. The solution seemed ready-made: MOMA would become the caretaker of *Guernica*, the preparatory paintings and sketches—and indeed all of the work in the retrospective the artist still owned—until Europe was at peace once more. No one knew how long the museum's guardianship might last—perhaps only a year or two if the madman in Berlin somehow could be brought to his knees—but Barr and his staff were nothing less than elated when a cord of complex international circumstances determined that the paintings and sculptures, now refugees themselves, would remain indefinitely under their care in New York.

Although he was put at ease by the certainty that Barr and his staff would be excellent custodians of his work, Picasso also was convinced that it remained important politically for as many Americans as possible to view *Guernica* and to consider its meaning in the context of the new war—

one that he, like so many, now believed the United States would have to enter sooner or later. Cognizant of the painter's desires, and believing as well that the great canvas was vital to the comprehensive exhibit he had curated, Barr insured that *Guernica* and its companion pieces were included in the Picasso retrospective as it journeyed to the Chicago Art Institute in January 1940, then on to St. Louis, Boston, San Francisco, Cleveland, New Orleans, Minneapolis, Pittsburgh, Cambridge, Massachusetts, and Columbus, Ohio, during 1941 and 1942.

In August 1943, MOMA officials were eager to tout the return to New York of the painting that unquestionably had become Picasso's most well-known work in the six years since its creation, and Barr did not miss the opportunity to remind museum-goers that it was against the very same military power that had destroyed the town of Gernika that the United States had been forced to go to war. "This destruction of a defenseless town was an experiment by the German Luftwaffe in the psychological effect on the surrounding population of obliteration by air power of a hallowed center of a people's culture and religion," read a museum press release issued as *Guernica* went on exhibit again. "The Germans considered the experiment (with its horrible mutilation and destruction of hundreds of humans beings . . .) an unqualified success. Reportedly it was written up in German military journals as an advance in the technique of total war."

Yet it wasn't solely *Guernica* that rhetorically answered the Nazi enemy, museum officials argued. Everything on exhibit at MOMA—and the museum's existence itself—also was proof of the elemental distinction between open and creative societies and those that tragically were not. The October 1942 edition of the museum *Bulletin* was emphatic:

The museum collection is a *symbol* of one of the four freedoms for which we are fighting—*the freedom of expression*. Composed of painting, sculpture, architecture, photography, films, and industrial design from 25 countries, it is *art that Hitler hates* because it is *modern*, progressive, challenging; because it is *international*, leading to understanding and tolerance among nations; because it is *free*, the free expression of free men.

But two more terrible years passed before Hitler at last was defeated and all of Europe liberated on May 7, 1945, a victory shared by both the western democracies and their ally of necessity, the Soviet Union. Five months before, thousands of westerners believed they had been betrayed, in fact, when Pablo Picasso declared himself a Communist, his timing chosen in largest part because—with the Germans now forced out of France—at last it was safe for him to do so. On October 4, 1944, at the offices of *L'Humanité*, Picasso had sworn an oath of allegiance in the presence of his friends Paul Eluard and Albert Camus, who were among the many writers, artists, and intellectuals in France who, beginning in the 1930s, had been drawn to the party as Europe's only viable alternative to fascism. Picasso first publicly explained his decision to join the party three weeks later in the pages of *New Masses* in New York as well as *L'Humanité* in Paris:

I have become a Communist because our party strives more than any other to know and to build the world, to make men clearer thinkers, more free and more happy. I have become a Communist be-

cause the Communists are the bravest in France, in
the Soviet Union, as they are in my own country,
Spain. . . . I have long been in exile, but now I no
longer am; until the day when Spain can welcome
me back, the French Communist Party has opened
its arms to me, and I have found in it those whom I
value most. I am among my brothers once more.

Although it's unlikely that Picasso ever had read the writ-
ings of Karl Marx, the notion of a particularly French kind of
communism—one stressing the critical role of the artist as
well as the worker, one committed to "tomorrows that sing,"
in the words of the martyred Communist journalist Gabriel
Péri—crackled with bright vitality in the first months follow-
ing the liberation of France and the end of the war. Like his
friends Eluard and Camus, Michel and Louise Leiris, Simone
de Beauvoir, Jean-Paul Sartre, the photographer Brassaï, and
many others, Picasso saw proof of the rightness of the party's
ideals in the fact that the Soviet Union had suffered far more
fatalities than any other country in the defeat of the Fascists,
in the French party's courageous role in the Resistance, and
perhaps most importantly, in the reality that among all the
great nations of the world, only the Soviet Union had at-
tempted to repel the Fascist insurgency in Spain. Picasso and
his Parisian comrades seemed to forgive Soviet leader Joseph
Stalin's slaughter of millions of Russian peasants, as well as
the Communists' bloody repression of anarchist movements
in Spain, in the hope that a newly western and democratic
communism also would take root and flower in France and
throughout much of Europe.

Yet they saw early evidence that communism and the
West might not, in fact, find common and fertile ground

when conservative students reacted violently on October 6 to the news of the Spanish artist's new political allegiance. Seventy-four paintings and five sculptures by Picasso had been collected for a special exhibition dubbed the Liberation Salon at Paris's Palais des Beaux-Arts, and on its opening day, the students stormed the museum, physically removing several paintings from gallery walls before the protesters were seized by guards and Paris police. Although none of the artist's work was damaged, the students ably succeeded in drawing attention not only to the fact that Picasso indeed had become a Red, but also the fact that the national government had chosen to celebrate the liberation by honoring a *foreign* artist, one who might well have become a French citizen during his forty years in Paris, yet who pointedly had not.

In the coming months, Picasso became aware of deeply divisive attitudes in France not only about the nature of this work—which always had been the subject of animated conversation and open disagreement—but about his proper role in French society as well. Communist party members were frustrated when his new work did not immediately take on overtly political themes, and groups like the reactionary students continued, in turn, to denounce the expatriate Spaniard's corrupting influence on the "pure" culture of France. His painting *Le Charnier* (*The Charnel House*)—a scene of stacked bodies painted in staccato blacks and whites that made it unmistakably reminiscent of *Guernica*, and which Picasso said was inspired by the first photographs to reach Paris demonstrating the horrors of the German concentration camps—was at least in part a personal reaction to the charge that he had a new and vital responsibility to wed political reality with his art. So too surely were comments he

made in March 1945 to Simone Téry of *Les Lettres françaises*, in which he insisted that no artist could ignore the world around him.

Téry interviewed Picasso in his studio, and when she asked whether his new comrades, the Communists, could, in fact, understand his paintings, he responded dismissively: "There are some who understand English, and some who don't. There are some who understand Einstein, and some who don't." Then he hurried to find a notebook, telling his visitor he wanted to make a written statement in response to the issues she raised in the hope of making his sentiments entirely clear. A few minutes later he returned and offered her two sheets of paper on which he had scribbled in pencil:

> What do you think an artist is? An imbecile who has only eyes if he is a painter, or ears if he is a musician, or a lyre in every chamber of his heart if he is a poet, or even, if he is a boxer, just his muscles? Far, far from it: at the same time, he is also a political being, constantly aware of the heartbreaking, passionate, or delightful things that happen in the world, shaping himself completely in their image. How could it be possible to feel no interest in other people, and with a cool indifference to detach yourself from the very life which they bring to you so abundantly? No, painting is not done to decorate apartments. It is an instrument of war.

The subject of Pablo Picasso's politics was not a dominant issue in the New York Museum of Modern Art's daylong *Guernica* symposium held on November 25, 1947, in largest part because anti-Communist sentiment in the United

States was still half a decade away from reaching its hysterical crest, but also because the several invited speakers dove instead into a lively debate over what the many images in the painting actually symbolized. On the dais with the museum's Albert Barr were Josep Lluis Sert, the architect of the Spanish pavilion of the Paris world's fair—living in New York since the end of the civil war—who outlined for the large audience how the painting was commissioned, executed, and exhibited; Juan Larrea, an archivist, scholar, and former Spanish embassy official in Paris who recently had published, in English, the first book-length analysis of the painting; and Jerome Seckler, the former American soldier who had interviewed the artist about *Guernica* four years before. Picasso had assured him, Seckler still maintained, that the bull plainly symbolized the brutality of Franco and his forces, and that the dying horse was symbolic of the suffering of the Spanish people. But Larrea, a friend of the artist and a fellow Spaniard, was equally convinced that Picasso had meant the bull to represent the particular courage and tenacity of the Spanish people themselves, while the suffering horse in turn predicted the ultimate collapse of Franco's Fascist regime. Further complicating the debate, however, was the letter Barr had received in May of that year from Picasso's longtime Paris art dealer Daniel-Henri Kahnweiler, in which he maintained that the painter had insisted to him as he neared completion of the canvas, "This bull is a bull and this horse is a horse. . . . It's up to the public to see what it wants to see."

Kahnweiler also had opined repeatedly over the years that his dear friend Pablo Picasso was, without a doubt, the most apolitical man he ever had known, yet in the two years since the end of the war, he had emerged as a catalytic and

hugely controversial political figure of proportions that were commensurate with his worldwide renown. His decades of artistic experimentation, his series of rather public love affairs, and his host of personal contradictions made him inherently fascinating, if often exasperating as well, friends and critics agreed. "The only person in France who can compare with Picasso as a subject of conversation is Charles de Gaulle," *Time* magazine had posited a month before the MOMA symposium.

The artist's postwar notoriety as a steadfast Communist comrade-in-arms was cemented when he traveled to the heralded Congress of Intellectuals for Peace in Wroclaw, Poland, in August 1948 and the Second World Peace Conference in Sheffield, England, in October 1950, for which he contributed a simple line drawing of a dove that was used for the conference poster, and which became a potent antiwar and nuclear-disarmament symbol around the world in the ensuing years. In the United States, where anti-Communist fervor reached a crescendo with the Army-McCarthy hearings in 1954, Picasso was perceived—it wasn't surprising—as at once the world's most important and influential artist and a conspiratorial fellow traveler bent on bringing about communism's dominion around the world.

American avant-garde painters including Stuart Davis, Robert Motherwell, Arshille Gorky, and Willem de Kooning each acknowledged particular debts not just to the genius of Pablo Picasso, but also rather more specifically to the painting they believed was the culminating work of his career—*Guernica*. Jackson Pollock bitterly lamented how hard it was to paint successfully in the Spaniard's shadow, and the abstract expressionist Barnett Newman groused that even though he and his circle of contemporaries sometimes sneered at

the celebrated painting, its big, apparently torn-and-pasted black shapes stuck in the backs of their minds and inevitably influenced the images they produced, whether they wanted them to or not. On the other hand, however, MOMA director Barr—for decades an apologist for Picasso the man as well as the artist—was far from alone in registering deep dismay when Picasso painted the openly propagandistic and anti-American *Massacre in Korea* in 1951, as well a portrait of Joseph Stalin in 1953.

And it was a poignant if not tragic symbol of the ambiguity, mistrust, and fear-plagued tenor of the times when virtually every one of the cultural and political luminaries who had sponsored the 1939 New York benefit for refugees of the Spanish Civil War discovered in the early 1950s that government dossiers on their activities and affiliations had been compiled, sometimes leading to public and deeply humiliating investigations—the sponsors' common transgression simply their efforts to bring before the American public a painted canvas called *Guernica*.

It was the obsessive anticommunism of Francisco Franco that increasingly endeared him to the governments of France, Great Britain, and particularly the United States as the cold war burned hot in the 1950s and 1960s. Immediately following the end of World War II, Spain had been ostracized by the newly formed United Nations because, as the world's only remaining Fascist state, its governmental structure and policies were trusted by neither the Western democracies nor the swelling Soviet empire. Franco had been perceived as a prickly kind of anachronism, but a very lucky one as well: if his 1940 terms had been met and he had joined the war with

Hitler and Mussolini, Spain too would have been invaded by Allied forces in 1944, and Franco and his government undoubtedly would have fallen.

But by 1953, the United States was far more concerned with Soviet expansion than it was with a curious remnant of 1930s-vintage fascism, particularly because Franco never had shown signs of looking longingly beyond the borders of Spain. The U.S. signed the first of a series of military assistance pacts with the caudillo that year—the western giant promising to defend Spain from the Soviets, if necessary, and offering direct aid of several kinds in return for Spain's willingness to allow the construction of American air bases on Spanish soil. Franco, the pious general who deeply believed that God had selected him to assist Adolf Hitler in returning Europe to the authoritarian inviolability of the state, now had become an ally of American president Dwight D. Eisenhower, the former American general who had been instrumental in engineering Hitler's defeat.

Inside Spain, the country had moved very slowly to rebuild itself following the civil war. Its infrastructure was shattered, its economy in ruins, its citizens profoundly uncertain of their personal and collective futures. Nearly half the nation's railroad stock had been destroyed during the war, and a third of the merchant marine had been sunk; livestock and crop losses had been staggering, and a severe famine had endured late into the 1940s. More than 150 churches had been destroyed across the country, and 4,800 more were severely damaged; 250,000 single-family homes and a far greater number of businesses had been so brutally damaged they remained unusable, and a total of more than three hundred towns and small cities had been damaged so extensively in the nearly three years of fighting that Franco

had made a grandiloquent show of "adopting" them, the national government assuming both administration duties and the cost of their restoration. Even the sacred Basque town of Gernika, in the region he continued to revile, was a recipient of the caudillo's complex largesse.

Beginning in 1940, the so-called Commissariat of Devastated Regions began the only complete redesign and reconstruction of a town among the hundreds of projects with which it was charged—because only Gernika had been all but wiped from the map. A survey by Franco's government concluded that 71 percent of the town's 271 houses had been destroyed, as had 100 percent of its public buildings and businesses. Although some salvage work had been accomplished already, the job of removing mountains of wood, stone, and masonry debris was a daunting one, and the work of demolishing standing walls, stripping foundations, and clearing rubble continued for months while architects Gonzalo de Cárdenas and Luis de Gana planned the three-stage rebirth of the ancient town. First, an entirely new sewer system would be built, followed by the reconstruction of public buildings, parks, and the communal market, then ultimately, a new system delivering water from nearby Monte Oiz would supply Gernika's new and returning residents.

The two architects agreed not to realign the town's former streets, and they decided that most schools and public buildings ultimately would rise again on or near their former sites, yet they also were eager not to miss, where possible, opportunities to provide the town with parks and other amenities it had not possessed prior to its destruction. Block-long arcades would be integral design features of the new buildings and would span the sidewalks in the core of the town— where the city hall, courthouse, and post office were located—

in order to shelter pedestrians from the region's virtually constant winter rains; an outdoor amphitheater with a splendid view of the surrounding mountains would be built near the undamaged Juntetxea, the ancient assembly hall and its sacred oak. The former town-center site of both the Monday market and seasonal fairs would reemerge as a dramatically landscaped garden, and a massive new marketplace, most of it roofed, would rise near the reconstructed train station, where one day market-goers from surrounding towns again would arrive by train. In every case, new buildings would be designed to reflect the historical regional style—Gernika would be a town of uniformly red roofs once more—and although roughly 7,000 people had lived there before the bombing, the architects and Devastated Regions officials determined that it would become home to as many as 12,000 residents when its long restoration was complete.

By 1944, at the height of the five-year project, thousands of former Republican army soldiers were at work rebuilding the town—not as employees of a beneficent national government, but rather as continuing prisoners of war. Confined in two bomb-ravaged former schools, the men worked fourteen-hour shifts under the wary eyes of guards wielding machine guns. The civil war had ended half a decade before, but because they had fought for the defeated democratic government, the workers' futures remained unknown; they likely would be freed one day, they suspected, yet it was a date they could look toward only with deep uncertainty. They would know they had played a role in bringing back to life a town the now-vanquished Nazis had destroyed, but that was a truth the national government still regularly denied in propaganda insisting that the town had been destroyed by Basque Communists. "A visit to a place

like Gernika . . . even without having seen the state of its destruction following its liberation," declared the Marqués de Santa Maria del Villar, writing in the government publication *Reconstrucción*, "is, we believe, edifying and greatly instructive—a journey that is necessary for all Spaniards, particularly our youth. How it teaches us of the distinctions between the destructive labor of Communism and the restoration of Franco's Spain!"

For fully two decades following the day in 1937 when Nazi bombers let true horror rain out of the April sky, Franco and his subordinates shuffled blame for the bombing between the *rojos*—the Reds, the still ill-defined Communist menace—and the tactical error of the inexperienced pilots of the German Condor Legion. When the rhetoric seemed to suit his rabid anticommunism, Franco remained eager to let the story persist that retreating Basque Reds had set fire to Gernika. Yet following Hitler's defeat—and as he increasingly shaped his comments to win approval in America—the caudillo spoke of the destruction of the town as eternally disturbing evidence of the deeds of which the contemptible Nazis were capable.

For their part, the Germans who had fought in the Spanish war appeared ready to acknowledge something akin to the truth about what had happened in the small Bizkaian town on April 26, 1937. "An international investigation about Gernika cannot be allowed under any circumstances," Hitler himself had declared eighteen days following the attack, obviously already aware both of what had occurred and how it was being characterized around the world. Yet in the spring of 1946, Hitler was dead and the dream of Nazism was destroyed, and Herman Göring saw no reason to persist with official lies. "Spain gave me the opportunity to test my

young air force," he confessed at his Nuremberg trial, at a time when the official truth in Franco's Spain remained that German bombers never had flown in the Spanish skies. In 1953, Condor Legion veteran Adolf Galland published a memoir of his experiences in Spain, which began with his arrival two weeks following Gernika's destruction. "At the time of my arrival, spirits in the Legion were very low. No one spoke willingly of Gernika." But bit by bit, Galland reported, he was able to ascertain that a mission in which bombers had attempted to destroy a highway bridge on the outskirts of the town had gone very badly because of poor visibility, and the town had been hit instead. "Gernika . . . was neither an open city nor a military objective, but an unfortunate mistake," he maintained. Although it remained most unlikely that fifty bombers had been dispatched over a period of three and a half hours in order simply to insure that a single bridge was well and truly destroyed, or that the effort to take out the bridge explained the strafing of fleeing civilians with machine-gun fire, at last a German military figure—one who had reached the rank of major general by the end of World War II—was ready to admit that it was indeed German bombs that turned the town to terrible ruin.

Inside Spain, it became a commonplace in the succeeding decades for people to presume that the bombing of Gernika had been "an unfortunate mistake" carried out by Nazi bombers. Yet by the close of the 1960s, when Franco had become both old and seriously infirm—at a time, astonishingly, when he had begun to ask aloud whether *Guernica* didn't rightfully belong in Spain—a rather more straightforward and nearly accurate version of the events of that awful Monday thirty years before at last could be confirmed

without fear of retribution. In his review in the ultra-right-wing journal *El Alcázar* of historian Vicente Talón's new book, *Arde Guernica*, Ricardo de la Cierva, official historian for the Franco regime, spoke boldly:

> Gernika was destroyed on April 26, 1937, by various flights of the Condor Legion, which in agreement with general and specific German standards during three hours smashed the lovely symbolic city (the heart of the symbol [the sacred oak tree], thanks be to God, remained untouched) with explosive and incendiary bombs.

Finally, it was no longer treasonous to speak the truth, and something akin to the full and complex reality of the bombing of Gernika could be spoken: the town was *not* destroyed by the retreating Basque army, *not* burned by Red hordes, and was *not* a mistake made in bad weather by inexperienced Nazi flyers. Yet elderly Francisco Franco remained very much alive in the summer of 1970 and he continued to pay close attention to his historical reputation, and therefore his historian la Cierva was quick to add: "The supreme national command and the command of the Army of the North were not informed before the operation and manifested their indignation when they learned of the facts."

Perhaps three decades after Gernika was destroyed, the aging ruler truly had come to believe the myth that he had responded with righteous anger to the news when it first was relayed to him. Perhaps he needed to insure that his own version of history would survive him, and that was why he now wanted to see Picasso's great painting in person before his days on the Spanish earth were done.

* * *

The Spain to which I arrived in the late summer of 1968 was a nation in which prisoners of war no longer performed forced labor, a country in which bands of self-styled patriots no longer marauded to avenge the perceived injustices of the republic, a place where clerics and closeted Communists alike were safe from slaughter. Yet in the three decades since the close of the civil war, the intimidation, arrest, torture, and imprisonment of artists and intellectuals never had subsided. Spain and Portugal remained the West's only totalitarian states, the high wall of the Pyrenees and the dim visions of their dictatorial leaders separating them from the rest of Europe and the bright vitality of freedom.

In 1968, press censorship remained as fierce as it had been at the close of the civil war, and censorship of theater, film, and the literary and graphic arts had silenced two generations of Spanish artists in the years since Franco had seized power. Divorce was difficult; public displays of affection were taboo, and even shop-window displays of lingerie often incited the ire of the authorities. Teachers and professors were forced to adhere to carefully scripted curricula, and young Spaniards in the prime of their working lives—people like Angel Vilalta—doubted they would live long enough to see their country become once again a place where personal liberties were both acknowledged and protected, and where the nation's political direction was determined in the minds of more than a single man.

Angel had enrolled in the University of Barcelona in 1945, soon after he, his parents, and brothers and sister had moved from Lérida to the city in hopes of recapturing some of the health, prosperity, and familial joy they had known be-

fore the war. By 1951, Angel had earned a law degree, then he spent two years at the University of Houston in the United States studying commercial law and teaching Spanish before returning to the Mediterranean city that enchanted him, the place, he knew, where he wanted to spend his life. He joined a Barcelona law firm specializing in international commerce, but he already harbored misgivings about whether his work was truly fulfilling him when in the spring of 1964 his friend Will Watson, an American historian at the Massachusetts Institute of Technology who had lived in Barcelona while researching the civil war, wrote to request his assistance. Phillips Academy, a preparatory school in Andover, Massachusetts, planned to open a schoolyear-abroad program in Barcelona, and Watson had offered to do what he could to help his alma mater recruit Spanish faculty members as well as someone who could find suitable host families for a dozen American students. Angel was intrigued by the school's goal of enlarging the international visions of young Americans, and he soon decided a bit of teaching would be a welcome adjunct to his other work. But by the time I met him four years later, his law career was entirely behind him, and he had become, without question, the most indispensable member of the program's Barcelona staff.

"Angel," his name pronounced in English by those of us who grew particularly close to him, wasn't far beyond boyhood himself in those earliest years of the program that was called School Boys Abroad. But in the eyes of us bona fide boys, he seemed remarkably sophisticated. Short, dark, possessed of sparkling eyes and hands that dramatically highlighted his speech, he was decidedly debonair, always impeccably dressed and disarmingly charming, his spirits seldom sagging, even at those times when we did our devilish best to weigh him

down. He was witty and patient, and could be counted on to provide us with a fountain of Iberian information. In worldly and alluring Barcelona, he was our go-between, our safety net, our confessor, and even—when the rare occasion seemed to warrant it—our corruptor.

But more than anything else, Angel Vilalta was willing to extend to us a *fuerte abrazo* of friendship despite the fact that we were often inattentive adolescents who hailed from a country that seemed to have forgotten how to behave in the world. Sometimes he suffered criticism from his contemporaries for devoting his manifold talents simply to us, and his patient response to them was that he hoped he could play a role in making these American boys a bit less jingoistic, a little less self-obsessed than they otherwise would grow up to be. Whether the occasion was opera at Barcelona's Liceu or "Guantanamera" sung at his flat; whether the subject was the CIA's covert work against popular uprisings in Latin America or the promise of a poet and senator named McCarthy who lately had run for the American presidency; whether he was marveling with us at La Alhambra in Granada or reveling with us in the classroom in a moment of high hilarity, his laugh overtaking him like a seizure, Angel continually demonstrated that the best kinds of men were inquisitive and energetic, courageous yet compassionate, attuned to the breadth of the world's worries and pleasures but also equally focused on family and friends.

The Barcelona I began to get to know through Angel's eyes was a global city caught in a country whose dictatorial leader deeply distrusted the rest of the world. It was the proud capital city of Catalunya—a region, like the Basqueland, with its own language, history, and culture—and yet its people were forced to pretend that Castilian Spain and

the language dubbed cristiano were what mattered enormously instead. As it had since the end of the war, the Catalan language remained outlawed—shops were forced out of business if they posted signs in Catalan, teachers were arrested when caught speaking Catalan with their students— and although some had begun to defiantly dance the sardana again in the plazas that fronted the cathedral and city hall, gruff guardia civiles toting machine guns watched the communal circle dance on Sunday mornings and evenings with a wary eye toward insurrection. Party affiliations were forbidden, yet many thousands of people were passionately political, and gatherings of socialists, democratic socialists, Communists, Catalan regionalists, and other groups were held only with the most carefully orchestrated kinds of secrecy. The professors from the University of Barcelona who were our instructors ran the risk, we understood, of losing their jobs and being jailed if their clandestine activities and alliances were discovered, and like many of them, Angel too had been arrested—the crime the joint letters of protest he and his friends sometimes believed they had no choice but to write, the secret assemblies they held, the banned books found in their possession.

In March 1969, armed members of the guardia civil pounded on the door of the house in which I lived with my host family and dragged away without explanation my "brother" Antonio Pérez Bayonga, a university student whose offense against the state, we later learned, had been his attendance at an unauthorized political demonstration. When Antonio at last returned home five days later—dazed and exhausted and somehow very different—he explained that while he had been held, his testicles were squeezed in a vise as a means of making him name others with whom he associ-

ated. His moustache and long hair had been shaved, and he cried as he confessed that he had joined the army as a means of freeing himself from further torture. He had two hours in which to say farewell for an uncertain length of time, then he and a host of other "recruits" were bused to an army base in the south of Spain.

It was a mean measure of that era as well that when Barcelona's Museu Picasso had opened to virtually no public attention in a converted palace in the city's labyrinthine La Ribera district in March 1963, its name officially had been the Fundación Sabartés—so called after the artists' longtime friend and assistant Jaime Sabartés, who had donated more than 600 paintings from Picasso's Barcelona years. Even the use of Picasso's name would have run the risk of inciting the ire and undesired attention of Franco's censors, the city's museum curators had worried, and thousands of Barcelonans began to visit the extraordinary but unheralded collection of the artist's early work with a sense that doing so was a deliciously subversive act.

Picasso, eighty-two in 1963, had not returned to his homeland and the seaport city he loved to celebrate the museum's opening. Although it no longer was likely that he would be jailed or assassinated if he returned to Spain—as almost certainly would have been the case in the first years following the civil war—he nonetheless chose not to repatriate himself, even briefly, while Franco remained in power. In the five years since the museum opened—the work of the country's greatest living artist was shown in Spain again for the first time in three decades—a curious softening of the official attitude toward Picasso had begun to take place, a shift in stance that could be sensed in a number of subtle ways. The museum hadn't been closed by authorities

in distant Madrid, and increasingly, people could be openly honest about whom it honored. Publishers in both Barcelona and Madrid recently had released books on the artist and his oeuvre, books that included reproductions and considerations of *Guernica*. Angel Vilalta and art history instructors like him now could introduce their students to Picasso's most renowned work without fear of reprisal—openly discussing, if they chose to, the painting's genesis, its meaning, and the role it had played in both art and politics since the close of the civil war. In ways that would have been unthinkable when Angel himself was a young university student and images of the painting had been furtively passed from hand to hand as if they were a kind of pornography, *Guernica* at last seemed only marginally more seditious to teachers and students alike than did Velázquez's *Las Meninas*.

And the shift in attitude was made stunningly apparent when, in December 1968, Luis Carrero Blanco, Franco's vice president of state, wrote to the nation's director general of fine arts, Florentino Pérez Embid, informing his friend and colleague that the caudillo recently had determined that the world-renowned painting now belonged in Spain, and had requested the director general to formally petition both Pablo Picasso and the New York Museum of Modern Art for the permanent move of *Guernica* to Madrid. It was a stunning turnabout, the sort the dictator simply did not make, one for which, at the moment, at least, there seemed to be no explanation, because theretofore Francisco Franco had expressed not the slightest interest in bringing any of Spain's aging exiles home.

The Last Refugee

Leonardo da Vinci's *Last Supper* hung above the dining tables of hundreds of thousands of Spanish homes in the 1950s and 1960s as a symbol of private faith and of the Roman Catholic Church's enduring importance. An almost equal number of copies of Pablo Picasso's *Guernica* hung on Spanish walls during those years as well—particularly in the Basqueland—as a memorial to the lives and hopes that were destroyed in the civil war, and as a symbol of defiance against the durable dictatorship of Francisco Franco. But unlike the former masterpiece, whose ubiquity threatened no one, a poster of *Guernica* was necessarily contraband. It had to be smuggled across the border from France or procured from a daring and entrepreneurial printer who risked jail or the loss of his business if he were caught offering it for sale. Copies of *Guernica* were torn down as a matter of course by members of the feared guardia civil when they were discovered in the houses they searched, and the black-and-white image that elsewhere in the world had become synonymous with a cry for peace remained a call for sedition in the eyes of those who enforced the caudillo's rule.

That is why reporters in attendance at the regular weekly press luncheon hosted by Spain's director general of fine

arts, Florentino Pérez Embid, were stunned on an afternoon in October 1969 to hear him announce that "the government of General Franco deems Madrid to be the place for *Guernica*, Picasso's masterpiece." It was a comment that seemed to come entirely out of the ether. Certainly no one—whether a partisan of Franco or a passionate opponent—had ever dared to suggest the "repatriation" of the painting, by now certainly the single most widely recognized artwork of the twentieth century. Yet here was Franco's own arts minister announcing that the caudillo himself wanted *Guernica* to come to Spain, and reports of Pérez Embid's shocking pronouncement spread like windblown flames across the country—where those who staunchly supported the Generalisimo and those who hated him found themselves in agreement for a moment at least that surely this was a fine idea. "*Guernica*, given by Picasso to the Spanish people, is a part of the cultural patrimony of this people and should be on exhibition in Spain as proof of the definitive end of the contrasts and differences aroused by the last civil conflict," opined *El Alcázar*, the journal-of-record for the nation's rabidly pro-Franco radical right, reducing the memory of the war that took the lives of half a million Spaniards to something of a lamentable disagreement, its statement in support of the move illustrated by a reproduction of the painting whose subject was the single most indefensible incident of that war.

The news of the Franco government's desire to take possession of *Guernica* soon also reached the village of Mougins near the Côte d'Azur, where eighty-eight-year-old Pablo Picasso now lived, as well as Manhattan, where the painting had become the signature artwork at New York's Museum of Modern Art in the three decades since its arrival, highlighting what now was probably the best Picasso collection in

the world. Yet at both locations, reactions to the Spanish
authorities' overture were quick and unequivocal: yes, *Guernica* would journey to Spain one day, but only when republican liberties were restored there, and that day continued to
appear distressingly distant. As Picasso specifically viewed
the matter, his painting was both safe and well-cared-for in
New York; Franco's repressive regime remained unchanged,
and therefore the subject of a move was out of the question.
At MOMA—from which institution Alfred Barr had retired
in 1967, and whose department of painting and sculpture
now was headed by art historian William Rubin—the response was even simpler: the museum was bound to respect
the artist's wishes and he wished for *Guernica* to remain in
New York.

A year later, however—as it began to appear that the
two elderly Spaniards were competing to see who could outlive the other—Picasso had become concerned enough about
Guernica's welfare following his "disappearance," as he would
only euphemistically refer to this death, that he endeavored
to provide for its future in a way he never had with any
other work in his oeuvre, nor with the members of his own
family. In particular, he worried that MOMA might not eventually surrender the painting, which many now argued belonged in New York in perpetuity, and on November 14, 1970,
he instructed his longtime Paris lawyer, Roland Dumas, to
draft a letter to museum officials restating his desires:

> You have agreed to return the painting, the studies,
> and the drawings to the qualified representatives
> of the Spanish government when public liberties
> are reestablished in Spain. You understand that my

wish has always been to see this work and its ac-
companying pieces return to the Spanish people.

To take into account your intention, as well as my
wish, I ask you to consider carefully my instructions
on this subject. The request concerning the return
of the painting and its accompanying pieces can
be formulated by the Spanish authorities. But it is
the duty of the museum to relinquish *Guernica* and
the studies and drawings that accompany it. The
sole condition imposed by me on the return con-
cerns the advice of an attorney. The museum must
therefore, prior to any initiative, request the advice
of *Maître* Roland Dumas . . . and the museum must
comply with the advice he gives.

In other words, all Picasso required the museum to do
when presented with a request to relinquish the painting was
first to consult with Picasso's lawyer—if the artist were
deceased—then to abide by his lawyer's instructions. Yet for
the first time since he had told Josep Lluis Sert in the winter
of 1938 that he intended for *Guernica* to reside in Spain one
day, the letter to MOMA affirmed Picasso's intention that it
was the return of "public liberties" to Spain, rather than a
specifically republican form of government, that necessarily
would have to precede any move.

Five months later, however, the artist who never had
executed a will despite his vast wealth—likely because of his
superstition that a will would somehow provoke his death—
did affix his signature to a one-sentence document specify-
ing *Guernica*'s future, but once more muddying the question
of Spain's prerequisite politics: "I confirm anew that since

1939 I have entrusted *Guernica* and the studies that accompany it to the Museum of Modern Art in New York for safekeeping and that they are intended for the government of the Spanish Republic," he wrote on April 4, 1971, forty years to the day since the republic was formed.

Although Picasso did not seem personally concerned as the 1970s opened that Franco and his subordinates might well claim the painting belonged to "the Spanish people" who had paid for it regardless, they might argue, of the form of government under which they currently lived, there were others who became substantially concerned that a claim of that sort would, in fact, be the Spanish dictator's subsequent move. As long ago as the autumn of 1937, the Spanish republic's ambassador to France, Luis Araquistáin, had been concerned enough about that possibility that he had made sure to include among the embassy papers he regularly shipped to the embattled Republican government in Valencia the receipt Picasso had signed affirming payment to him of 150,000 francs in return for his creation of the world's fair mural. But in a 1953 letter to Picasso, Araquistáin obliquely had assured the artist that the particulars of that payment need never be made public: "Except for the above-mentioned amount given by the embassy of Paris for purposes of propaganda, my personal testimony and the testimonies of Sr. Álvarez del Vayo and Sr. Max Aub, no traces remain of the agreement you made with the latter. Thus the fate of *Guernica* will depend only on you."

It was Max Aub who had paid Picasso for the painting on May 28, 1937. He had emigrated to Mexico at the end of the civil war, and in the years since always had been circum-

spect about his role in remunerating Picasso because of his own concerns about the possibility that the Franco government might therefore claim ownership of it. When he was asked late in 1969 by Spanish diplomat Rafael Fernández Quintanilla to clarify what, precisely, he had purchased from the artist on the Spanish embassy's behalf, Aub responded with words that clearly were tailored to help prevent the painting from falling into Franco's hands rather than tell an unvarnished truth: "I delivered 150,000 francs for the costs of painting the mural," Aub wrote to Quintanilla from Mexico City, "with the precise condition that when the exposition was finished the artist would remain the sole and absolute owner of the painting, and that he could do with it whatever he wished. The past, present, and future governments of Spain have nothing whatsoever to do with *Guernica*." A sum of more than 6,000 dollars would have covered paint, canvas, and stretcher costs by more than threefold, however, and, almost certainly, Aub did not, in fact, discuss with Picasso at the time of the payment the "precise condition" of which he wrote. Perhaps neither did he know that in the decades since its creation, the artist himself had told friends and colleagues on numerous occasions that the painting "belonged" to the people of a democratic Spain rather than express his desire to give *Guernica* to them one distant day.

During the ensuing decade, however, MOMA would prove to be a far more prickly negotiator for control of *Guernica* than would either the government of Spain or the elderly man who had painted the canvas forty years before. Franco's interest in the painting—or rather the prestige he hoped the painting's presence in Spain would lend his regime—proved tepid enough that he never made a great

show of demanding the painting, nor did he even ask for it a second time. Despite the willingness he had expressed for both *Guernica* and its creator to return to Spain, he continued to loathe both Picasso and his art. Franco had not discovered, late in his life, a taste for contemporary art, nor had he come to believe that Pablo Picasso was the kind of man whom proud Spaniards should revere. For his part, neither did the artist ever address the matter again, but before the 1970s had played themselves out, MOMA's William Rubin, a former professor of art history at Sarah Lawrence College, would battle not only the government of Spain but the United States as well over the question of what Picasso's true wishes were for *Guernica* and where it therefore ought to reside.

Most of those who viewed *Guernica* in 1970 in its small gallery near the third-floor landing at the Museum of Modern Art knew almost nothing about the civil war in Spain that was the painting's genesis, nor did they know it was World War II that was chiefly responsible for its long tenure in New York. It was an intractable war in southeast Asia that rather more centrally occupied their thinking that year, and Pablo Picasso's massive mural seemed to speak directly to the now-common perspective that America's participation in that war was wrong in every way. In the thirty-three years since its creation, *Guernica* had become the world's most recognized symbol of war's brutality and ruin, and although most people who were familiar with it also knew its creator was the Spanish—or was he French?—artist who liked to wear striped sailor shirts, the painting itself had come to seem rather American in many ways. It wasn't surpris-

ing therefore when *Guernica* became a favored backdrop for anti–Vietnam War demonstrations late in the 1960s—the painting, resident in New York for so long, now appeared to portray the legacy of a particularly American kind of aggression—but museum officials and many others were astounded in March 1970 when a group of artists and writers publicly approached Picasso to suggest that because of U.S. atrocities in southeast Asia, he ought to take *Guernica* home, or at least insist that it come down from MOMA's walls.

A parcel containing 265 letters was mailed to Picasso at his home in Mougins in the south of France on March 13 by members of the Art Workers Coalition—kindred radical artists like Alexander Gross, Jean Toche, Jon Hendricks, and Faith Ringold—each including the same precisely worded plea to Picasso in response to the news, made public only recently, that in March 1968 U.S. soldiers had executed hundreds of villagers in the South Vietnamese hamlet of Mylai. "Dear Pablo Picasso," the letters began,

> When the Franco government of Spain recently invited you to return and to bring *Guernica* to Madrid, you said no: only when Spain is again a democratic republic will *Guernica* hang in the Prado.

> American artists have always been proud of the fact that your great painting, an outcry against injustice, hangs in our leading museum, in temporary refuge on the way to your freed homeland. But things have changed. What the U.S. government is doing in Vietnam far exceeds Gernika, Oradour and Lidice [Czech and French villages destroyed by the Nazis in Word War II]. The continuous housing

of *Guernica* in the Museum of Modern Art, New York, implies that our establishment has the moral right to be indignant about the crimes of others—and ignore our own crimes. American artists want to raise their voices against the hundreds of Gernikas . . . which are taking place in Vietnam. We cannot remain silent in the face of Mylai.

We are asking for your help. Tell the directors and trustees [of MOMA] that *Guernica* cannot remain on public view there long as American troops are committing genocide in Vietnam. Renew the outcry of *Guernica* by telling those who remain silent in the face of Mylai that you remove from them the moral trust as guardians of your painting. American artists will miss *Guernica* but will also know that by removing it, you are bringing back to life the message you gave three decades ago.

The eighty-nine-year-old artist did not respond to the request however, nor was the painting put in storage. MOMA officials declined to offer an official statement, but in response to the flurry of publicity that surrounded the Art Workers Coalition request, a number of commentators expressed the opinion that *Guernica* eloquently served the antiwar cause and that its removal would silence a vitally important voice. Meyer Schapiro, a highly respected art historian at Columbia University—who had been an influential Marxist critic early in his career, and whose politics therefore never could be confused with those of Richard Nixon—spoke vehemently:

To ask Picasso to withdraw his painting from the museum because of the massacre at Mylai is to charge the museum with moral complicity in the crimes of the military. This I cannot do.... The role of the United States during the Spanish Civil War, when our government imposed an embargo on trade with the Spanish Republic, was hardly a moral one; would it have justified asking Picasso in 1939 not to entrust his *Guernica* to the Museum of Modern Art? A democratic republic is capable of great evils like a dictatorial state. But unlike the latter, it has a free press and free elections through which individuals and organized groups may criticize, resist, and act to change what they believe is wrong.

It was the kind of rejoinder the elderly artist himself might have made, one very much akin to what he had said with some pride many years before to his friend the poet Rafael Alberti. The two men had been discussing the artist's proper role as a citizen of the world, and Alberti had asked whether Picasso was pressured by those critics who believed his work ought to do more toward making vitally important political statements. "The truth of the matter," Picasso had told him, "is that by means of *Guernica*, I have the pleasure of making a political statement in the middle of New York City every day."

The middle years of the 1950s—the period when Picasso lent his notoriety to the ideal of a worldwide, democratic, and humane kind of communism—had been years when

Guernica itself circled the planet and was seen in person by millions of people for whom it had become a legendary icon of its times. Beginning late in 1953, the painting had returned to Europe, where it was featured in a Picasso retrospective at the Palazzo Reale in Milan, then early in 1954 it traveled to the Museu de Arte Moderna in São Paulo, Brazil. In the summer of 1955, *Guernica* returned to Paris after an absence of eighteen years as the centerpiece of a retrospective at the Musée des Arts Décoratifs, and, markedly unlike its initial reception in 1937, this time the painting was received by Paris's museum-going public as an honored—if long-absent—native of the city in which it was created. But because he had committed himself that summer to participating in the filming of Henri-Georges Clouzot's documentary *Le Mystère Picasso* in Nice, Picasso did not see *Guernica* that year. He had not viewed his single most renowned painting since he shipped it to New York in the spring of 1939—nor would he ever see it again.

In the fall of 1955, *Guernica* was shown to enormous acclaim at Munich's Haus der Kunst, the same museum in which "degenerate" art like Picasso's had been ridiculed by the Nazis two decades before. At the close of the year, the painting traveled on to Cologne, then to Hamburg, Brussels, and Stockholm during 1956 before crossing the Atlantic once more for its inclusion in May 1957 in the New York Museum of Modern Art's exhibition celebrating Picasso's seventy-fifth birthday, a show that moved to the Chicago Art Institute and the Philadelphia Museum of Art before *Guernica*—now a bit battered by its itinerant travels—at last returned to New York.

In the twenty years since its creation, the painting had suffered significant damage. Paint had cracked and flaked

away, particularly near the painting's edges, and the unpainted canvas that wrapped around the wooden stretcher had grown weak from its repeated piercings by tacks. MOMA conservators had strengthened those edges by adhering strips of new canvas to them as early as 1946, and soon thereafter, they had repaired from the back a small tear positioned near the eyes of the prostrate soldier in the painting's lower left quadrant. *Guernica* was thoroughly cleaned when it returned to MOMA in 1958; a clear protective varnish was applied to the painting's surface in 1962, and numerous cracks received spot treatments and the back of the canvas was treated with a preservative in 1964. A decade later, conservators at the museum were forced to use the solvent xylene to restore the canvas after New York artist Toni Shafrazi spray-painted the words KILL LIES ALL in meter-high, bloodred letters across the painting's surface as part of what he called a "collaboration" with Picasso in ongoing protest of the Mylai massacre in Vietnam. The protective veneer of varnish made removing Shafrazi's graffito a relatively simple task, but soon thereafter, conservators applied a new coat of varnish to further defend the canvas from vandals, and following the February 1974 incident, a guard thenceforward was posted near the painting during all viewing hours.

Pablo Picasso never had been an inveterate traveler, but like his peripatetic painting, he too had been physically worn by the sweep of years. His once-incredibly keen eyesight had softened, he had grown distressingly deaf, and by the occasion of his seventy-fifth birthday he had begun to prefer the warm days and bright skies of the Côte d'Azur to the dark and too-often dreary winters of Paris. Yet he remained a man of complex and often conflicting desires, one whose delight in companionship always was matched by

his need for the clarifying solitude of his studio, an artist who made things—paintings, drawings, sculpture, ceramics, figurines—as readily and as necessarily as he drew breath, one whose creative energy still stunned those he let draw near him.

It was a measure of Picasso's complexity that by the time he received the second of two Lenin Prizes in May 1962, awarded by the Soviet Union in hopes of "strengthening the bonds of peace between all peoples," he had abandoned his passion of the previous decade for politics in general and communism in particular. Late in his long life, his deceased mother remained his most profound influence, yet he continued to crave the worshipful attention of a series of lovers far younger than himself. His decade-old liaison with Dora Maar had dissolved in the midst of World War II in favor of a tempestuous relationship with a young Parisian student and artist named Françoise Gilot, and in 1953, that relationship, in turn, gave way to an affair with Jacqueline Roque, a woman fully fifty years his junior whom he met in a pottery shop in the village of Vallauris near Nice, and whom he married in 1961. Forever something of a child himself, Picasso adored the company of children at moments of his choosing, yet by the time his third and fourth children, Claude and Paloma, were born to Françoise Gilot, he still had learned little about how to be a true and nurturing father. He was a worldly man whom the material and sensual gratifications of Madrid, Barcelona, and Paris always had brought most vitally to life, yet he chose to spend his final years in a series of isolated chateaux he both adored and despised on the outskirts of tourist villages in the south of France. Throughout his life, he had paid rhetorical homage to the causes of peace and justice, yet only the Spanish civil war ever truly elicited

his outrage, his resources, and his intrepid artistic expression. He was a Spaniard, perhaps more than he was anything else, and his country's devastation by war—*his* war, a war in which the passionate duende of the bullring gave way to the deliberate death of the slaughterhouse—transformed his love for Spain into a tragic lament.

Always, the artist whose talent first had begun to astound his parents while he was still a small boy in Málaga, continued to draw and paint, to make prints and three-dimensional pieces at an obsessive pace, and, as his life neared its end, it seemed fitting that his last significant body of work was a series of 357 engravings charged with powerfully explicit erotic energy—prints that were not the work of a man who longed for a life that had passed him by, but which were the frank expression instead of what to him remained the raw essences of living—the seduction of beauty, the rush of desire, the sublime pleasure of creation.

Ninety-one-year-old Pablo Picasso had suffered influenza in the winter of 1973, yet he was regaining strength and had begun to talk enthusiastically about the work he looked forward to completing in the coming year when he began to have difficulty breathing at his home in Mougins on April 7. A local physician worried that his lungs were septic and were rapidly filling with fluid, and that his heart had grown terribly weak. The following day, a cardiologist who was a longtime friend of the elderly painter's arrived from Paris to confirm that the great man was gravely ill and that little could be done for him except to make him comfortable. Yet because of the welcome presence of a visitor in the vast house, Picasso had insisted instead on rising, shaving, and dressing, and he was eager as well to show the doctor a painting in progress in his studio, but soon thereafter he

needed to lie down. His wife Jacqueline helped him to bed, and throughout the morning he weakened, his breathing becoming quite labored. A bit before noon, the artist whose many thousands of images by now had become synonymous with both the delights and terrors of the twentieth century, slipped out of consciousness and died.

The news of Picasso's death in the spring of 1973 deeply saddened those in Spain who, like Angel Vilalta, believed it was to their country's collective shame that great Spaniards still should be dying in exile. Yet for Francisco Franco, the nation's autocratic leader for thirty-four years to date—one of the longest dictatorial rules in the world in the twentieth century—there was a satisfying personal pleasure in having outlasted the artist whose renown he always had coveted, but whose work, like all contemporary art, he deeply despised.

The caudillo's own leisure tastes always had run toward hunting, card-playing with an intimate circle of cronies, watching Western movies, and zealously following the fortunes of the football club Real Madrid. Sports of every kind fascinated him enough, in fact, that while vacationing in the Basque resort city of San Sebastián in September 1970, Franco had wanted to attend the Spanish national championships of the Basque-born handball sport called *pelota*, or jai alai. But during the match, however, the caudillo briefly was forced to confront the fact that memories of the civil war remained raw and unhealed in the region he had taken such pleasure in bringing to its bloody knees.

Thirty-three years before, a Basque nationalist soldier named Joseba Elósegi had witnessed the Nazi attack on Gernika, and had fired a machine gun into the sky in a vain

attempt to defend the imperiled town. Two weeks later, he had succeeded in shooting down near Bilbao a German Heinkel bomber, in the diary of whose pilot Elósegi had discovered the word *Garnika* under the heading for April 27. When Franco's rebel forces had completed their rout of the Basque region in the summer of 1937, Elósegi had been sentenced to death, but had escaped to exile in France before he could be executed. "I do not intend to eliminate Franco," the now-middle-aged man wrote in his own diary a few days before he knew he could draw near the dictator at the *pelota* championship. "I want only for him to feel on his own flesh the fire that destroyed Gernika . . . because Gernika represents for Basques something more than a pile of stones. Its destruction signifies persecution and oppression. And the man who personalizes all this will be there before my eyes."

As he had carefully planned in the days prior to the incident, in the midst of a morning match Elósegi doused himself with gasoline, set himself on fire, then dropped onto the *frontón*—the court on which the game is played—from a wall high above it, falling only a few meters away from a momentarily terrified Franco. "Long live the free Basque country!" he shouted as security agents took control of him and extinguished the flames from his burning clothing. Soon the aging dictator appeared impassive again, and in less than an hour the matches resumed. Elósegi slowly recovered from severe burns, and this time, his sentence for his self-immolating act of protest was limited to seven years.

At the time of Picasso's death in 1973, Spain had been in violent turmoil for four years, longer than at any time since the civil war, a period of protest and repression that began when Franco declared that then-thirty-two-year-old Prince

Juan Carlos—grandson of King Alfonso XIII, who had abdicated Spain's throne in 1931 as the republic was being formed—would succeed himself as Spain's absolute ruler. Born in Rome in the midst of the civil war, Juan Carlos had received a strict Spanish military education under Franco's watchful eye while his father had remained in exile. In the few public statements he ever had made, the young prince always had insisted that he believed his father, Don Juan, should, in fact, become king. Franco's pronouncement therefore was crushing news for the millions of Spaniards who long had hoped, perhaps naively, that Franco's death would initiate massive change, because the cautiously tutored Juan Carlos, it was widely believed, would have no interest in anything other than fulfilling the caudillo's wishes, and because—Franco made it surpassingly clear—his trusted subordinate, Prime Minister Luis Carrero Blanco, would insure that his iron rule would continue long after his death.

A wave of illegal strikes and university protests that followed the 1969 announcement led Franco to order a state of emergency—making the mildest statements in opposition to Juan Carlos subversive acts that were summarily countered with arrests and imprisonment. In the Basque region in the north of Spain, members of the underground organization known as ETA, an acronym for *Euskadi Ta Askatasuna*, Basqueland and Liberty, which had been formed in the 1950s, grew increasingly bold and violent, as did the Franco government's response. When ETA claimed responsibility for the August 1968 assassination of a reviled San Sebastián police captain, Franco declared martial law throughout the Basque region; sixteen suspected ETA terrorists were arrested, and in December 1970 three were sentenced to death. In December 1973, the ETA offensive escalated to the highest

levels of the Spanish government when Prime Minister Carrero Blanco's car was dynamited in Madrid, and his death led once more to nationwide martial law and the arrest, imprisonment, and torture of hundreds in the Basqueland and throughout the country.

By the late summer of 1975, thirty-three Basque nationalists—only a few of them actually ETA members—had been killed by officers of the guardia civil. ETA, in turn, claimed responsibility for thirty-eight political murders. When Franco, despite being bedridden, ordered five Basque prisoners shot by a firing squad in September, people in the Basque region responded with massive—and, of course, illegal—strikes. Trade unions throughout Europe initiated boycotts of Spanish goods; fifteen European nations withdrew their ambassadors from Madrid, and Mexican president Luis Echevarría, himself of Basque descent, called for the expulsion of Spain from the United Nations. Once again, repressive and still-fascistic Spain became openly reviled around the world, and following nearly forty years of Franco's rule, the nation was wracked by violence that was grimly reminiscent of the years of the civil war, when blood ran in the streets and bombs rained out of the skies.

It appeared the nation might erupt into civil war for the second time in the century, when, on November 20, the frail and infirm caudillo died quietly in Madrid. Two days later, Juan Carlos acceded to the Spanish throne, and the onerous era of Francisco Franco, which had begun with his rebellion against the Republican government thirty-nine years before, at long last came to a close.

* * *

"It was a very intense time," Angel Vilalta remembered. "Every day the radio and television would report how sick Franco was. He was getting sicker every day. And really, we wanted him to die. We gathered in each other's homes and had champagne ready to celebrate, but it seemed he just got sicker. You cannot imagine what it meant to us. All of my life I had spent under Franco, but now, was it possible that things would change? ETA had done a very good thing. They had killed the terrible Carrero Blanco, who would have continued Franco's brutality, even with Juan Carlos as king, so we knew a better Spain, a freer Spain was possible, but after so long, could we dare hope for it?

"I'm afraid very many Spaniards got very drunk when at last Franco died. Oh, it was wonderful, really. Then we all watched his huge funeral, which he had planned—so ridiculous, like a Hollywood movie. But then Juan Carlos was sworn in as king and the bishop who swore him, Bishop Tarancón, a very brave man, gave a wonderful speech—which, of course, Juan Carlos must have approved of in advance—telling him, 'Your Majesty, you have not become king for yourself, but for the Spanish people. You now are called to help all Spaniards, whoever they are, whatever they say.' It was then for the first time that we felt things would go well for us.

"And they did go well, of course. It was wonderful, really. The first election the king called was simply to ask the question: Spaniards, do you want to continue with the current system, or do you want to transform Spain into a Western democracy? I remember that a BBC journalist asked the king if he was happy with the answer the voters gave him, and replied, yes, of course. Then the man asked, would you have accepted it if your countrymen would have chosen not

to change, and Juan Carlos told him, 'I would have accepted it, but it would have made me very sad.'

"The king soon began to impress us very much. When Henry Kissinger suggested to him that the Communists should not be allowed to participate in the first elections, the king listened instead to the Spanish people and said, 'No, they must participate. How can elections be free if one party isn't allowed to participate?' Oh, we all liked that very much. Then, when Juan Carlos met La Pasionaria, Dolores Ibarruri, who after the civil war had lived in Russia many years and had returned to Spain and was elected to parliament once more, he told her, 'To shake your hand is to enter Spanish history.' That is the kind of person he is."

When I told Angel I remembered well how he had spoken with bitter condescension about Juan Carlos back in 1969—how surely he was being trained to become Franco's puppet—he said, "Of course, how could we think anything else? How could we imagine that Franco would choose someone so different from himself? But thank God we were wrong. You know, Franco detested the Spanish people. He despised us and that was why he was so cruel. But our king turned out to be just the opposite. He trusts the Spanish people more than he trusts anything else."

Four days following Juan Carlos's inauguration as king of Spain, the first of what ultimately would become a chorus of calls for *Guernica* to move permanently to Spain came from Herschel B. Chipp, a Picasso scholar and professor of art history of the University of California. In a letter published simultaneously in the *New York Times* and the *Times* of London, Chipp argued that

the passing of Francisco Franco now makes it possible for one of Spain's most renowned exiles to return to its homeland. It is Picasso's *Guernica*, his greatest work and probably the most important history painting of the twentieth century . . . [which has] become a world symbol of man's abhorrence of warfare as an instrument of terror against noncombatants. . . .

Picasso's widow and his children now have the opportunity to honor his wishes and send his painting to Spain, where once again in its history it could exert a powerful force for humanity. The gift of *Guernica* to the Spanish people could, by its message of universal suffering in warfare, help heal the wounds of the bitter civil war. It could be a stimulus toward a freer and more humane regime under their new leader, and it could even become a symbol before the world of a more unified and more liberal country.

Chipp's letter immediately generated an indignant response by William Rubin, the often-abrasive director of painting and sculpture at MOMA, one in which he accused the historian of not knowing what he was talking about. Franco had never expressed an interest in the painting going to Spain, Rubin claimed, incorrectly, adding that, in accordance with the painter's wishes, MOMA would surrender *Guernica* "only when a genuine Spanish republic has been restored," a circumstance that seemed most unlikely in the autumn of 1975, a few days following the reformation of the Spanish monarchy under Juan Carlos. For reasons that were

unclear, Rubin chose *not* to mention Picasso's 1970 written instructions to the museum that the painting would be returned "to the Spanish government when public liberties are reestablished in Spain." MOMA, it now appeared, planned to keep control of the single-most-renowned painting in its collection as long as it possibly could—a circumstance that wasn't particularly surprising—and the hair-splitting distinction between whether the artist wanted the painting to return to a reinstated Spanish republic or to a Spain in which "republican liberties" had been restored now appeared likely to aid the museum in its efforts to have the question resolved as slowly as possible.

A week later, Picasso's lawyer Roland Dumas responded in Paris's *Le Monde*, reminding museum officials in New York that the two essential truths in the matter were that Picasso had believed *Guernica* belonged to the Spanish people and that he had looked forward to the day when the painting would be at home in a newly free Spain. But the bottom line, in any case, said Dumas, was that he was in possession of a written statement from Picasso specifying that *he* would decide when conditions in Spain warranted the painting's transfer. MOMA officials, he made it clear, really had no voice in the matter.

As Picasso's widow, Jacqueline; his three surviving children; and two surviving grandchildren continued what had become a bitter battle over the settlement of the painter's enormously valuable estate—a familial conflict the painter could have precluded had he chosen to execute a will—the political landscape in Spain changed dramatically. Trade unions and political parties were legalized; divorce and limited abortion rights were granted; the press was unshackled;

pensions and disability allowances were awarded to war veterans who had fought for the republic; both Catalan and Euskera legally could be spoken again, anywhere and at any time. In Catalunya, once more people danced the simple *sardana* to celebrate the rights that had returned to them. In June 1977, Spaniards elected a right-of-center government, headed by Prime Minister Adolfo Suarez, in their first free elections in forty-six years, and from the Basque region, both Dolores Ibarruri, La Pasionaria, and Joseba Elósegi, the war survivor who had immolated himself in front of Franco, were elected as members of the Communist and Basque Nationalist parties to seats in the Cortes, the nation's newly revived parliament. In December 1978, Spanish voters overwhelmingly ratified a progressive constitution that explicitly guaranteed numerous human rights, a constitution that immediately was signed into law by the king, and the Cortes passed by an equally wide margin a resolution introduced by Basque Senator Justino Azcárate, himself a civil war refugee, calling for the formal repatriation of three more exiles from the civil war years: the physical remains of the king's grandfather, Alfonso XIII, and of Manuel Azaña, the first president of the republic, as well as Picasso's masterpiece, *Guernica*. The painting was SPAIN'S LAST EXILE, shouted the leftist journal *Cambio 16*, but in Paris, *Maître* Dumas remained unconvinced that the time was right for the painting to leave New York City. "The situation in Spain is evolving well," he admitted, "but there are, of course, certain problems. The Basque question, the terrorism. One does not yet feel that the young Spanish democracy has the profound stability that one feels in France, the United States, or other countries. I should not like to have been seen to have been too hasty by a year. I have no electoral constituency. *Guernica* is for eternity."

Three years had passed since William Rubin had claimed that the painting never could go to Spain absent the return of a constitutional republic to that country—three years during which it had continued to anchor MOMA's collection—and nowadays Rubin eagerly aligned himself with the French lawyer whose patience he very much applauded. "We agreed from the start with *Maître* Dumas that the operative phrase was 'democratic system.' We never intended it in narrow terms that would have made the Spanish monarchy any more ineligible than the British monarchy. The question of a republic per se has never been an issue for us," Rubin told the *New York Times*, twisting the truth as dramatically as Picasso often had reshaped physical reality.

But to governments in Madrid and Washington, it seemed, MOMA's eventual willingness to surrender the painting had become more than a little suspect. Already, Prime Minister Suárez had met with U.S. president Jimmy Carter and had asked for his help in persuading both MOMA and Dumas that the time was right for *Guernica*'s repatriation to Spain. In October 1977, the Cortes declared officially that the Spanish government now should "request—through the most appropriate procedures—of the directorate of the Museum of Modern Art in New York and other competent authorities their solicitude in the return of the painting entitled *Guernica* by Pablo Picasso." The use of the word *return* was not a rhetorical misstatement, but rather a subtle reminder on the part of the Spanish legislators that the painting had belonged to the people of Spain since its creation, and that it therefore would *return* to its rightful owners when it traveled to Spain for the first time. In Washington a year later, members of the Congress at last had grown equally impatient, and, in a joint resolution sponsored by Senators George

McGovern and Joseph Biden, they declared that "it is there-
fore the sense of Congress, anticipating the continuance
of recent promising developments in Spanish political life,
that *Guernica* should, at some point in the near future and
through appropriate legal procedures, be transferred to the
people and government of a democratic Spain."

At the end of 1978, the national governments of the two
countries involved in the issue had gone on record stating
that the painting should be moved, yet MOMA officials re-
mained sanguine about not having to relinquish it any time
soon, and in Paris, the affable *Maître* Dumas still would say
no more than "In time, in time."

Before *Guernica* could cross the Atlantic again, the swell-
ing numbers of people working for its repatriation faced two
ongoing obstacles: Roland Dumas had to be persuaded to
announce that the time was right, and Picasso's heirs had
to be convinced that they should surrender all legal claims
to the painting—converted to the belief, in other words, that
the Spanish people had purchased the mural in 1937, and
that therefore it was no longer part of the artist's estate. And
there was one more question to settle as well: precisely *where*
in Spain should *Guernica* rightfully reside?

Picasso had been the honorary director of the Museo del
Prado in Madrid and had looked forward to his work being
shown in the nation's great museum one day, and many ob-
servers simply presumed that for those reasons, if no others,
the Prado would welcome the painting one day. But others
believed the painting would be far more at home in the new
museum of contemporary art in the city's outlying Ciudad
Universitaria district than it would among the work of Spain's

old masters, and, further afield, the citizens of the town of Gernika believed *they* made the most compelling claim for the painting; it owed its very existence, after all, to their monumental suffering. In April 1977, officials in Gernika had constructed a full-size replica of the painting, which hung behind an outdoor altar during a memorial mass for those who had died in the Nazi attack precisely forty years before. In Málaga, where Picasso was born, city officials recently had completed construction of a fine new museum, one that could house *Guernica* wonderfully, they believed— and the port city on the Costa del Sol had been similarly destroyed during the war, they hoped their fellow Spaniards would remember. Yet Barcelona remained the only city in Spain that already possessed a museum dedicated solely to the work of Picasso. It could receive *Guernica* almost immediately, and surely the painting would be very comfortably at home in the city the painter considered his truest home as well.

Wherever *Guernica* belonged, first and foremost it belonged in *Spain*, argued a group of Spanish students who entered MOMA on September 4, 1978, ascended to the third-floor gallery where the painting was hung, then unfurled a Spanish flag, symbolically taking possession of *Guernica* for the people of Spain. Yet Roland Dumas and most of Picasso's heirs, it appeared, still did not agree that the painting belonged anywhere other than New York.

Dumas, in fact, muddied the water rather dramatically when he raised the possibility that Picasso's heirs might possess *droits morals*, moral rights, to the painting, which would have to be considered in addition to the painter's own desires, and the fact that Dumas represented Jacqueline Picasso in the dispute over her late husband's intestate estate

now made his personal claim of complete impartiality in the matter more than a little suspect. For their part, officials in Spain determined that their best strategy for securing *Guernica* in the foreseeable future was to prove, if possible, that it was the rightful property of the first legitimate government to succeed the Spanish Republic, and that the opinions and desires of lawyers and family members in France therefore didn't have any standing.

Prime Minister Adolfo Suárez appointed veteran diplomat Rafael Fernández Quintanilla—son of artist Luis Quintanilla, who had been a friend of Picasso's—ambassador-at-large, with the specific charge of confirming that no one had a stronger claim to *Guernica* than did the government of Spain. Quintanilla quickly determined that documents created in 1937 by former Republican officials might well make a strong case that the painting had, in fact, been purchased, and that its ownership was not in question—if such documents still existed. Quintanilla's investigations sent him rummaging into archives on two continents, and in the end he succeeded in foraging three vital documents. The first was a 1937 ledger from the Spanish embassy in Paris showing payment of 150,000 francs to "P. Picasso," with the handwritten notation "*gastos Guernica*"—*Guernica* expenses. The second was a May 28, 1937, letter from Max Aub to Ambassador Luis Araquistáin in which Aub enthusiastically reported that "this morning I arrived at an agreement with Picasso."

> In spite of the resistance of our friend to accept any remuneration from the embassy for the commission of *Guernica*, as he is donating it to the Spanish Republic, I repeatedly insisted on transmitting to him

the government's desire to reimburse him at least for the expenses he incurred in making the painting. I eventually succeeded in persuading him, and subsequently gave him a check for 150,000 French francs, for which he signed a receipt. Although the sum is rather symbolic, considering the inestimable value of the painting, it nonetheless represents the acquisition of the painting by the republic. I believe that this was the most feasible method of establishing property rights to the painting.

Although Quintanilla never found the receipt itself, he did encounter a letter written to Araquistáin in January 1953 by former Republican Prime Minister J.A. del Vayo in which del Vayo well remembered the receipt in question and speculated that it must have been lost in January 1939 when officials frantically evacuated the Republican government from Barcelona.

When Quintanilla presented his findings to Roland Dumas in Paris on February 20, 1981, the lawyer at last had all the information he believed he needed. It now appeared incontestable to him that Picasso had received a sum equivalent to more than 6,000 dollars for the painting that would become the property of the people of Spain. And in the five and a half years since Franco's death, the sons and daughters of those Spanish Republicans, together with their progressive king, had created an open, democratic, and newly flourishing society, and therefore, Dumas declared, now was the time for *Guernica* to move to its permanent home. Yet if Picasso's lawyer was newly satisfied by Quintanilla's investigation, opinions about the painting's rightful ownership

remained divided among his family members, so new efforts now were focused on them.

Prime Minister Adolfo Suárez wrote to each heir early in the year to suggest that *Guernica*'s arrival in Spain should be the highlight of a celebration of the centenary of the patriarch's birth, which would commence in October. Picasso himself would heartily endorse the painting's transfer at this moment, he wrote, "thanks to the constitution approved by an immense majority of Spaniards and universally recognized as free, democratic, and sovereign." The artist's widow Jacqueline and granddaughter Marina responded quickly, assuring the prime minister that they would no longer impede the painting's move, but the others did not reply. Spain's current director general of fine arts, Javier Tusell, believed the two children of the late Françoise Gilot, Claude and Paloma, simply hoped to delay decision-making on the disposition of *any* painting until the estate was entirely settled. Grandson Bernard announced after visiting Madrid that the Spanish democracy was fragile and that he therefore could not sanction the move; and when Tusell met personally with Maya, who now lived in Spain, he discovered that she was more concerned about potential changes in Spanish family law, which could affect her status as Picasso's illegitimate heir, than she was about the fate of *Guernica*.

Six months before, Director Tusell himself had taken charge of the question of precisely where in Spain the renowned painting should reside by beginning the renovation of the Casón del Buen Retiro, a small and rather elegant seventeenth-century building that adjoined and belonged to El Prado, and which currently housed rather inconsequential nineteenth-century Spanish art. The costly project included sophisticated temperature and humidity

controls, explosives detectors, radio and television surveil-
lance devices, and other features designed to limit potential
terrorism inside the building. *Guernica* would be housed be-
hind a cage of bulletproof glass in the Casón's large central
gallery, and without a magnetic security card, no one would
be able to enter the sealed enclosure and reach the canvas
itself. When the retrofitting was complete in February 1981,
officials from MOMA agreed with Tusell that concerns they
previously had expressed about the painting's safety—in a
country where political terrorism remained a constant threat—
now had been allayed. And within Spain itself, it increas-
ingly appeared that the majority of the country's citizens
were at ease with the fact that when the painting at last did
arrive in Spain, its home would be Madrid.

It was a measure of just how passionately Spaniards had
regarded the question of where *Guernica* ought to hang in
perpetuity that, four years before, Spanish national televi-
sion had hosted a sometimes contentious debate between
the mayors of Madrid, Málaga, Gernika, and the director of
the Museu Picasso in Barcelona, one in which each partici-
pant ardently made the case that *his* city was the painting's
proper home. But by now, a national poll conducted by a
Madrid magazine showed that a majority of Spaniards agreed
that *Guernica* should reside in the capital city; fully 40 per-
cent of those queried favored El Prado as the painting's
permanent home, while 20 percent favored Barcelona, 10 per-
cent Gernika, and 7 percent the city of Málaga. Yet still,
Guernica remained in New York; Museum of Modern Art of-
ficials continued to express concerns about the Spanish gov-
ernment's property rights to the painting; and in Madrid for
a few hours on February 23, 1981, it appeared that that very
government was in grave peril.

Following the resignation in January of Prime Minister Suárez—whose national support had shrunk dramatically because of a declining economy and rising concerns about Basque terrorism—King Juan Carlos had nominated Leopoldo Calvo Sotelo to serve as an interim prime minister until new elections could be held in the fall. His selection of the conservative son of an early stalwart of Spain's Fascist Party worried many observers that the king actually opposed his country's swift democratization, and their concerns turned suddenly to horror when twenty armed members of the guardia civil—led by Lieutenant Colonel Antonio Tejero, a radical Francoist who had been relieved of his command in the Basque country four years before because of his refusal to accept the legalization of the *ikurriña*, the Basque national symbol—stormed the Cortes as the Congress of Deputies was voting on the Calvo Sotelo nomination, fired shots into the building's ceiling, and ordered the terrified legislators to the floor. From the podium, Tejero, wearing the loathsome tricornered hat and brandishing a pistol in his hand, announced that the guardia and the national army were seizing control of the government. Tanks rolled into central Madrid; rebel officers commandeered television and radio stations to broadcast the shocking news, and it appeared that after only six years of the light of liberty, Spain would be thrown back into the dark well of dictatorial rule in which its citizens had lived for so long.

Yet the king, as the constitutional commander-in-chief of the military, acted swiftly, ordering his subordinates to remain loyal to him and forming a provisional government that gave him sweeping temporary powers. It was Juan Carlos's daring and decisive opposition to the rebellion that per-

suaded scores of military officers not to join it, and within eighteen hours Tejero and his confederates surrendered. Two days later, the Congress of Deputies reconvened to approve Calvo Sotelo's nomination as prime minister; in the succeeding days, the king was heralded across the nation and around the world as the savior of Spanish democracy, and Tejero and a fellow conspirator ultimately received thirty-year prison sentences for their roles in the attempted coup d'état—a shrill warning to anyone else who believed he might emerge as a latter-day Francisco Franco.

For those in the government who were at work attempting to secure *Guernica's* return to the nation to whom it belonged, the February day of terror served foremost to quicken their efforts. They understood that those who previously had expressed concerns about the stability of Spain's democracy might well use the events of February 23 to buttress their arguments. Yet those same events could be employed as readily, Spanish officials believed, to prove how strong that democracy was, in fact, given its ability to withstand a serious attempt to destroy it. It appeared increasingly clear as well that the strategy of courtesy and patience now had run its course, and continuing it might well result in an indefinite delay in the painting's transfer to Madrid. Convinced that the documents Quintanilla had uncovered were sufficient proof of its rightful claim to the painting, the government of Calvo Sotelo decided simply to ignore the Picasso heirs who still opposed the move and to make a formal demand of the Museum of Modern Art for *Guernica's* immediate transfer. In the first week of April 1981, Quintanilla and his legal assistant Joaquín Tena traveled to New York and, in the company of the Spanish consul in New York, Rafael de los Casares,

went to MOMA to present the demand in person to museum director Richard Oldenburg. Acknowledging the "excellent way in which the museum has taken care of and exhibited *Guernica* and related works during more than thirty years," the petition outlined Picasso's often-stated desire for the painting to find a final home in Spain one day, the property rights the Spanish government believed it possessed, as well as its efforts to construct a secure exhibition space for the painting in the Casón del Buen Retiro. It was time, Quintanilla said bluntly to Oldenburg and Rubin, for *Guernica* to go home.

But still the museum stalled, as it had since 1975. MOMA was open to the transfer, Oldenburg assured his visitors, but before it took place, he proposed that they all meet behind closed doors in Paris with Picasso's heirs as well as with Dominique Bozo, the director of the soon-to-be-opened Musée Picasso, which would be filled with works the French government had accepted from the heirs in lieu of taxes. The Spaniards had little option but to agree to the proposal, and in Paris at the end of June, all parties—American, Spanish, and French—agreed at the close of a marathon session that *Guernica* should move forthwith to the Museo del Prado. Oldenburg now could assure his board of directors that everything possible had been done to keep the painting in New York as long as possible; the heirs were newly confident that only *Guernica* and its preparatory works were deemed to belong to Spain, and Director Bozo—still a bit unclear about why she had been brought into the discussions—was relieved to hear that MOMA would not request that its signature painting be replaced by other Picasso works. *Guernica* had not traveled since the spring of 1958, but—inevitably at last—soon it would fly to Spain.

Following the Paris meeting, MOMA officials hired former secretary of state Cyrus Vance to advise the museum on its potential liabilities in the transfer of the painting, and Vance recommended that in addition to requesting a formal letter from Roland Dumas certifying his belief that Picasso's conditions for the transfer had been met, the museum also demand from the Spanish government a written agreement indemnifying MOMA from any future liability related to the painting. In August, the museum received documents from Paris and Madrid that satisfied those concerns, and on September 6, Spanish Minister of Culture Iñigo Cavero and Director General of Fine Arts Tusell arrived in New York to take physical possession of the painting. In order to conceal the particulars of the painting's transfer from potential terrorists, both MOMA and the Spanish government had begun in the previous weeks to talk openly about the likelihood that *Guernica* would be released to King Juan Carlos when he traveled to the U.S. in the winter. Yet on Wednesday, September 9—a day on which the museum was closed to the public—Cavero and Tusell joined museum officials Oldenburg and Rubin, chairman of the board William S. Paley, and president Blanchette Rockefeller in a private ceremony during which documents were signed, grateful thanks were expressed, and good wishes were shared all around.

Soon thereafter, the painting that had been seen by an estimated twenty-five million people during its long tenure in New York was taken down from its familiar wall by museum conservators, then was removed from its stretcher, meticulously padded and rolled onto a newly constructed wooden drum, and placed in a stout crate marked only with the identifying words LARGE PAINTING and the cautionary

USE NO HOOKS. The painting next traveled by truck to Kennedy International Airport, where it was placed in the cargo hold of a regularly scheduled Iberia Airlines flight, and early that September evening, a disguised and anonymous *Guernica* flew home to a place it never had been before.

Guernica in Gernika

It was a stunning sight, the kind of scene people in Spain increasingly had begun to encounter, a blend of the old and feared with the wonderfully new. There on the tarmac at Barajas Airport on the outskirts of Madrid stood a dozen members of the guardia civil—their eyes scanning for potential trouble, their machine guns cradled in their palms—charged with protecting a painting by Pablo Picasso that only a few years before they would have been bound to destroy. The Iberia Airlines flight had arrived from New York City early on the morning of September 10, 1981, and the guardia had been waiting to secure the plane as it parked, then to stand watch as the long crate that contained *Guernica* was off-loaded into an unmarked truck for transport to the Museo del Prado's Casón del Buen Retiro.

The painting's arrival that morning purportedly remained a carefully guarded secret, yet by the time the truck that carried it reached the small buff-colored building that lay between El Prado and Retiro park, a sizable crowd had gathered, newspaper reporters and television crews were on hand to record the auspicious arrival, and helicopters fluttered overhead. Clearly aware of the significance of the moment, the group of Prado conservators assigned to facilitate the move

appeared like pallbearers curiously dressed in white as they slowly and proudly bore the crate from the truck to the large front doors of the building, and as *Guernica* disappeared inside—finally at home for the first time since it was created forty-four years before—the crowd of onlookers, and even members of the media, burst into loud applause.

THE WAR HAS ENDED were the words that headlined the national newspaper *El País* the following day above a lead story about *Guernica*'s successfully uneventful transfer from the Museum of Modern Art to its new home in Madrid. The headline bore a remarkably important symbolic truth: nothing in the forty-two years since the civil war's guns were stilled, nothing in the long and terrible reign of Francisco Franco, ever had signaled a deeply shared and satisfying conclusion of hostilities in the way this single painting's repatriation to Spain had done, its complex and profoundly disturbing images of horror at last a perfect symbol of peace.

It took six weeks to prepare for the official unveiling of *Guernica* as part of *Legado Picasso*, Picasso's Legacy, a centenary exhibition of the artist's work—almost all of it shown in Spain for the first time—in a number of venues around Madrid and across the country. During that time, anticipation palpably mounted among the many thousands of people for whom *Guernica* always had been personally important but who never before had been able to view the massive canvas in person. And inevitably, there was dissent as well. Factions of the extreme right groused loudly about all the attention being paid to a *Communist* artist, about the half-million-dollar cost to renovate the Casón del Buen Retiro that might well have been better spent, about the fact that many young people now were mistakenly blaming Franco

for the bombardment of Gernika when, in fact, it was Hitler's air force alone that had been responsible for the attack. In the Basque country far to the north of Madrid, hundreds had gathered on Friday, September 11, outside the historic assembly hall in Gernika to protest the fact that Picasso's painting would travel no farther than Madrid and that—at least as far as the protestors were concerned—little had changed about the way in which the region and its people were treated by the rest of the nation. "We gave up the dead and they have the picture," the Basque Nationalist Party officially declared, claiming that "an authentic cultural kidnapping done by the Madrid government" had precluded the possibility that Basques one day might view *Guernica* in Gernika.

Yet it was a remarkable moment nonetheless when the octogenarian member of parliament from Bizkaia, Dolores Ibarruri, La Pasionaria, joined a legion of other dignitaries on the afternoon of October 24 for the official inauguration of the painting's permanent installation in Madrid, the city she valiantly had helped defend against Franco's forces in the early months of the civil war. A number of Franco partisans who long had been her bitter foes attended the by-invitation-only gathering as well, as did many who had witnessed the painting at a variety of points along the way from its fevered creation as a Republican propaganda piece to its present status as one of the most recognized and important artworks in the world. Douglas Cooper, the British art historian and longtime friend of Picasso's who had viewed *Guernica* in the artist's studio on several occasions while it was in progress, was present, as was Josep Lluis Sert, who had encouraged its creation and designed the location for its first exhibition. Thirty-two-year-old Paloma Picasso—who for a

time had joined her brother Claude in vigorous opposition to the painting's transfer to Spain—was the only member of the artist's family who attended the reception, but many were present who had played vital roles in facilitating its journey, among them Madrid lawyer José Mario Armero, who had led the earliest efforts to bring *Guernica* to Spain and who was a principal architect of the country's new constitution; Roland Dumas, the Paris lawyer in whose hands Picasso had lain the canvas's fate; Museum of Modern Art Director Richard Oldenburg; and Ambassador Rafael Quintanilla, Minister of Culture Iñigo Cavero, and Director General of Fine Arts Javier Tusell, each of whom had played key roles in the recent negotiations with Oldenburg and his staff. "*Guernica* is a cry against violence, against the horrors of war, against barbarism," Cavero told those in attendance. "No one should interpret the work as a flag for any sector— let us look at *Guernica* as a pure and simple rejection of brutal force."

On the previous afternoon, Prime Minister Leopoldo Calvo Sotelo and his cabinet privately had visited the Casón del Buen Retiro, and he had pronounced himself impressed by the wall of impenetrable glass that protected the painting from harm, seeing in its fortitude a symbol of the determination of the people of Spain to end violence of every kind. And although there were many who were distressed by the way in which the painting was sealed off from those who saw it—as if *Guernica* itself were hazardous somehow—and who were equally offended by the machine-gun-toting guardia civiles who stood watch at its flanks, many others opined that for the first time ever, the painting now could be seen at an appropriate distance and that the lighting and protective

shield framed it remarkably successfully. "Never in its history has *Guernica* been displayed so beautifully or so entirely to its advantage," Cooper later informed British readers in the *Burlington Magazine*. The renowned critic and historian, himself a trustee of El Prado, almost certainly had seen the painting in more settings than anyone else in the world, but he never had been more moved by it than he was in Madrid.

Cooper had viewed the painting during its creation in Paris in May 1937, then had seen it as well at the Spanish pavilion of the world's fair, where, he believed, Alexander Calder's "toy" had detracted attention from it. He had seen the painting in London and at the Valentine Gallery in New York and it had seemed sadly out of place to him in both of the private galleries. It was in Milan in 1953—when *Guernica* briefly had been displayed at the Palazzo Reale— where Cooper had been shocked for the first time by his "discovery of its incalculable importance" as it hung amid the bomb-damaged marble and plasterwork of the palace's great hall.

> I saw *Guernica* again many times after 1953: at Paris in 1955 and, off and on until 1980, hanging in MOMA. Yet I never again experienced the deep thrill of Milan until I saw the canvas in place at last in the Casón in Madrid in October. There I was more overwhelmed and convinced than ever before by its extraordinary purity of invention, the absence of any sort of anecdote or sentimentality and its strictly pictorial imagery. This is a painting which brings tears from the heart, arouses belief in the courage and endurability of human beings, and inspires one to take up arms and demolish the forces

of evil, whenever, wherever and in whatever guise (fascist or not) they manifest themselves, before they can succeed in suppressing the manifold forms of liberty which civilized man has won for himself, or in destroying the world around us.

More than four decades after it occurred, the destruction of Gernika remained etched as an act of barbarism in the world's collective consciousness. It was the first city ever to have been completely destroyed by aerial bombardment, and in 1937 its annihilation by this most modern means of warfare seemed unimaginably brutal. But by now, the devastation of Coventry, Dresden, Hiroshima, and other cities had made the descent of terror from out of the sky something that was simply all too commonplace, if not yet comprehensible. Gernika remained a name that was synonymous with savagery in part because the town's small size made the attack appear particularly inexcusable, but foremost because the events that unfolded there on an April afternoon had shocked Pablo Picasso into making its devastation the horrible subject of a mural he had promised to paint.

Almost half a century had passed, but still no one knew precisely how many people had perished in Gernika, and neither was it entirely clear who had ordered the attack. But the facts that hundreds, perhaps thousands had died at the hands of German and Italian airmen and that Franco and his minions first had denied that truth, then had worked feverishly to insure that they weren't blamed, were issues beyond dispute—at least with a single exception. In January 1973, William F. Buckley's *National Review* had embarrassed itself by publishing an article entitled "The Great Guernica

Fraud" by a conspiracy theorist and professor of English at Dartmouth College named Jeffrey Hart. "It may be that Picasso was not the only great artist, or even the greatest one, connected with the mythologization of Gernika," he had written. "He painted the picture, but Müzenberg invented the episode out of the whole cloth."

As far as Hart had been concerned, Willi Müzenberg, a Comintern agent based in Paris who was commanded in his evil deeds by the Soviet Union, had devised the plan for Basque Reds to dynamite and burn their sacred town and then to blame its annihilation on the Nazis, who, Hart contended, had *not* been warring for Franco in 1937. Never mind the hundreds of eyewitnesses to the aerial attack; never mind Lieutenant Colonel Wolfram von Richthofen's journal detailing the events of that day or Hermann Göring's Nuremberg admission of Nazi responsibility, nor even the official position of the Franco government that the reckless Luftwaffe had destroyed Gernika. For rabid anti-Communists such as Hart, none of those facts mattered as much as the desperate need to find a Soviet-inspired culprit on whom to lay the blame. Spain had been fascism's only victory in twentieth-century Europe, and for members of the radical right like the English professor, that great triumph could be remembered all the more sweetly if somehow the "myth" of Gernika could be made to go away.

It wasn't surprising when Hart's article quickly attracted attention in both Germany and Italy, where, understandably enough, others were eager as well to see Gernika yield much of its infamy. Within a few days of its publication in the *National Review*, a translation of Hart's article was published in its entirety in the German newspaper *Die Welt*, and the daily *Il Tempo* in Rome carried a detailed summation of his argu-

ments under the headline SENSATIONAL REVELATIONS THAT ARE BREAKING UP A MYTH, although the promised revelations turned out to be nothing more than the author's unsupported contentions that the Nazis never had flown in the skies above Gernika, and that Franco's air force simply hadn't possessed enough bombs to commit the destruction itself.

Since the day after Gernika was reduced to ruins, and now for nearly fifty more years, people had worked with passionate abandon to blame the town's devastation on the Basques themselves, or, barring that, to link it to a vast Communist conspiracy to destroy fascism's good name. And for all of that time, a Texan named Herbert Southworth had meticulously collected, recorded, and publicized those obfuscations, becoming in the process such a thorn in the side of the Franco regime that its ministry of information had established an entire department whose job it was to monitor him and counter him when it could. Born in Oklahoma in 1908 and raised on the sere plains of West Texas, Southworth was a lifelong bibliophile who in 1937 had been persuaded by the information office of the Spanish Republican embassy to leave his clerical job in the Library of Congress and join its efforts to convince the American public that the insurgent general represented a grave threat to international democracy. It was a task Southworth never really abandoned in a long life spent primarily in Morocco and France, where he kept exceedingly close watch on the nearby country that captivated both his professional attention and his heart.

In *Guernica! Guernica!*, his scholarly 1977 account of the dedicated efforts of Franco's own propagandists and his many admirers to erase the horror of Gernika from the world's memory, Southworth had set out to answer definitively the questions of the number of dead, and how, by whom, and

why the town was destroyed. Not surprisingly, despite an exhaustive, forty-year effort, he had been only partially successful in the end, acknowledging that much about the atrocity would remain clouded forever by the chaos of the war and the complex agendas of its participants.

For Southworth, the historical record was satisfyingly—if tragically—clear that Gernika had been obliterated by percussion and incendiary bombs dropped from German and Italian bombers, and that significant numbers of its citizens attempting escape had been machine-gunned from the air as well. Although the unimaginable chaos that surrounded the town's bombardment and subsequent capture by the rebels had made an accurate counting of the dead and wounded impossible, Southworth's examination of dozens of estimates made over many decades led him to believe that the Basque government's figures of 1,654 killed and 889 wounded during the three-hour attack came closest to being correct. He concluded that the genesis of the attack had come not from Nazi officials in Berlin, as many investigators long had believed, but rather from Franco's high command, *perhaps* planning in concert with those who headed the Condor Legion in Spain. Yet although he believed he understood in the end *why* Gernika had been targeted, Southworth acknowledged that existing documents could not entirely prove his thesis, one shared by British historian Arnold Toynbee, which maintained that Gernika had been specifically selected for massive destruction to demonstrate to the citizens of Bilbao—the city whose capture had been the vital goal of the rebels' Basque offensive—what was in store for them if they did not surrender. "I will raze Bizkaia to the ground, beginning with Bilbao's industries of war. I have the means to do so," Franco's subordinate, General Emilio Mola, had de-

clared at the end of March 1937, and the atrocity of Gernika that followed four weeks later very likely was intended to prove those means as well as Mola's acid resolve. That had been the catastrophic motive, Southworth believed: Bilbao's vital port and industries might be spared for utilization by the victors—and its surrender might come quickly—if a defenseless town were wiped from the earth instead.

With funds for its reconstruction supplied by the regime that had destroyed it, and with labor supplied by Republican prisoners of war, the town of Gernika had risen slowly yet nonetheless phoenixlike from its ashes, and by the time the painting that shared its name came to Spain in 1981, it had once more become the bustling commercial center of the Mundaka valley. As they had for millennia, the broad and beautiful estuary still spread inland from the sea and high Monte Oiz continued to keep watch over the lower summits and forested hills that surrounded the town. Although Gernika itself appeared too orderly to those who knew it before its destruction—its architecture too uniform and too much the product of solely the 1940s—those who saw the town for the first time inevitably were struck by its quiet charm and the sense that it was one of those rare small towns that was at once contemporary yet intimately connected to it past. The railway station, municipal building, schools, churches, businesses, and homes appeared—at forty years of age—neither new nor decrepit, and their identical vintage lent them a pleasing visual unity. The relocated and now-covered market was alive with vendors and shoppers every Monday and a third of the Saturdays of the year, and carefully tended gardens filled the triangular plaza where the

bomb-destroyed market once stood, fronted by a street re-named in honor of Pablo Picasso.

In the industrial sector of town, plastics, cutlery, and ar-mament factories provided employment that augmented agriculture and a growing tourism trade, and Gernika, like its sister cities and towns throughout Euskadi, had begun to lift out of a long economic stagnation during the first six years of King Juan Carlos's reign. As they had before the war, once more the people of the Basqueland elected repre-sentatives to a regional autonomous government, and the venerated assembly hall in Gernika now was no longer sim-ply a relic of an earlier time, but rather the contemporary governmental seat, a place to which King Juan Carlos him-self had journeyed in April—as Castilian kings before him had done for centuries—to guarantee to the Basque people the nation's respect for their ancient fueros as well as their modern-day right to self-determination.

Yet despite its new self-governance, its hopeful economy, and its freedoms, the region remained deeply troubled by the pervasive sense that it was indentured to the rest of Spain, that its otherness was neither respected nor encouraged, and a brutal reign of terrorism whose ultimate if unlikely goal was an independent Basque nation continued unabated. To-gether with the time-tested car bomb, pistols made in Ger-nika increasingly became the change agents of choice for the clandestine organization known as ETA, one whose at-tacks on police, military, and political targets had only in-creased following the October 1982 election to power of the Spanish Socialist Workers Party and its charismatic prime minister, Felipe González. Although the Socialists became Spain's first leftist government since the republic—as well as the first government since Franco's death to be entirely free

of the dictator's former subordinates—González failed to remove long-tenured police officials in the Basque region who were notorious for rights abuses, and he succeeded in passing antiterrorism laws that gave police the draconian power to hold prisoners for up to ten days without access to legal counsel or without being charged with a crime. The Socialist government began arresting Basque journalists whom it believed were "apologists for terrorism," and its decision to fund and support the so-called Grupos Antiterroristas de Liberación—violent right-wing underground cells whose explicit missions were to assassinate ETA leaders in Spanish Basqueland as well as in France—led to a wave of bloody recriminations. GAL murders that were meant to curtail ETA violence provoked savage revenge operations instead, which, in turn, led to still more government-sponsored killing. To many Basques, even those who openly abhorred ETA's tactics, it appeared that the democratic government in Madrid was as bent on lawless repression as Franco ever had been. And for many outside the region, past sympathies for Basque suffering and injustices inevitably gave way to disgust and incredulity. What freedoms did the Basques still lack? millions outside the region wanted to know, including many like Angel Vilalta, who once had heralded ETA's elimination of Luis Carrero Blanco from his likely succession to post-Franco power. At the Mediterranean end of the Pyrenees in comparison, the people of Catalunya had fought for and won remarkable regional autonomy as well as national acceptance of the Catalan language and culture in the years since Franco's death, yet had done so without ever firing a shot. If the Basques once more governed themselves autonomously and their language and culture also were free to

flourish, why, Spaniards everywhere increasingly asked, did radical Basques still continue to kill?

Into this climate of change, hope, and continuing bloodshed early in the 1990s came an unlikely yet inspired proposal: the city of Bilbao would construct an art museum of international stature, one that would entice visitors from around the world to come to the Basqueland despite its growing reputation for terror, one capable of housing the world's best-known painting decrying violence just a few miles from the town of Gernika, a place now synonymous both with death and rebirth. In an effort to continue its ongoing transformation from a smoky, one-dimensional industrial capital into the kind of cultural Mecca that cities like Barcelona and Sevilla had become, officials of the Basque regional government, the Bizkaia provincial council, and the city of Bilbao set out to capture the attention of New York's Simon Guggenheim Foundation, which had begun to scout for a European city in which it could locate a new museum. A Guggenheim project planned for Salzburg, Austria, had stalled, and expansion of the Guggenheim's small museum in Venice would require a decade of maddening collaboration with the infamous Italian bureaucracy, so Guggenheim director Thomas Krens was willing at least to listen to the overture from Bilbao, but his skepticism was etched on his face when he made his initial visit to the hill-bound industrial city that immediately reminded him of Pittsburgh, as it did so many other Americans. Yet Pittsburgh was a city with a wonderful arts tradition, and surely the Basque city could build a tradition of its own around an extraordinary building that would house the foundation's renowned exhibitions of contemporary art, Krens's hosts wanted him to believe.

Basque officials hoped to finance a museum that would

do architecturally for Bilbao what Sydney's world-renowned opera house had done for the Australian city, they explained. So when Krens subsequently brought American architect Frank Gehry to Bilbao to help him consider potential sites, everyone began to get excited. Gehry was fascinated by the city-center site on the bank of the Río Nervión where an abandoned lumber mill still stood. Basque politicians assured Krens that they could supply 100 million dollars for the project, and yes, said the Guggenheim's board of directors, it could be persuaded that Bilbao was the perfect site for its new museum. "Throughout 1991, there were many further discussions and a feasibility study was conducted, as well as a restricted competition for possible architects," explained Juan Ignacio Vidarte, then tax and finance director for the Bizkaia provincial council. "We all jointly decided that we wanted to build a museum here. Then Frank Gehry's extraordinary design was selected. In early 1992, an agreement was signed and everything moved forward very quickly."

A year later, word had spread throughout the international architectural community that Gehry was planning a remarkable museum indeed, and people in the Basque region had begun to express openly the hope that the only true hurdle to bringing *Guernica* to Gernika soon would be surmounted. When the town had expressed interest in becoming the painting's long-term home a decade before, it had been unable to counter the argument that neither it nor the region at large possessed a museum capable of successfully caring for and exhibiting the painting; yet soon one that would rival any in the world would rise in Bilbao, only thirty kilometers away. Wouldn't arts and government officials in both the Basque country and Madrid inevitably recognize both the symbolic and redemptive power of bringing the painting

as close to its namesake town as possible? Surely, they told themselves, *Guernica* would travel once more.

That certainty proved partially correct, as it turned out, but only in a way that served to further embitter those Basques who believed in their bones that Madrid's antipathy toward them and their homeland was too endemic ever to change. *Guernica* did move in the summer of 1992, but its journey took it only ten blocks, and *this* would be the very last time it traveled, its caretakers contended, just as they had a decade before. The governing board of the Museo del Prado had voted in May in support of the transfer of the painting from its ten-year-old home in the Casón del Buen Retiro to the nation's new contemporary art museum, whose permanent collection was scheduled to go on exhibit for the first time in September in the dramatically and expensively renovated Hospital de San Carlos, an enormous and rather subdued eighteenth-century building that had sat empty since 1965. Rather abundantly named the Museo Nacional Centro de Arte Reina Sofía, in honor of Juan Carlos's wife, Queen Sofía, the museum would house the collection from the defunct Spanish Museum of Contemporary Art, a decidedly undistinguished assemblage of both Spanish and international art that would pale beside the grandeur and reputation of *Guernica*. Yet Picasso's masterpiece would, without question, draw people through the new museum's doors, and its presence would be a matchless foundation on which to strengthen its acquisitions over time. Opposition to the move came principally from those who believed, incorrectly, that Picasso had stipulated that the painting should be housed in El Prado, as well as the chorus of Basque voices expressing both astonishment and more than a bit of betrayal.

When the king and queen inaugurated the Reina Sofía's

permanent collection on September 10, 1992, Prado director Felipe Garín wanted to make it clear that while "no museum director likes to lose a picture, the reordering of our national collections makes good sense. *Guernica* is a very, very important painting, and we are proud to have had it in our care for ten years. But it does not form part of the historical collections of the Prado." Garín's predecessor, José Manuel Pita Andrade, had not been thrilled, in point of fact, when a decade before then–Director General of Fine Arts Javier Tusell had mandated the painting's placement in the Prado annex as a means of getting it out of New York and safely exhibited *somewhere* in Spain as soon as possible, and when the government chose to move quickly and override his plans to place *Guernica* inside the museum proper, Garín promptly had resigned.

This time, however, the only strident opposition to *Guernica*'s move came from the Basqueland—from the legion of nationalists who saw the decision as a blatant and all-too-predictable emblem of the way Madrid both ignored and oppressed them, from the Basque Nationalist Party politicians who viewed fighting valiantly for *Guernica* as an opportunity to conspicuously prove their worth to their constituents, and from Guggenheim officials who believed they had been duped when they were informed that the great painting would not be able to travel to Bilbao, even temporarily, because it was too fragile ever to travel again.

As Frank Gehry's building rose from the riverbank in Bilbao, Juan Ignacio Vidarte, the former provincial tax official who had been named the new museum's managing director, and city and regional government officials quietly approached the management of the Reina Sofía museum in Madrid with a request for the loan of Picasso's *Guernica* to coincide with

the museum's scheduled opening in October 1997. It was a confidential proposal that included detailed and highly technical plans for transporting the painting, the Guggenheim's express offer to share 50 percent of its revenues with the Reina Sofía while it was in possession of the painting, as well as an assurance that officials from Madrid could oversee and indeed manage every aspect of the loan in order to assure themselves of *Guernica*'s safety. But as Vidarte later described the refusal the Guggenheim received from Madrid, he could not hide his disappointment, nor his certainty that far more than the painting's fragile condition had formed the basis for the proposal's rejection. "We were asked to believe that the painting had traveled successfully from New York to Madrid in 1981 and from the Prado to the Reina Sofía in 1992, but then it suddenly became very, very sick and could never travel again."

Guernica simply could not be moved, he was told, yet the painting—mounted on its wooden stretcher and transported inside a specially outfitted truck—*had*, in fact, recently moved, without incident and apparently absent damage of any kind. "The sixtieth anniversary of the destruction of Gernika offers an unrepeatable historic opportunity for Basque people to see this work, the most important painting in twentieth-century art, in their own homeland for the first time," Vidarte told reporters. "This [refusal] transcends technical considerations. To say it is too fragile is to insult our intelligence. We have made extensive plans to transport the painting on its frame in a special protective, temperature-controlled vehicle. It's not a problem of cost. We will pay every expense." The Guggenheim director contended that with the use of state-of-the-art shipping procedures and without the need to remove the painting from its stretcher,

the painting would be as well protected en route to Bilbao as it was on a gallery wall in Madrid—*if* it were allowed to travel once more. Then he added, "Historically, in the Basque country, we have always believed *Guernica* should be located here. We have felt we have a spiritual claim to it. But that's an old story. For now it's settled. *Guernica* is in Madrid."

By the time the Museo Guggenheim Bilbao was nearing completion in 1997—a stunning and sensuously amorphous building clad with half-meter-square titanium scales, one that alternately appeared to be a great fish, an oceangoing ship, or an unfolding flower—the new museum no longer was alone in being denied the loan of *Guernica*. Officials at the Reina Sofía in Madrid by now repeatedly had offered a polite but unmistakably firm *no* to numerous suitors. Olympic officials in Barcelona had hoped to bring it to their city as part of the cultural Olympiad of the 1992 summer games; in Japan, curators wanted *Guernica* to highlight a 1995 exhibition planned to commemorate the fiftieth anniversary of the bombing of Hiroshima and Nagasaki and the end of World War II; French president François Mitterrand personally had petitioned for the loan of the painting for a major Picasso retrospective at the Centre Georges Pompidou beginning in December 1996; and even at the Museum of Modern Art— where painting and sculpture director William Rubin had denounced *Guernica*'s transfer to the Reina Sofía prior to his retirement—officials had made an exploratory inquiry about the possibility of borrowing the painting for MOMA's own Picasso show in 2000, an inquiry that already had been re-buffed. But in the Basque country, despite having been turned

down flatly—and presumably finally—sometime before, Guggenheim Bilbao director Vidarte and his colleagues weren't ready to surrender their efforts to bring *Guernica* to the people for whom the painting remained a profound and still-deeply emotional symbol of their suffering. And they were about to be assisted in their efforts by the country's recently elected conservative prime minister, José Maria Aznar, whose ruling People's Party would require—not coincidentally—the support of Basque members of parliament in order to maintain a fragile ruling coalition.

Although he had gone on record insisting that the loan of *Guernica* to the Guggenheim Bilbao was "an artistic question, not a political question," Aznar also was eager to sustain the support of both the Catalan and Basque nationalist parties. In early May 1977, the autonomous Basque congress had unanimously passed a resolution requesting the temporary loan of the painting for the opening exhibition of the Bilbao museum, noting that "for the great majority of our citizens, *Guernica* by Picasso symbolizes to the Basque people their fight for their liberty." With that resolution in hand, senators and deputies representing the Basqueland in the national assembly presented their own resolution requesting the loan as well. "Picasso had only expressed the wish for *Guernica* to come to Spain," explained Iñaki Anasagasti, a Basque Nationalist Party congressional deputy from Bilbao.

> If people in Madrid truly believe the Basque country is part of Spain, then why couldn't the painting be here, at least temporarily? After all, Picasso titled it *Guernica*, not *Madrid*. But because of a very strange bureaucratic process, technicians, rather than

the politicians who represented the people, were controlling where the painting could be and where it could not be. We understood the concerns about the painting's fragile condition, but please, this is an era in which we have put men on the moon. Surely we could safely bring *Guernica* to Gernika, or as we say in Basque, *Gernika Gernikara*.

Privately, off the record so to speak, we were told the reason the painting had to stay in Madrid was that we Basques couldn't be trusted. If the painting came to Bilbao, how could the *Madrileños* be sure we would return it to them? But the Guggenheim Foundation is enormously respected around the world. The idea that it would be a party to a Basque kidnapping was absurd.

With the aid of Prime Minister Aznar's impressive skills of persuasion, the resolution requesting the Reina Sofía to allow the painting to travel briefly to Bilbao eventually won the support of all the nation's political parties. Yet in the meantime, the museum had found an ally of its own in the study it had commissioned on the painting's physical condition, one which included recommendations for *Guernica's* future conservation. The *Study of the State of Conservation of Picasso's Guernica* was a book-length document published by the museum and contributed to by its staff of conservators and restoration experts, one that included dozens of photographs and X-rays that ably demonstrated the painting's deterioration as well as the specific kinds of injuries it had suffered in being moved thirty-two times over its life of sixty

years. Among its conclusions were the recommendation, expressed inescapably in capital letters, that those charged with the painting's care should REDUCE TO THE MINIMUM ITS HANDLING AND AVOID ITS TRANSPORT because "the canvas is especially sensitive to all types of vibrations, which are inevitable in transportation, vibrations capable of producing new cracks and the flaking and loss of paint." Although the study made no mention of the request for the loan of *Guernica* by the Guggenheim Bilbao, nor of the special vibration-limiting vehicle the museum had offered to construct for transporting the painting, it did curiously note that trucks with adequate temperature, humidity, and motion-dampening controls large enough to contain *Guernica* mounted on its frame simply did not exist in Spain or elsewhere in Europe.

"For us, the most important question is the conservation of the painting," said José Guirao, director of the Reina Sofía, in the days before the museum's board of trustees was scheduled to make a final vote on the issue. "I know there are others who want to turn it into a political question, but not us." By the time the museum board convened on May 13, Prime Minister Aznar's own cabinet had joined the chorus of voices in asking the museum to weigh the extraordinary circumstances and the *necessarily* political nature of the Guggenheim's request, but in the end, the board chose not to be swayed. "*Guernica* is enormously valuable in the history of contemporary art, and its physical state must be looked after," insisted Valeriano Bozal, president of the museum's patrons' association at the press conference at which the decision was announced. "It must not be moved to another museum."

It was apparent that no one associated with the Reina Sofía cared at that moment to consider that if a similar kind

of intractability had been imposed in the years before, the painting still would be housed in the Prado annex—or perhaps even in New York—and few, if any, of the partisans in favor of the loan believed the museum board had acted solely with the painting's protection in mind. When in June the national congress passed by a wide margin a resolution requesting the Reina Sofía to loan *Guernica* to officials at the Guggenheim Bilbao "if they can technically guarantee proper conditions for its conservation and transfer," it briefly appeared that the move remained possible, and some news agencies around the world even went so far as to report that the loan now certainly would be made. But soon the Reina Sofía's Director Guirao reiterated his staff's belief that those guarantees could *not* be met under any circumstances, and when Minister of Culture Miguel Ángel Cortés refused to override the museum's management, there was little left to debate. *Guernica* would remain in Madrid far into the future, and many in the Basqueland would continue to insist that regional and political antipathy toward them was the principal reason why. "Think about the Oklahoma City bombing," the Guggenheim Bilbao's communications director, Nerea Abasolo, told a reporter for the *Washington Post* in response to the deflating news, "and imagine that a picture of it could never be seen by the people of Oklahoma City. They say it's a political issue as if that was something to be ashamed of. *Guernica* is probably the most political picture in history."

"This is where *Guernica* will go," architect Frank Gehry explained to the king of Spain late in October 1997 as he escorted King Juan Carlos and Queen Sofía into a third-floor

"chapel" galley in the midst of a private tour of the extraor-
dinary new museum they had come to Bilbao to inaugurate.
It was the kind of statement the often unabashed Gehry was
noted for, but the Spaniards who heard him were both
shocked and a little delighted by the American's brash state-
ment to the crowned head, one that seemed to take it for
granted that the last word on the subject had not been spo-
ken. Yet for the moment it had. The museum would open
officially on Saturday evening, October 18, with a stellar ex-
hibition of international art of the twentieth century, but
absent the one painting that Director Vidarte and his col-
leagues foremost had hoped to display. "There would have
been such poetry," he lamented, "in bringing *Guernica* to
within thirty kilometers of Gernika on the sixtieth anni-
versary of the bombing, and to this building that is such an
important new symbol of Basque culture and the Basque de-
termination for peace."

A hundred thousand citizens of Bilbao had marched for
peace on the previous Thursday in response the shooting
death of policeman José María Aguirre, the latest of 800 vic-
tims of ETA terrorism since its armed, clandestine struggle
for Basque independence from France and Spain began
three decades before. On Monday, Aguirre had attempted
to question three terrorists who were posing as gardeners,
attempting to place remote-controlled grenades, concealed
inside flowerpots, in artist Jeff Koons's enormous plant sculp-
ture located near the museum's entrance, and the policeman
had been felled by a bullet fired by one of the terrorists as
the three attempted to flee.

Police snipers were posted atop the shimmering roof of
the Guggenheim Bilbao on Saturday evening and hundreds
of officers circled the building as the king and queen and

eight hundred invited guests arrived, without incident, for the inaugural ceremony, during which Juan Carlos proclaimed the luminously sculptural Gehry design as "the best building of the twentieth century." Outside the museum, 500 dissenters loudly protested the king's visit and the construction of the museum itself, which they charged was a symbol of U.S. and Spanish cultural imperialism and an extravagant waste of money that could have better served the poor. But José Antonio Ardanza, president of the Basque autonomous government, assured those inside that the policeman's death in defending the unique new structure already had transformed it into something far more than a museum. "The inhumanity of a few fanatics has cost a life in this moment of culture, tolerance, and humanity," he said. "Officer Aguirre's sacrifice has made this museum a powerful new symbol of our freedom and of art's role in constructing peace."

The bulletproof shield that had protected *Guernica* against an attack by terrorists at the Casón del Buen Retiro since the painting's arrival in Madrid in 1981 also had made the short journey to the Reina Sofía museum in the summer of 1992, where it and the painting it protected had been installed alone in a small second-floor gallery prior to their re-exhibition again in the fall. In the first days when Spaniards at last had had the opportunity to see the world-renowned painting a decade before, they had formed queues that stretched for blocks and had waited patiently for hours in order finally to see *Guernica* with their own eyes, and in the years since, millions of Spaniards as well as people from around the world had made simple yet often deeply meaningful pilgrimages to the painting. In that time—and surely

owed, in part, to the extraordinary security the Prado and the Spanish ministry of culture had provided—there had not been a single incident of vandalism nor any kind of attack. It seemed to be a very reasonable risk therefore when, in 1995, officials at the Reina Sofía decided the bulletproof glass now safely could come down. "In the first years that *Guernica* was in Spain," explained María José Salazar, chief conservator in the Reina Sofía's department of collections, "both the right and the left supported bringing it here, but everyone was afraid of something bad happening. Even well after Franco's death, everyone was afraid, and it was very critical that nothing happen to the painting. *Guernica* was a kind of confirmation that there was a new moment in Spain, and it *had* to be protected. But it was wonderful. Everybody behaved excellently; there never were any molestations, or even any protests."

At the same time that the painting's protective covering was removed, *Guernica* itself made a minor journey once more, traveling thirty meters from the enclosed gallery with a single entrance where it initially had been displayed to the lateral wall of the long gallery through which the museum's visitors naturally flowed. The move meant that patrons no longer could approach the painting from a distance and view it frontally and in its entirety as they drew near it; but in a trade-off that museum curators deemed acceptable and important, hundreds of people at a time no longer found themselves trapped in something of a bottleneck, as had often been the case in the previous space, and *Guernica* once more was placed in the context of many of the preliminary studies that had played such a vital role in its creation. Now the large crowds that filled the museum each day filed laterally past the painting—guards with pistols on their hips

still stationed at each flank—most visitors stopping for a time beneath the salon's high and vaulted ceiling to consider the breath-catching work, standing as close as four meters from the canvas itself and held at bay only by a thin, thigh-high bar that was a replica of the restraining rail that had been employed six decades before at the Spanish pavilion of the Paris world's fair.

In the spare and open plaza that fronted the museum, a replica of Alberto Sánchez's fanciful sculpture, *The Spanish People Follow a Way That Leads to a Star*, which had stood like a proud totem at the entrance to the pavilion of the Spanish Republic in 1937, now greeted the museum's patrons, their numbers surpassing those who visited Madrid's legendary El Prado by the time the widely heralded Museo Guggenheim Bilbao opened late in 1997. *Guernica*'s presence already had made the Reina Sofía the most visited museum in all of Spain, and there was little question that virtually all who entered the cool and cloistered and quietly formal building that once had been a hospital made their way most importantly to the huge painting that a grand world's fair and a terrible civil war had engendered sixty years before.

"For the old people who see *Guernica* for the first time," explained María José Salazar, "it is very emotional. Many of them cry. Some cry bitterly. For them, it is still a dream that this painting can be viewed in the heart of Madrid, that no one tells them it is evil or the product of a traitor. The painting remains very powerful for them, for people my age and older—those of us who remember what it was like to live under Franco. For us, *Guernica* is a symbol both of what once was horrible in Spain and what Spain has

become. A painting that can symbolize both those extremes is an extraordinary painting, of course.

"My own children have never known anything but democracy. For them, Franco seems as ancient as *los Reyes Católicos*. They study *Guernica* in school and yes, they understand that it is an important historical painting, but for them, it is not emotional; it is not deeply meaningful. For me, that is a little sad, the fact that my children cannot view it as proof that Spain has made an extraordinary transition. But isn't it wonderful in a way as well that after all these years, for the young, *Guernica* now becomes only an arrangement of paint on a very large and aging canvas?"

Epilogue

People from around the world had traveled to Madrid specifically to see *Guernica* on September 11, 2001, as they had in every season since its arrival in Spain precisely twenty years before; already the painting had resided in Spain for nearly a third of its illustrious life. No longer was its presence in the city that had been fought for so brutally and relentlessly during the civil war an occasion for heady celebration, yet unquestionably, it remained an enormously powerful icon in which *Madrileños* took surpassing pride. During its two decades of residence in the Spanish capital, the painting had been freed from protective custody. Its bulletproof shield had been abandoned, and by now the museum guards who protected it throughout each day were armed with nothing more lethal than two-way radios. The long and vaulted salon where *Guernica* hung—its frame also supported from beneath by a low banquette that relieved the strain of its weight—was carefully temperature- and humidity-controlled and was kept dim except for banks of cool-spectrum lights that brilliantly and safely illuminated the massive canvas. Four security cameras were trained in the direction of the

painting, and at virtually every moment during the day, literally hundreds of people viewed it intently as well, their voices softened to whispers, their postures subtly reverential in the presence of an image so familiar and yet so stunning, so disturbingly violent and yet beautiful as well.

During the hours in which I studied the painting—seeing it for the first time in the thirty-three years since Angel Vilalta had told me and a clutch of American boys that it mattered immensely—I was struck first of all by its enormity, by its commanding presence in the huge room that was its home. I was awed too by a three-dimensional quality that reproductions of the painting never had evidenced and by the way in which subtle colors—blues in particular—seemed to leap from the canvas that in fact was painted only in hues of black and white and gray; by the exposed nipples of the female victims that evinced terrible pain instead of succor; by the extraordinary motion in the mane of the stricken horse, by the stippling of its body that seemed to tally Gernika's dead. And I was moved by the massed images in a way that left me stilled but also stirred by the emotive certainty that this monumental painting perfectly echoed its tragic times.

Few of the people with whom I contemplated *Guernica* during those hours wept, as had been commonplace in the years before, yet no one among the thousands blithely dismissed the painting or its subject and virtually everyone was halted by it for minutes at least, their survey of the huge museum interrupted by the visual impact of a painting that unmistakably had changed the world. A few elderly Spaniards made signs of the cross before they departed; young people— some of whom obviously were students spending a year abroad, like I once had been—sometimes sat on the marble floor and copied particular images into sketchbooks. Japanese

visitors, of whom there were many, paid the painting particularly long and thoughtful attention, and one of their guides explained to me that for them, the painting's true title perhaps was *Hiroshima*; for the Japanese, she said, *Guernica* had become "a cultural habit." I was surprised by how few people needed to examine the small card mounted beside the painting, which read

> Pablo Picasso
> Málaga 1881–Mougins, France 1973
> *Guernica*, Paris, 1 May–4 June 1937
> Oil on canvas

It was interesting to note how many visitors chose to carry rented compact-disk players through which they could hear Claude Picasso read in resonant French, Spanish, and English lines from the poem his father had written, somehow very presciently, three months before Gernika was destroyed:

> . . . cries of children cries of women cries of birds
> cries of flowers cries of timbers and of stones cries of
> bricks cries of furniture of beds of chairs of curtains
> of pots of cats . . .

But then, suddenly, throughout the museum and the sunlit city spread the strange and impossible rumor that New York City was under attack. "You're American, aren't you?" someone said. "It's serious. You should go find a television." It was unthinkable gossip that couldn't possibly be true, yet the video images soon confirmed it: a brand new kind of warfare *was* under way, one in which a previously unknown

terror screamed out of the sky, its target as many innocent people as possible, its apparent purpose only the threat of doom.

"Wars end," said Picasso, "but hostilities endure forever."

In Barcelona in the succeeding days, despite the unsettling experience of being far away from the U.S. at a time when friends and family were grieving and struggling to comprehend madness, it was comforting to attend with thousands of Barcelonans a requiem mass for those who had died, and later it was wonderful to watch Catalan citizens both young and old dance the powerfully symbolic *sardana* in the Plaça Sant Jaume, where both the city hall and the Generalitat of the Catalan regional government have stood since the fifteenth century. The occasion was the Festes de La Mercè, the weeklong end-of-summer celebration that honors Nostra Senyora de la Mercè, the city's patron saint, and as I watched the many hundreds of merry dancers moving lightly on their feet, their hands joined and held high to form giant circles, it was hard to imagine that the late and unlamented Generalisimo Franco had outlawed this simple expression of regional pride, afraid, I suppose, that this innocuous folk dance might give way to revolution. High on a temporary bandstand erected against a wall of the Generalitat hung a banner that read in English, NEW YORK NOW MORE THAN EVER.

It was remarkable too to renew my friendship with Angel Vilalta, the extraordinary teacher who had inspired so many young Americans to set their sights very high. I sadly had said good-bye to him thirty-two years before, certain that we would rendezvous again before long, yet somehow that reunion had had to wait until now. I couldn't be sure whether

he truly would remember me; I was only one of thousands of his students, after all. Yet during three remarkable days we were able to create once more an ineffable bond that teachers and their students sometimes share, a link we remade as readily as if we had been separated only a month or two. I marveled at how ebullient Angel remained at seventy-five, how passionate he continued to be about life and art, and I was reminded too that the richest relationships in our lives often do not depend on daily contact for their sustenance. We reminisced about the shared days when both of us had been far younger and remembered how pessimistic he had been back then that Spain would ever be free of oppression. He recalled the years of the civil war with a kind of detail that visibly unsettled him; he remembered, reluctantly, the persecution that had sent him and fellow artists and intellectuals to jail, and he described the miracle of King Juan Carlos with the zeal of a converted monarchist. He showed me with obvious pride the impressive art collection that was the product of a lifetime spent supporting young and emerging artists, and we spoke at length about *Guernica*, the painting that first had stirred his emotions when he too was young and eager to live a life that mattered.

"I can't look at *Guernica*, even today," he explained, "without remembering the bombing during the war. I think of the terrible bombing in Lleida and my mother covering all of her children with her body to protect us. I look at the painting and remember being sure we were going to die. I was a student at the university when I first saw a photograph of *Guernica*, and I knew immediately that it was something stupendous, something very, very important. It spoke so correctly about the disaster of the Spanish war, yet clearly it was

about every war, about the way in which every country in the world at one time has been guilty of great crimes. When at last I saw *Guernica* in person in New York in the summer of 1969, I was so moved. It made me so sad for Spain, for which I was homesick, so sad for people everywhere who suffer. I think of the many, many people in New York who have just died. Picasso's genius was that although he did not suffer horribly himself, he could comprehend the horror. He turned terror into art that teaches us something, and that is a profound and difficult and wonderful thing to do."

On the final day of our time together we visited Angel's close friends Albert Rafols-Casamada and his wife, María Girona, both of them painters. Together with fellow Catalan Antoni Tàpies, Rafols-Casamada was, in fact, one of Spain's foremost living abstractionists, but he was elderly now and in declining health, and he spoke in barely more than a whisper as he described first seeing reproductions of *Guernica* soon after the civil war at the French Institute in Barcelona, an island of cultural and political freedom in a Spain Franco had transformed into a gulag. "I was very impressed by what Picasso had attempted to do," he explained in Catalan as Angel translated, "and by how he had succeeded. It seemed to me that he had synthesized all the important movements in painting of the early twentieth century—some of which he had created himself, of course—into one great work. It seemed too that he had synthesized the history and thinking of the century as well. I believed then, and still do, that *Guernica* was very well thought out; it is not a masterpiece by accident. Picasso thought more about this painting than perhaps any other. He worked very hard to make it work visually, and of course, he attempted to find and describe the essence of suffering."

Rafols-Casamada's own work had become entirely abstract soon after he became aware of and deeply affected by *Guernica*, and he admitted that surely he had seen something in the painting that had helped point him toward his own future. In his living room, we were surrounded by his sensuous and wonderfully saturated color-field paintings, and we were silent for a moment as he contemplated a large photograph of *Guernica* in a book that lay in his lap. "My eye is still drawn to it, fascinated by it," he confessed. "I see its rhythm, the space, the spare language that is limited to black and white. Then behind the paint and the nearly perfect composition, I also see the fight for freedom and peace. People say the painting is so Spanish, but what I see can only be called universal."

In rain- and sea-shaped Euskadi that autumn, it appeared that for many Basques the ideas of freedom and peace remained somehow at odds with each other. Bull's-eyes spray-painted on doors by ETA operatives were distressingly common sights, the words YOU WILL DIE often added to underscore the brutal intent. Posters commemorated young heroes who had been killed in ETA's underground war against the national government, and everywhere signs shouted EUSKAL PRESOAK EUSKAL HERRIRA—Basque Prisoners to the Basque Country—in angry opposition to that same government's policy of imprisoning terrorists in remote corners of the country, far away from family and friends in their homeland. For many young Basques, the painting that for their parents had been a powerful symbol of solidarity against Franco's oppression—and which had hung in their homes like a sacred talisman of their struggle—now uncomfortably seemed to insist that violence

always was wrong, when, the young Basques believed instead, violence sometimes was the essential catalytic component of change.

"Gernika is the happiest town in the world," wrote French philosopher Jean-Jacques Rousseau at the midpoint of the eighteenth century. "Its issues are governed by an assembly comprised of peasants, which meets under an oak tree and always makes just decisions." And early in the twenty-first century, his words somehow continued to ring true, despite the fact that the evidence of societal unrest was as visible in Gernika as anywhere else in the Basqueland. Its citizens seemed remarkably contented, in fact—confident that they had rebuilt their town into a place where lives could be well and productively lived, yet mindful too that their singular history had made them responsible for ensuring that they and their visitors never forgot the horrible acts of which humans were capable.

A group of leftist historians, each too young to remember personally their town's most tragic day, had formed an organization called Gernikazarra in 1985, which was dedicated to accurately and dispassionately disseminating the truth about Gernika's destruction, work which by now convinced them that the 1937 attack's specific intent had indeed been to murder civilians, yet which also had led them to conclude that the number of townspeople killed was approximately 250—a death toll far lower than normally believed, even by Franco's apologists—but a number that did nothing to lessen the enormity of the crime. Gernika Gogoratuz, a peace research center established in 1987 by the Basque parliament, now attracted students from around the world who attended seminars in international understanding, conflict resolution, and nonviolent change; and the Gernika town government

planned to begin construction soon on an international peace museum that would invite visitors not only to experience something of the horror of the town's destruction but also to "reflect on the meaning of peace, a concept which is so commonplace and yet so complicated," and to envision new ways in which to nurture it. "The museum will be associated with peace museums throughout Europe located at sites where other atrocities have taken place," as part of a pan-European effort to unite people who once were foes, explained city attorney Bittor Zarrabeitia. "Already we have formed a brotherhood with a town in Germany called Forchheim, which was bombed terribly during World War II. It is an attempt to link our common experiences, to end bad feelings, and to share the lessons people who have suffered have learned. Now, of course, New York City has become a brother to Gernika, hasn't it? They destroyed Gernika on a market day when it was full of people, and New York was attacked on a day when thousands of people were working. Here, it was the first time airplanes were used to bomb civilians. There, for the first time, the bombs were the airplanes themselves. We have no skyscrapers here, but nonetheless now we are very alike."

At the Juntetxea, the ancient assembly hall that had escaped destruction in 1937, small groups of visitors from across Spain, from France, Israel, Japan, and the United States paid quiet homage to the tradition of Basque democracy and the notion that even peasants should collectively decide their fates for themselves on a day when light rain presaged the long winter to come. Outside, the eldest of the three sacred oaks of Gernika, now just a gnarled trunk, was protected from the weather by the domed roof of a cupola, but two other trees—one planted in the nineteenth century

and now nearing the end of its long life, the other a vigorous offspring planted back when the town's reconstruction began—seemed to welcome the rain that would freshen their leaves and soak down to their vital roots.

The Museo Guggenheim Bilbao had received a million and a half visitors by the end of its first year of operation, and architect Frank Gehry's shimmering, kinetic, and multitiered building had won the coveted international Pritzker Prize and had been proclaimed by Philip Johnson, the dean of America's contemporary architects, "the greatest building of our time." Yet the museum's staff and people throughout the Basqueland continued to believe that the refusal to loan *Guernica* for the museum's inaugural exhibition had been a "thumb in the eye" to them, proof that they were deeply mistrusted and that the refusal was indirect punishment for the terrorist violence that had spread from Euskadi to every corner of Spain.

"They were dirty discussions prior to the opening of the museum," its director, Juan Ignacio Vidarte, remembered in English that autumn. "We attempted to engage in conversation with the Reina Sofía confidentially, as quietly as possible, and to make the request very sensitively. But when news of our request leaked into the press, we began to be accused of wanting *Guernica* because we had nothing else to exhibit; we were accused of planning never to return the painting; we were told we couldn't protect it from terrorists, all of which was completely false.

"But we take the long view. We still say to Madrid, 'we would love to have *Guernica* here at any point in time for as long or short a period as you choose.' Certainly, there will

need to be a change in order for that to happen—a political change, or somehow a leader must emerge who can influence both hearts and minds. But we can be patient, because we continue to believe that it would be a gesture of reconciliation of enormous importance to bring *Guernica* to this museum, so near Gernika itself. It would be healing for all of Spain, and would do an enormous amount by way of assuring the Basque people that we *are* a part of this nation. *Guernica* is the most reproduced work of art from any era in the Basque country; people here care more about this one painting by Picasso than about any other painting ever produced. The space we call the chapel on the third floor of the museum continues to wait to host *Guernica*, and it will wait for a very long time."

Pablo Picasso had waited for the opportunity to return to Spain for thirty-four years following the end of the civil war, but Francisco Franco and his regime stubbornly had outlived him. Yet four years following his death, the painter would have been enormously cheered by the first appeal in the Spanish parliament in 1977 to bring *Guernica* to his homeland, a nation where a new king courageously had rekindled democracy. Early in the twenty-first century, the painting that had been created to help alert the world to the horrors of that war had been at home in Spain for two decades, and the Spanish pavilion of the Paris world's fair was far from forgotten. Joan Miró's interior mural and Alberto Sánchez's monolithic pillar both had been lost en route to Spain at the close of 1937, yet a concrete replica of the towering Sánchez sculpture now guarded the entrance to the Reina Sofía museum in Madrid, and a bronze casting of Picasso's *Woman*

with a Vase occupied a place of prominence inside the building, only steps away from *Guernica*, the three pieces at least partially and very symbolically reunited. Alexander Calder's groundbreaking fountain, *Spanish Mercury from Almadén*, nowadays greeted visitors to the Fundació Miró high on Bacelona's Montjuich, and on the opposite side of the city, an exact replica of Josep Lluis Sert's pavilion itself had been constructed in the heights of the Horta district, where it housed a branch library of the University of Barcelona. The pavilion of the Spanish republic had stood in Paris for only five months sixty-four years before, yet its legacy—the artwork it had presented and the embattled ideals it championed—would endure in a new and dramatically remade Spain, it appeared, for many years to come.

"*Guernica* was the last great history-painting," wrote the Australian-American art critic Robert Hughes. "It was also the last modern painting of major importance that took its subject from politics with the intention of changing the way large numbers of people thought and felt about power. . . . Picasso could imagine more suffering in a horse's head than Rubens normally put into a whole Crucifixion. The spike tongues, the rolling eyes, the frantic splayed toes and fingers, the necks arched in spasm: these would be unendurable if their tension were not braced against the broken, but visible, order of the painting." Surely that was the painting's genius, in the end—its brilliant synthesis of both doom and beauty—and that was the reason why its renown had grown so great in sixty-four years, why so many people from around the world still made long pilgrimages to see it, and then spent hours transfixed in its presence.

For a long time, curators at the Reina Sofía were struck and made more than a little uneasy by another of the paint-

ing's apparent powers. For reasons they couldn't explain, it seemed to impart a subtle band of blue color, about a meter above the floor, to the wall opposite it in its second-floor gallery. The wall was regularly repainted, but then soon thereafter the horizontal blue blur would reappear, always at the same height above the floor. Was there something in the way the painting was lit that colored the wall? Surely the painting itself didn't emanate blue light—or did it? "Finally, mystified, we posted staff who did nothing but observe the opposite wall," explained chief conservator María José Salazar, "and then it was quickly obvious. So many of our patrons wear blue jeans, and so many of them stand against that wall and study *Guernica* for hours. Once each week, the wall is painted white again, but each week the blue line returns."

In a 1994 book review critical of British historian Paul Preston's new biography of Franco, once more the American magazine *National Review* insisted, rather unimaginably, that Gernika's "destruction could not have been caused by air bombardment." Yet on March 27, 1997, sixty years to the date since the town was reduced to ash, German president Roman Herzog presented to town officials a letter acknowledging that Gernika was, in fact, destroyed by "an indefensible act of aerial bombardment. The victims of this terrible atrocity suffered human anguish. We renounce the bombardment by the German aviators and the horror it caused. Now we call for reconciliation and peace between our two peoples." A year later, the German parliament similarly recognized the role of "German pilots of the Condor Legion in the destruction of the town," and soon thereafter, the German government and town officials completed negotiations

for the construction in Gernika of a costly and extensively equipped sports center, paid for the people of Germany as a "gesture of peace."

In the early autumn three years later, a group of school-girls who believed the new sports center had made their town an even grander place in which to live, offered competing answers when asked their opinions of why Gernika was famous far and wide. "For football," and "for beautiful boys," came the first replies. "No, for the sacred oak of Gernika," others soon scolded. "We are famous because our grandparents suffered very greatly during the war," said a girl whose hands were wrapped around the handlebars of her bicycle. It wasn't until they were repeatedly pressed that a small and rather serious member of the group recollected the mural that in recent years had been mounted on a wall near the Juntetxea. Comprised of 540 individual tiles, it was an exact-size ceramic reproduction of a famous painting. GUERNICA GERNIKARA, read the two words beneath it. "The Spanish painter Picasso made a painting about Gernika," she explained. "That too is why we are famous, but that was a very long time ago."

In the autumn of 1933, at a time when hope for the new republic in Spain burned bright, Pablo Picasso sculpted a larger than life-size image of a female with an enormous head and voluptuous figure presenting in her huge right hand—as if in a gesture of supplication, perhaps by way of making an offering—a tall and slender and classically shaped vase. This is the sculpture whose concrete casting stood alone in a little garden outside the pavilion of the Spanish Republic at the 1937 Paris world's fair; in bronze, it also is

currently positioned near the artist's celebrated *Guernica* in Madrid. A third casting, in bronze as well, languished for decades in the artist's several studios, and a note attached to it continually explained that he believed that artwork too should become the property of the Spanish Republic when it was restored one day. But as it happened, however, that particular casting ultimately would reside atop the grave of the great painter at his château at Vauvenargues in Aix-en-Provence in the south of France. "I stand for life against death," Picasso had claimed a quarter-century before his demise, in the midst of a fear-wracked era when *Guernica* had hung in a bold but far more innocent New York City. "I stand for peace against war."

Bibliographical Note

This narrative is intended for general readers rather than scholars, and for that reason I have chosen not to cite sources in the text or in accompanying notes. But I will be pleased to answer queries directed to me through the publisher about specific sources. *Picasso's War* is built, of course, on the foundation of the documents, letters, articles, and books that preceded it, and I would like to express my particular debt to *Picasso's Guernica: History, Transformations, Meanings* by Herschel B. Chipp; *Picasso's Guernica*, edited by Ellen C. Oppler; *Picasso and the War Years: 1937–1945*, edited by Stephen Nash; *Guernica! Guernica!: A Study of Journalism, Diplomacy, Propaganda, and History* by Herbert Southworth; and *The Basque History of the World* by Mark Kurlansky.

To readers interested in critical and Spanish perspectives on the creation and impact of *Guernica*, I recommend *The Genesis of a Painting: Picasso's Guernica* by Rudolph Arnheim; *Picasso's Guernica: The Labyrinth of Narrative and Vision* by Frank D. Russell; *Guernica: Historia de un cuadro* by Joaquín de la Puente; *El Guernica* by Francisco Calvo Serraller; *La*

Odisea del "Guernica" de Picasso by Rafael Fernández Quintanilla; and *Arte, historia y política en España* by Javier Tusell.

Hugh Thomas's *The Spanish Civil War* is a comprehensive and exhaustive account of that tragic and hugely consequential conflict; and Paul Preston's *A Concise History of the Spanish Civil War* and *Franco: A Biography* are also indispensible to those who desire a deeper understanding of the era. María Jesús Cava's *Memoria colectiva del bombardeo de Gernika* is a deeply moving oral history of the bombing of the town, as is the pictoral *Gernika 1937: Sustrai Erreak* by the Grupo de Historia Gernikazarra.

The fascinating Paris International Exposition of 1937 is the subject of two important books: *Paris 1937: Worlds on Exhibition* by James D. Herbert and *France on Display: Peasants, Provincials, and Folklore in the 1937 Paris World's Fair* by Shanny Peer. *Fireworks at Dusk: Paris in the Thirties* by Olivier Bernier offers readers a compelling and more comprehensive picture of that focused place and time.

Readers interested in learning more about the life of Pablo Picasso will enjoy *Pablo Ruiz Picasso: A Biography* by Patrick O'Brian; *Picasso: His Life and Work* by Roland Penrose; *Picasso: Life and Art* by Pierre Daix; as well as *Picasso's Weeping Woman: The Life and Art of Dora Maar* by Mary Ann Caws and *Picasso and Dora: A Memoir* by James Lord. I also draw their attention to Enrique Mallen's "Online Picasso Project," an extensive Web-based resource on Picasso's life, work, and extraordinary legacy.

Additional information about this book's genesis, the travel and research that preceded the writing, and additional authorial perspectives on the importance of the painting called *Guernica* can be found at the *Picasso's War* website.

Acknowledgments

This book began half a lifetime ago when Angel Vilalta, an extraordinary teacher, introduced me to both the tragedy of Gernika and the transcendent importance of *Guernica*. Thirty-three years later, Angel shared with me once more his passion for painting, for Catalunya, Euskadi, and all that is Spain, and for the poetry of essential truths. I am deeply indebted to him for helping set my life on its early course, and for aiding this project in innumerable vital ways. Lydia Nibley—my life-mate, traveling companion, colleague, and mentor—brought her extraordinary insight and sensitivity to the subject; she helped me see parts of the story I otherwise would have missed, and brought a mother's care and concern to every word of the manuscript, for which I offer her my soul-felt thanks.

Jody Rein did a masterful job of finding this book a home; Mitch Hoffman championed it early, offered critical support, and lent the manuscript the kind of eye that only the best editors possess, and it was a pleasure to work with Carole Baron and all of her dedicated staff at Dutton. Two

translation and research assistants—Ernesto de Casas in Madrid and Patricia Benito in Bilbao—made miracles happen on repeated occasions; they offered their huge talents, energies, and friendship, and I give them my enduring thanks because this book simply could not have been written without them.

Dozens of people were vitally helpful along the way, particularly Félix Herrera, María José Salazar, Javier Tusell, and Barbara Woods in Madrid; Iñaki Anasagasti, María Jesús Caba, Silvia Colmenero, Aitor Ibarrola, Javier Uriarte, and Juan Ignacio Vidarte in Bilbao; José Angel Extaniz, Juan Gurierrez, Bernardo of Muxika, and Bittor Zarrabeitia in Gernika; and María Girona and Albert Rafols-Casamada in Barcelona. The staffs of the libraries of Madrid's Museo Nacional Centro de Arte Reina Sofía, the Museo Guggenheim Bilbao, the Museoa Gernika, and the Museum of Modern Art in New York offered kind and constant assistance as well. I offer all of them my heartfelt thanks for helping me tell a story that profoundly reinforces my belief in art and freedom and redemption.